IMAGES
of America

GULFARIUM
MARINE ADVENTURE PARK

IMAGES
of America

GULFARIUM
MARINE ADVENTURE PARK

Russel Chiodo and Krista Stouffer

ARCADIA
PUBLISHING

Published by Arcadia Publishing
Charleston, South Carolina

Library of Congress Control Number: 2014944078

For all general information, please contact Arcadia Publishing:
Telephone 843-853-2070
Fax 843-853-0044
E-mail sales@arcadiapublishing.com
For customer service and orders:
Toll-Free 1-888-313-2665

Visit us on the Internet at www.arcadiapublishing.com

*We dedicate this work to the past and present employees of
Gulfarium Marine Adventure Park and all the great work they do.*

CONTENTS

ACKNOWLEDGMENTS

The Gulfarium's rich history exists thanks to the animals that live or have resided within and the dedicated people who have and continue to provide care for the animals and a meaningful experience for visitors.

We wish to thank Gulfarium's board of directors, including the Merrill family, for their support of this project and ongoing contributions to the park and its visitors.

Many of the incredible photographs provided for this book were sourced from Tony Mennillo of Arturo's Studios, taken by his father Arturo Mennillo, the premier photographer of Florida's Emerald Coast in the 1950s and 1960s. We encourage readers to visit Arturo's Studios for prints of these and other vintage photographs of beautiful northwest Florida.

We wish to thank all the former Gulfarium employees, their families, and local historians who contributed memories, stories, and photographs for the book, including George Gray, Billy Hurley, Russell McLendon, Lee Kellar, Tom Rice, Teri Horton, Ron and Martha Bradford, Doug Thompson, Terry Watkins, Dr. Forrest Townsend, Dewey Destin, Steve Shippee, Dorothy Manning, Stacy and Derek DiDonato, and Paul Bratton. Your dedication and love for the Gulfarium exude through your words and encouraged us on this journey.

We would like to thank our editor at Arcadia Publishing, Julia Simpson, for her guidance through the production process.

Lastly, Russ thanks his wife, Cat, for her strong support from the moment this book was merely an idea, and Krista would like to thank her husband, Chad, for his confidence, patience, and support along the way.

INTRODUCTION

In the early 1950s, J.B. "Brandy" Siebenaler graduated from the University of Miami with a degree in marine biology and the desire to share his love of the sea with the world. He selected Fort Walton Beach, Florida, as the perfect place for his vision and set about seeking development partners and funding, both of which he found in experienced real estate developer Lloyd Bell.

Siebenaler and Bell hatched a plan to build an attraction showcasing marine life unseen by the majority of people on the shore of the Gulf of Mexico, where clean salt water could be drawn continuously to fill habitats of sea life. The men drew simple plans for their attraction and presented them to Okaloosa County authorities in 1953 as they sought additional investors to get the project off the ground. Siebenaler's impassioned description of an attraction that would make Fort Walton Beach a tourism destination swayed the Okaloosa County Council in favor of Siebenaler and Bell's grand idea, and the men secured a lease for their tourist attraction in a county where agriculture was traditionally the cash cow.

Steel was still peaking in price during the post–World War II building boom, so surplus battleship steel was sourced from the shipyards in Mississippi. Huge plates initially intended to create the immense hulls of mighty warships were trucked onto Okaloosa Island for their new purpose of containing a marine ecosystem.

As construction neared completion and sea life was collected to fill the Gulfarium's massive main tank exhibit, Siebenaler, Bell, and their initial investors discovered that their new attraction was proving more costly than they had expected. Nevertheless, the park opened on schedule in August 1955 and entertained guests from near and far with high-flying dolphin performances and exciting scuba diver shows.

Guests were thrilled by the shows and exhibits at the Gulfarium, but daily operations were costly, and admission revenues were not keeping pace in the early years. Local businessman Burney Henderson had been developing beachside property throughout the Destin and Fort Walton Beach areas and saw incredible potential in the Gulfarium. He invested in the park as Siebenaler and Bell saw their project run dangerously low on funding. Henderson became president of the Gulfarium, a title that he held for decades. His grandson Willis C. Merrill III would follow in his footsteps as president and carry the park well into the 21st century.

With a fresh shot of funding and the support of a growing Fort Walton Beach community, the Gulfarium thrived and quickly became the tourism destination Siebenaler and Bell had conceived. As the park gained popularity from year to year, it grew with new exhibits, more elaborate shows, and an ever-growing list of animal species. By the end of the 1970s, the Gulfarium boasted a sea lion show, harbor seal interaction programs, river otters, exotic birds, sharks, and even miniature ponies for a brief time.

The Gulfarium impressed visitors more and more over the years as it grew, becoming a vacation tradition for many families, but it earned a strong reputation in the marine mammal care and research communities as well. Dr. Lowell Longaker studied dolphin sounds as early as the 1950s,

and Drs. David and Melba Caldwell published their findings about dolphin vocalizations, gleaned in part from research at the Gulfarium, in a 1965 issue of *Nature*.

In the 1990s, a dorsal pack was developed at the Gulfarium, which was later adapted and used by the US Navy to aid in their research and training operations with dolphins.

The Gulfarium was also rescuing and rehabilitating native wildlife from its earliest days. From sea turtles and manta rays to dolphins and large baleen whales, the Gulfarium staff often had to adapt their expertise on the fly to move, house, and care for wildlife of all sizes. Brandy Siebenaler never backed down from a challenge, and as a result, many animals went back to their native habitats fully recovered.

One notable rescue effort involved a Bryde's whale that became stranded on a shallow sandbar in Pensacola Bay. When Gulfarium staff members responded to the call about a "small whale," they discovered an animal some 50 feet in length firmly stuck on the sandy bottom. Working with the US Coast Guard and the Florida Marine Patrol, Gulfarium veterinarian Dr. Forrest Townsend directed the effort to fashion a towing harness for the animal and pull it to the safety of deep water. For three days, the animal floundered while Gulfarium staff, including George Gray, spent countless hours in the water with it to monitor its status and attempt to keep it comfortable. The whale was eventually pulled free from the sandbar, and onlookers watched as it swam directly out to sea.

The Gulfarium rescued many stranded dolphin calves over the years and eventually became the first facility to raise an orphaned dolphin, April, with voluntary bottle-feeding. April was a huge success and a groundbreaking case in animal rescue, dolphin husbandry, and cetacean research. With trainers using the techniques learned at the Gulfarium, many calves have been instructed to take prepared milk formula from a bottle.

Even through hurricanes and the changing landscape of Okaloosa Island, the Gulfarium endured through the 1990s and beyond the relentless hurricane years of the early 2000s. After many upgrades and renovations following storm damage, the Gulfarium continues to operate today as a modern zoological facility. Amazingly, the battleship-steel dolphin habitat constructed in 1954 still stands as the centerpiece of the park, and dolphin shows take place daily for cheering crowds. This pool is now the longest-surviving completely man-made dolphin show habitat anywhere in the world.

Water for the park is still drawn directly from the Gulf of Mexico, giving the park an umbilical connection to the resource it strives to conserve. Trainers in the dolphin show inject each performance with an educational message to complement the dolphins' incredible aerial flips and spins against the backdrop of the beautiful Gulf waters.

Today, the Gulfarium's mission continues to focus on educating the public and inspiring stewardship of our marine ecosystems by providing visiting guests with a window into the sea—a continuation of Brandy Siebenaler's original intent for the attraction.

One

A Dream as Big
as the Sea

In 1953, a young man with piercing blue eyes and an ambitious vision stood beside a respected developer in front of the Okaloosa County Council in Crestview, Florida. John "Brandy" Siebenaler and Lloyd Bell pitched their intention to build a huge tank filled with sea creatures on Okaloosa Island, a stretch of sand dunes on the Gulf shore bisected by a two-lane highway. Siebenaler and Bell needed the land, and they insisted the funding would come.

The Gulfarium, the brainchild of Siebenaler and Bell, would become the Emerald Coast's signature attraction. It would contribute tomes of research and data to veterinarians studying marine mammals, rescue and rehabilitate countless numbers of native wildlife, and hold a special place in the memories of vacationers from all over the world. On that day in 1953, however, roadside attractions were a new phenomenon, the Emerald Coast had yet to assume that name, and the Okaloosa County Council wondered why they should parcel out land for such a dreamy project when the cash cow in Florida's panhandle was agriculture.

Siebenaler and Bell were the Gulfarium's biggest advocates before the first shovel broke ground, but they needed financial support to make the park possible. Area businesspeople and investors, including Lloyd Bell's friends Jack Manning and Walt Ruckel, backed the construction and collection efforts from the start. Another original investor was former Fort Walton Beach mayor Holton L. Hudson, who served as the Gulfarium's first president.

Men and machines went to work in 1954, and the Gulfarium opened its doors to eager guests on August 14, 1955.

The idea for a marine exhibition like the one Siebenaler envisioned was a dream so big it needed the nurturing of a visionary. Siebenaler took an active role in every aspect of the park's management throughout his life, from a revolutionary design for the immense main tank to animal collection and care. Siebenaler's former colleagues speak of his wise business sense and his undying passion to make the Gulfarium the world's foremost oceanarium.

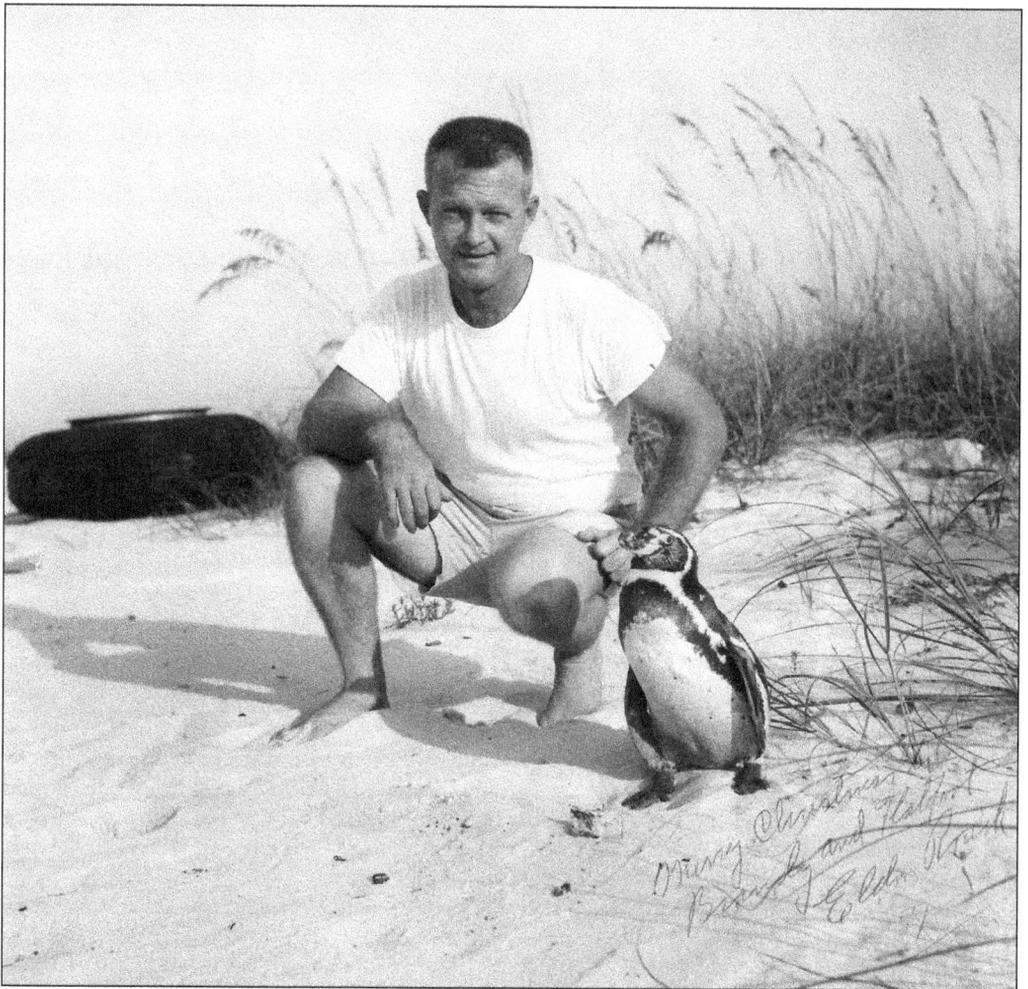

In the early 1950s, Brandy Siebenaler, a well-respected marine researcher and graduate of the University of Miami Marine Laboratory, had a vision to display marine life in a way that visitors to the panhandle of Florida had never seen before. With bright blue eyes and a passion for marine life, Siebenaler and local businessman Lloyd Bell sold the developers of northwest Florida the idea that Fort Walton Beach needed an aquarium, a tourist attraction, and a scientific research center. In early 1954, a total of 15 scientists at the University of Miami and 50 local residents incorporated the Gulfarium. Today, many of the Gulfarium's stockholders, or their heirs, are the same as they were back then. Siebenaler managed the Gulfarium's operation with the assistance of his wife, Marjorie, and their kids, Karen, Brandon, and Greg, until shortly before passing away in 2000. (Courtesy of Gulfarium Marine Adventure Park.)

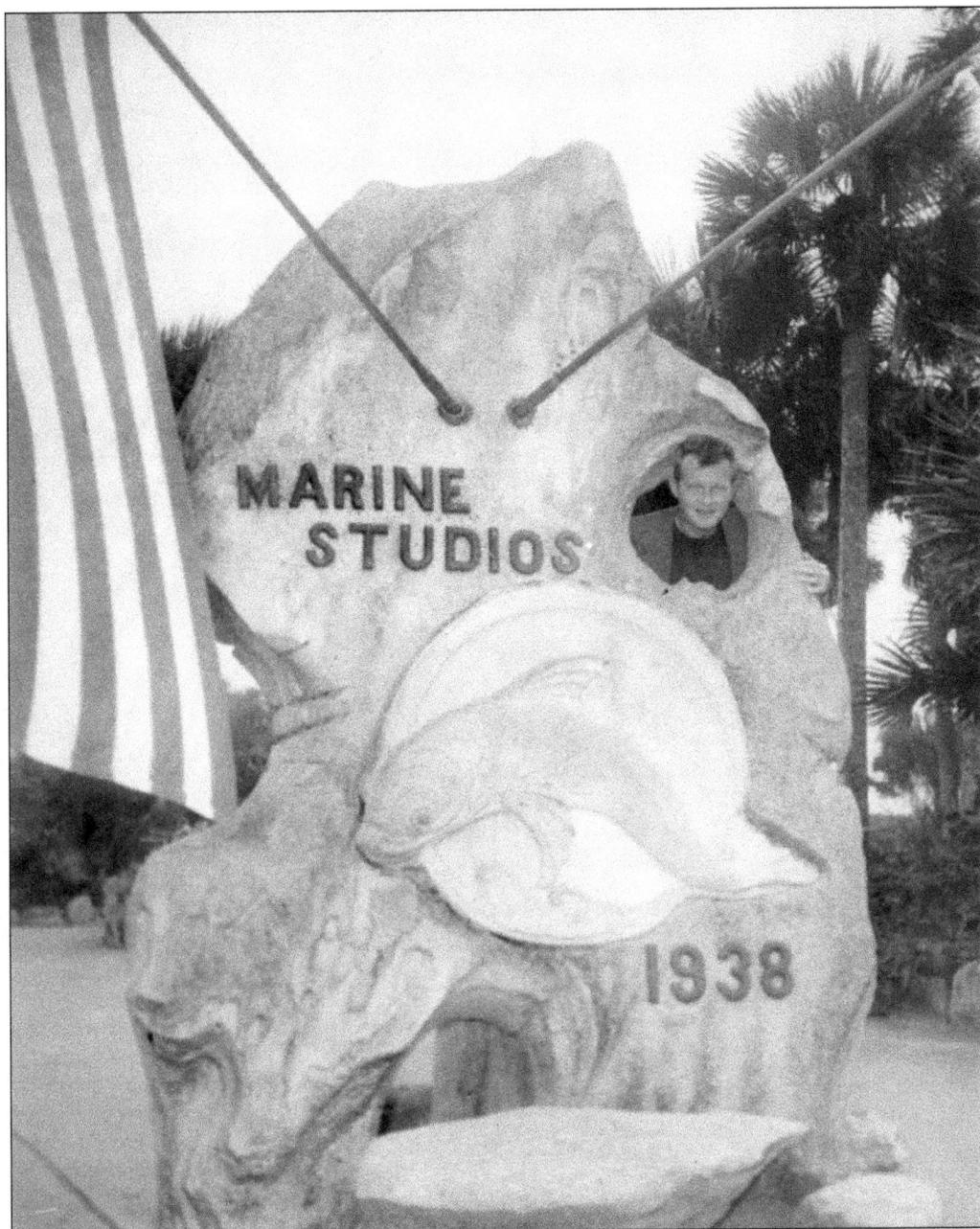

Gulfarium founder Brandy Siebenaler drew inspiration and knowledge from the world's first oceanarium, Marineland. Throughout his development of the Gulfarium, Siebenaler worked closely with his friends David and Melba Caldwell, who were key figures in Marineland's inception. Here, Brandy is shown visiting Marineland in the early 1950s. The iconic coquina sign he is posing with still stands in its original location at the edge of State Road A1A to this day, more than 75 years after it was first placed there. (Courtesy of Gulfarium Marine Adventure Park.)

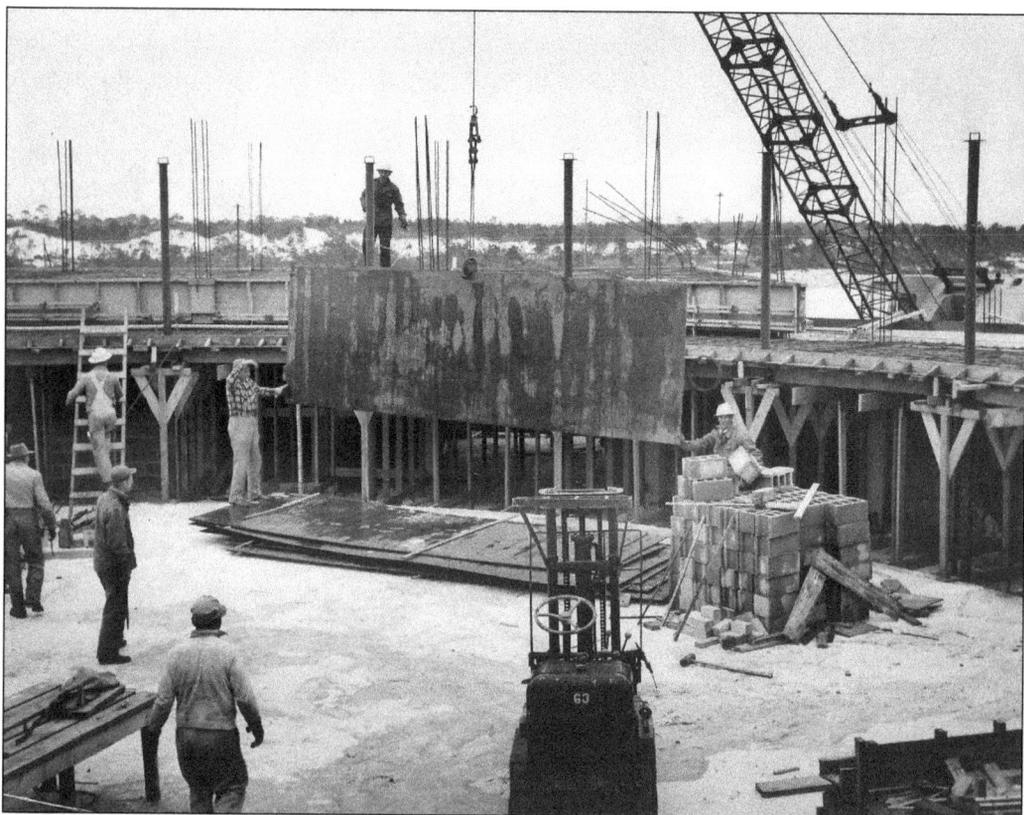

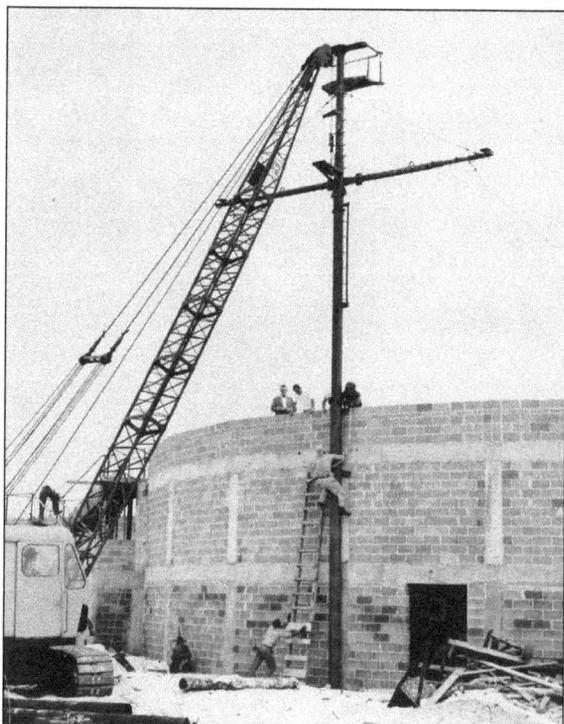

Brandy Siebenaler's vision begins to take shape as construction commences in 1954. Erected first was the ground level of the building's exterior, a circular midpoint with rectangular extensions on either side. Above, workers use a crane to bring in sheets of battleship steel that would be bent by hand with a come-along winch tool and worked to create the freestanding pool, held in place by poured concrete. At left, with the second level built, workers, including contractor Paul Leslie at the top of the ladder, install the towering ship's mast that gave park patrons the feel of embarking on a nautical voyage, without ever leaving dry land. It also served as a crane to transport dolphins and other sea life in and out of the main tank. With a rope pulley system and standing platform attached to a swiveling arm, marine animals weighing hundreds of pounds could be easily lifted up and over the top deck using minimal manpower. (Both, courtesy of Arturo.)

Jim Kline, the first Gulfarium dolphin trainer, performs masonry work during the construction of the Gulfarium in 1955. Present-day trainers face surprises every day, but a trainer's duties in the early days of the Gulfarium could include everything from construction labor and vehicle maintenance to animal medical procedures. The job entailed much more than showmanship, although each trainer had to master his or her presence in front of the crowds. (Courtesy of J. Douglas Allen.)

A worker puts the finishing touches on the Gulfarium's main tank windows in 1955. Looking beyond the pool across what would become the parking lot, US Highway 98 is visible past the row of freshly planted palm trees. The desolate sands to either side of the Gulfarium's entrance indicate how sparsely populated and utilized the land on Okaloosa Island was at the time. (Courtesy of J. Douglas Allen.)

13

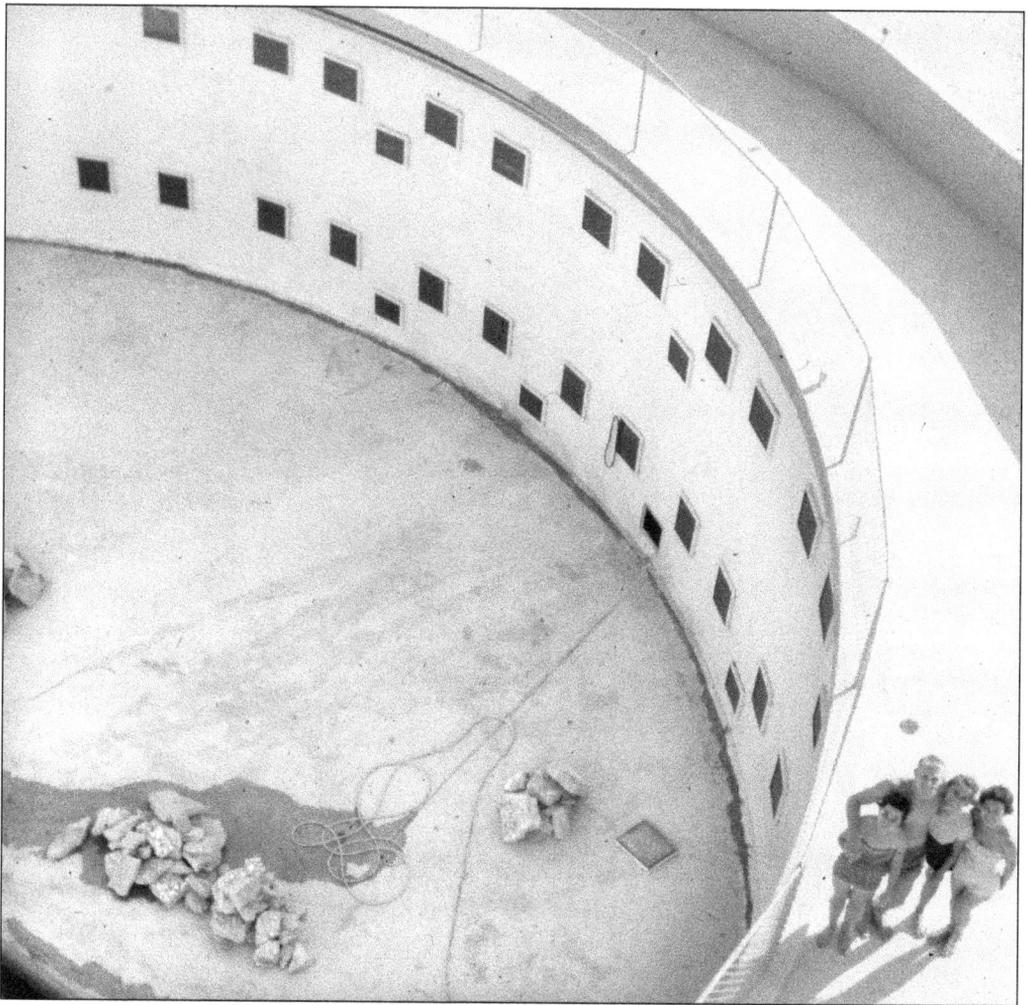

In this photograph taken by J. Douglas Allen from the Gulfarium's mast are, from left to right, unidentified, Don Fitzgerald, unidentified, and Juanita Terrebone. Construction on the main tank is nearly complete, with the windows in place, the top deck finished, and rock piles placed in the bottom, quite possibly the beginning of the tank's original reef structure. Allen never officially worked for the Gulfarium but often helped out during the construction of the park and the collection of animals because he had friends, such as Jim Kline, working at the park. Local residents were excited about the island's new attraction, and many lent a hand to help the Gulfarium establish itself as a primary Gulf Coast attraction. (Courtesy of J. Douglas Allen.)

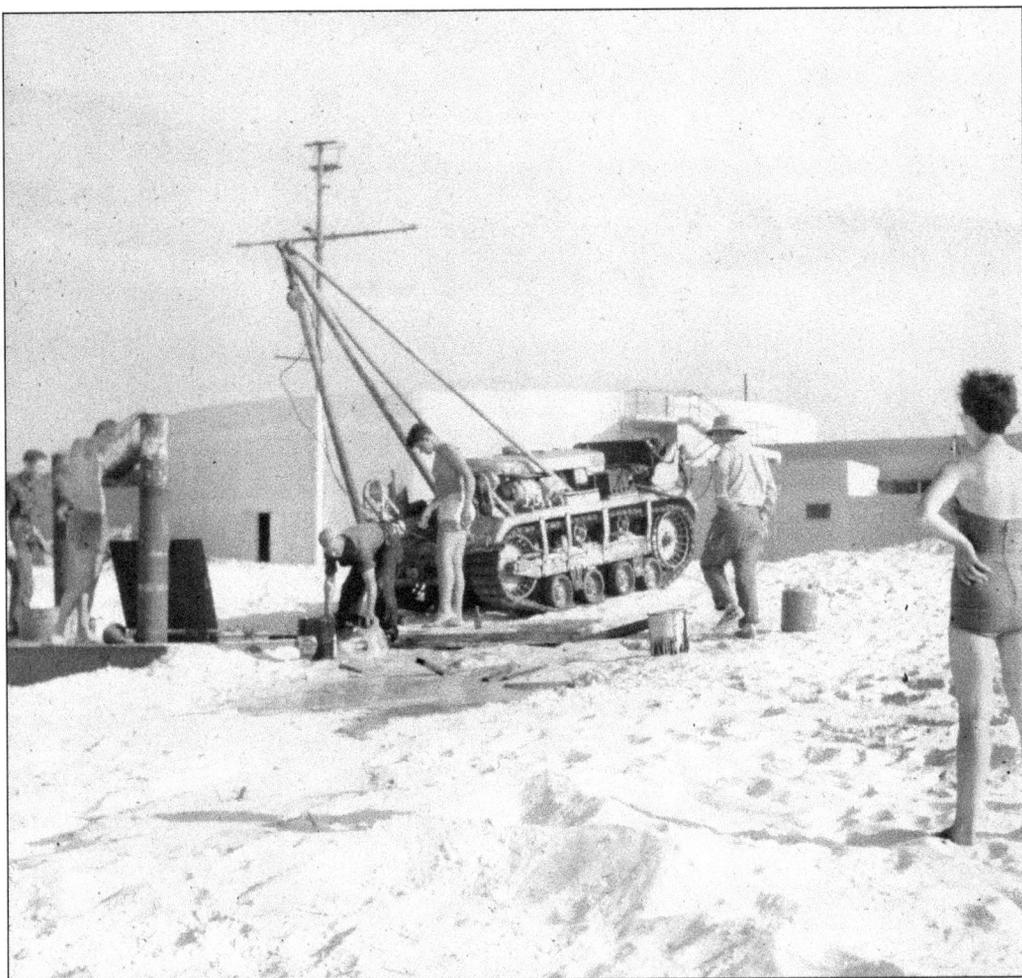

Don Fitzgerald (holding the vertical pipe section) and his unidentified date (far right) look on as work continues on the installation of the Gulfarium's lifeline—its pipeline to the Gulf of Mexico. Sections of pipe, like the one Fitzgerald is holding upright, were laid together to form the link that would draw seawater into all the Gulfarium's saltwater habitats. Machines and men with shovels dug a trench in the soft, white sand for the pipe. By pulling water through a pipe buried beneath the floor of the Gulf, the water was naturally filtered as it was drawn through the fine sand. The Gulfarium currently utilizes the same intake system. Today, the most sophisticated aquariums utilize man-made sand filters to achieve crystal clear water for their animals. (Courtesy of J. Douglas Allen.)

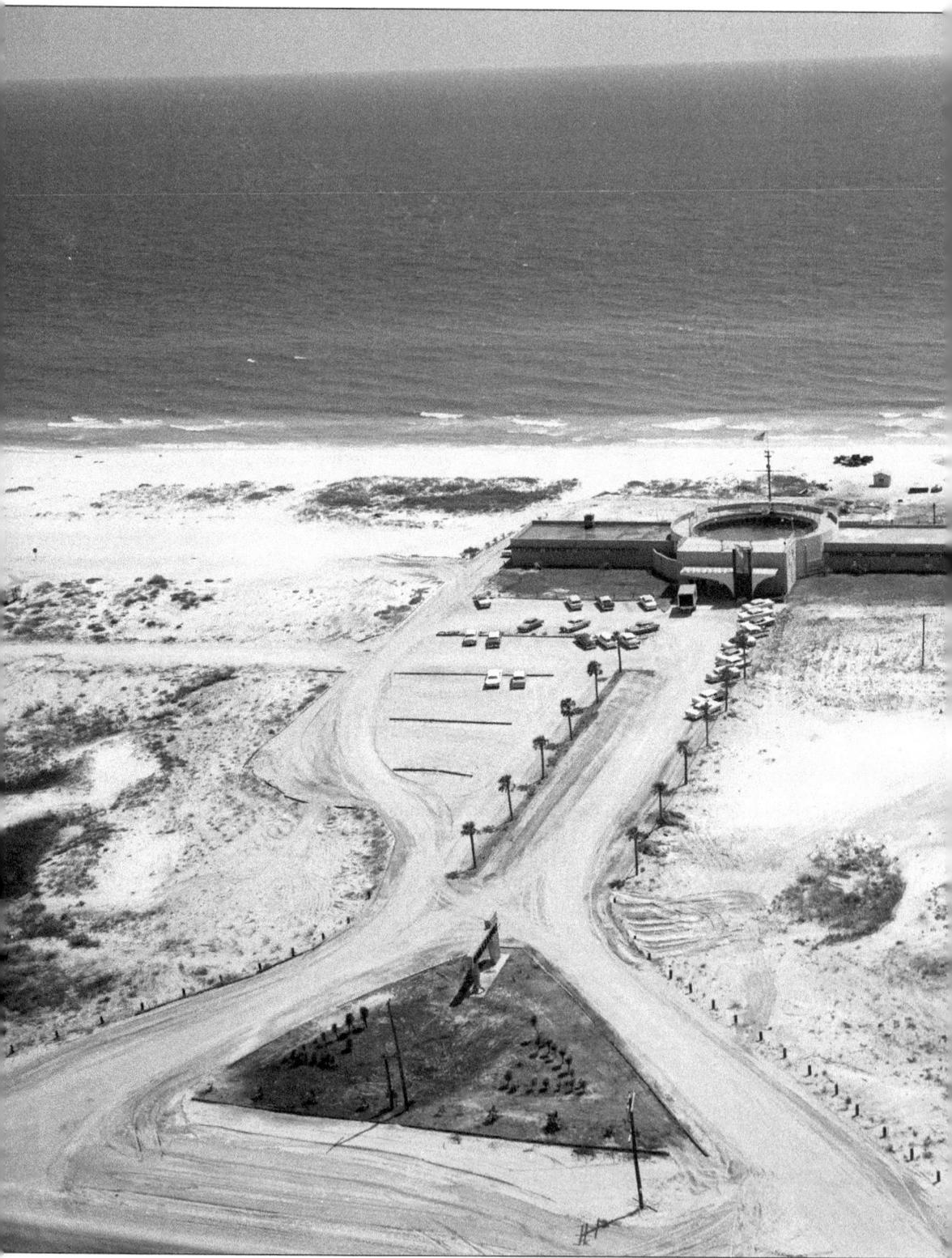

This aerial photograph of the Gulfarium from 1959 shows not only its original form but also its lonely existence on Okaloosa Island in the early days. Flanked on both sides by sand dunes and coastal vegetation, it is no wonder that founders Brandy Siebenaler and Lloyd Bell had to work so hard to convince Okaloosa County officials that a marine park attraction on the island would thrive. Many hotels, restaurants, and the Okaloosa Pier would eventually join the Gulfarium over the decades as this stretch of coastline became known first as the Miracle Strip and later as the Emerald Coast. (Courtesy of Arturo.)

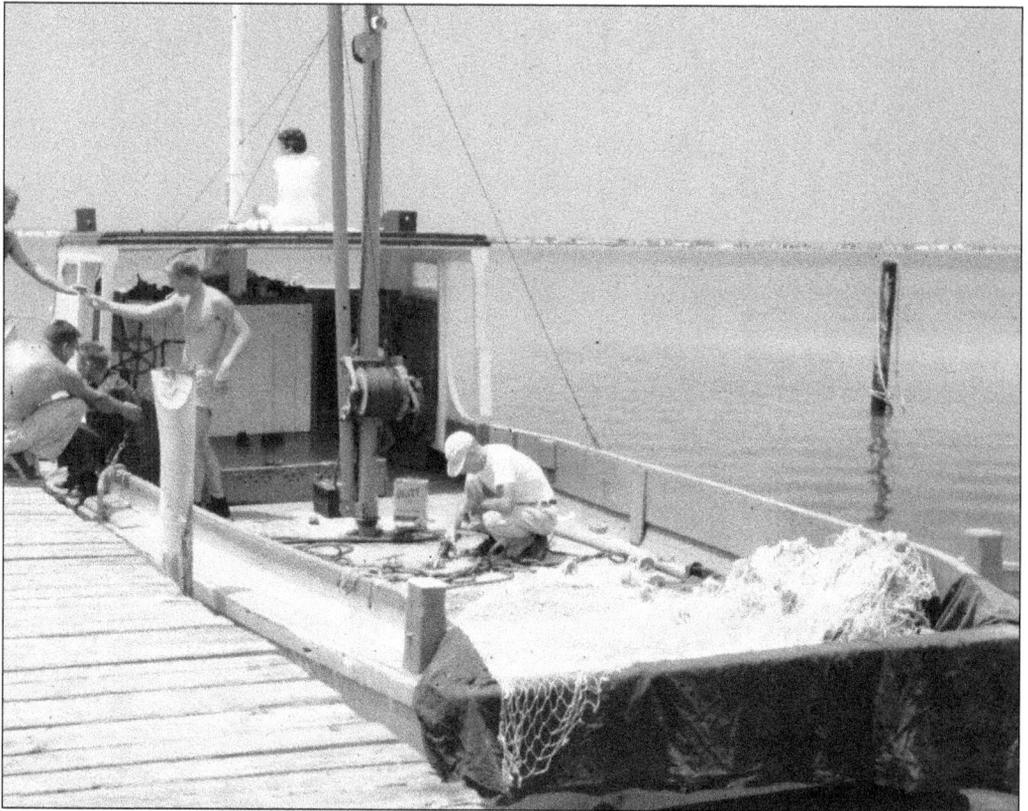

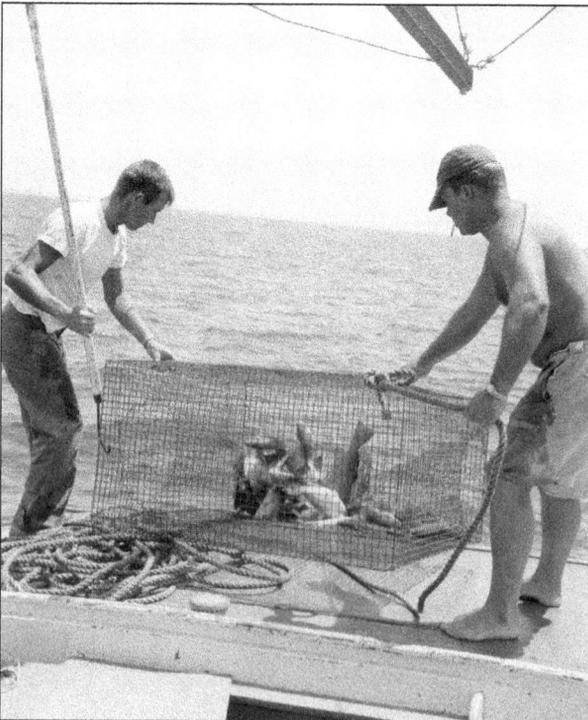

During the stocking phase of the Gulfarium, local fishing boats were used to collect Gulf of Mexico specimens, such as dolphins, sharks, and myriad other sea life. One of these local fishermen included Capt. Dewey "Buck" Destin, a descendant of the city's namesake, Leonard Destin. Above, Destin's *Gee-Eye* is shown at her dock in 1955. Her open deck space, sturdy mast and booms, and the nets she carried made her the perfect collection vessel for the wide variety of species desired for the Gulfarium's exhibits and to feed the park's larger animals. At left, fish are collected with deepwater traps and nets. The experience and ingenuity of the crew was tested as they pioneered methods of collecting specimens and delivering them to the Gulfarium, with care to minimize animal stress and maximize survival rates. (Above, courtesy of J. Douglas Allen; left, courtesy of the State Archives of Florida.)

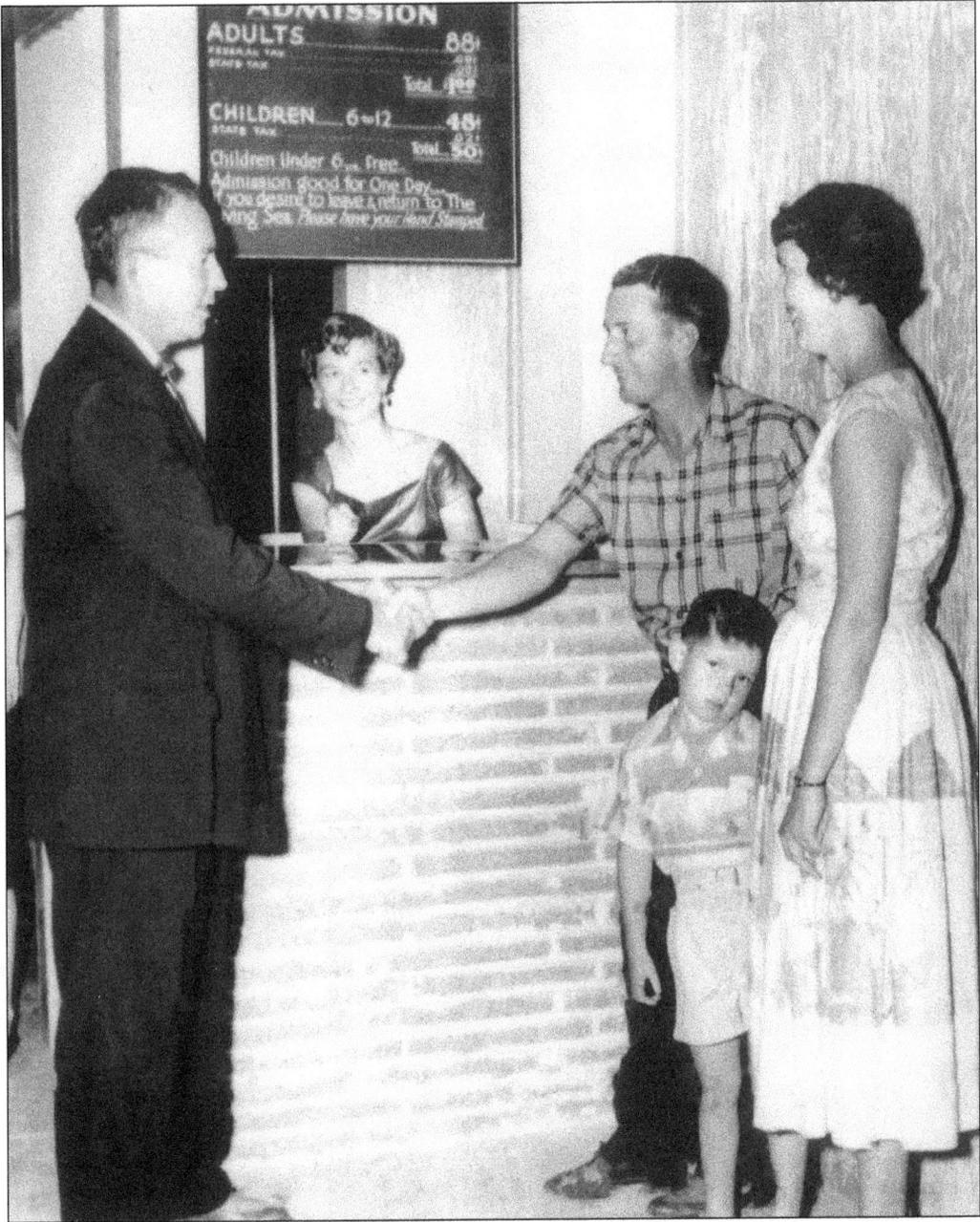

Following great anticipation and last-minute touches continuing into the wee morning hours (Marjorie Siebenaler and friend Melba Caldwell sewed and hung curtains in order to reduce echoing in the hallways), opening day finally arrived on August 14, 1955. In this photograph, Gulfarium president Holton L. Hudson welcomes the very first park visitors: Mr. and Mrs. Raynor and their son Ralph of Marigold, Mississippi. On their way home from a vacation in Panama City Beach, the Raynor family decided to stop in on a whim, not realizing the significance of their visit until they were face-to-face with the president himself. Marjorie Siebenaler collects admission fees—$1 for adults and 50¢ for children. At this time, a season pass was only $5, and the whole family could visit for the entire year for merely $10. (Courtesy of Arturo.)

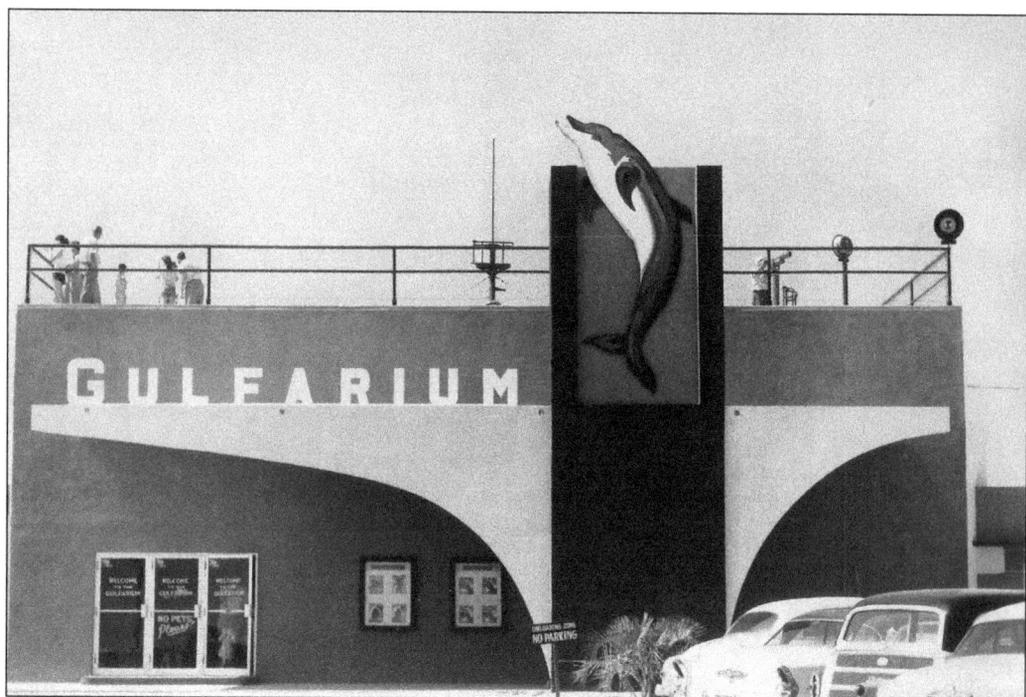

Pictured in 1955, the Gulfarium facade was a welcoming vision of the marine animal menagerie held within. Posters on the front of the building featured photographs of jumping porpoises, along with the daily show schedule. Above, guests can be seen roaming the elevated viewing platform, observing the dolphins and taking in unparalleled views of the Gulf of Mexico to the south and Choctawhatchee Bay to the north. (Courtesy of Arturo.)

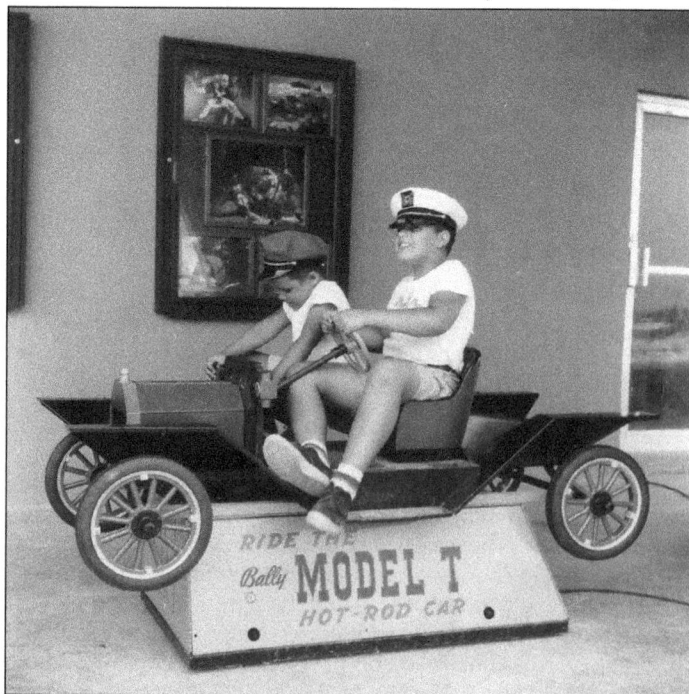

Brothers Michael (left) and Stephen Rouillier enjoy the Model T hot-rod car ride at the Gulfarium's front entrance in 1958. The Rouillier family of Louisiana vacationed in Destin and Fort Walton Beach every summer, and as a diving fanatic, Michael made sure they never missed a trip to the Gulfarium. (Courtesy of Michael Rouillier.)

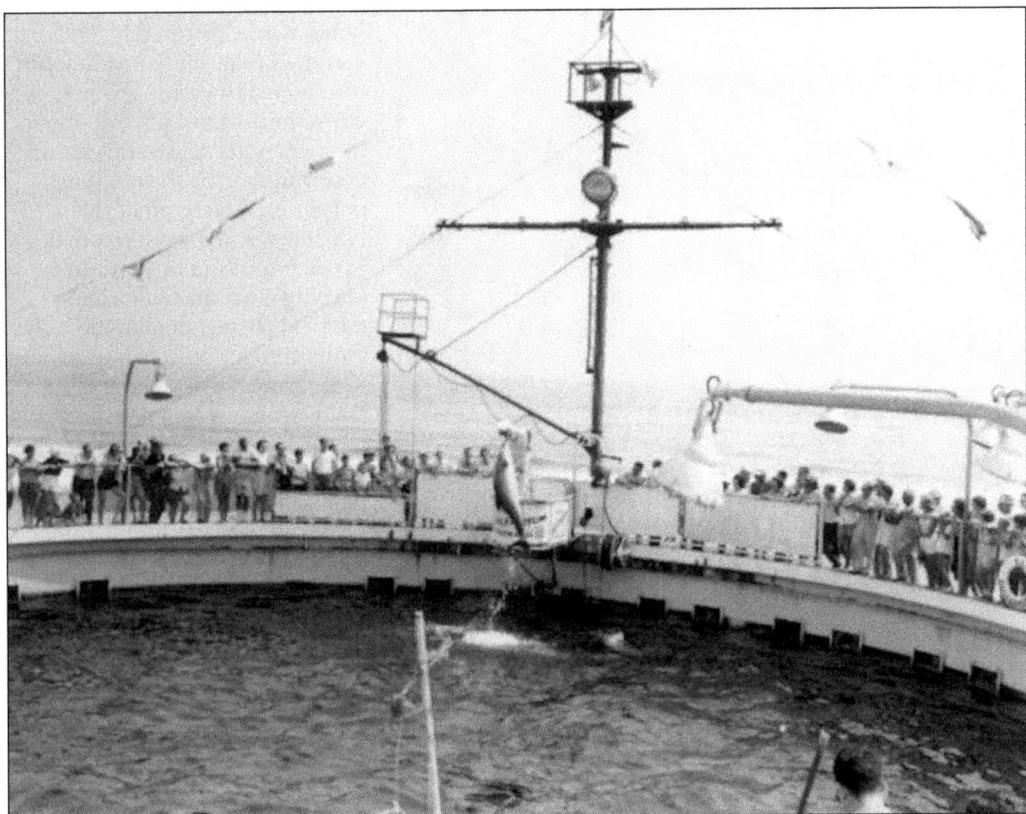

In the early days, the Gulfarium was known around town as the "Living Sea," the first man-made attraction in northwest Florida. During the summer, thousands would flock to see the mysteries of the sea revealed. What was once foreign and at a safe distance in the Gulf of Mexico was now right in front of spectators' eyes through viewing ports and thick glass. And at the heart of it all was the parade of porpoise stars—Humpty, Dumpty, Jumpty, and Sam—offering high-flying performances on the hour, rated second to none. The photograph above, taken in August 1959, reveals the perspective of a guest standing on the elevated platform on the north side of the habitat, while at right is a bird's-eye view of a dolphin high jump taken from the ship's mast. (Above, courtesy of the State Archives of Florida; right, courtesy of Gulfarium Marine Adventure Park.)

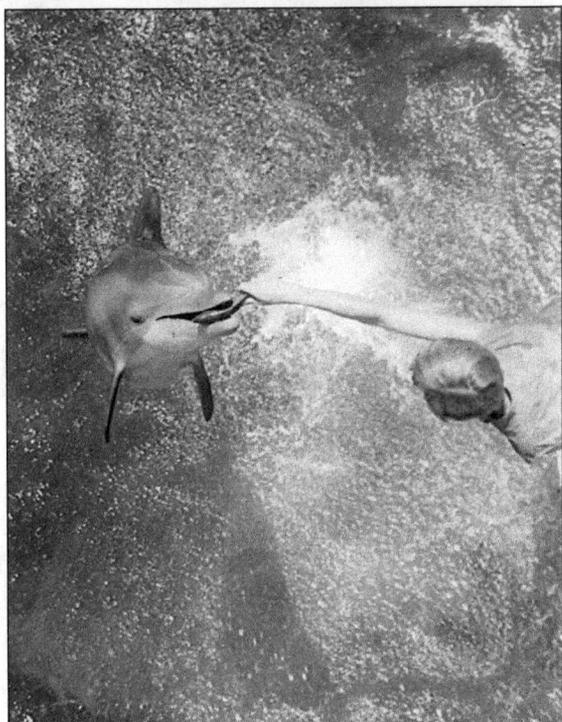

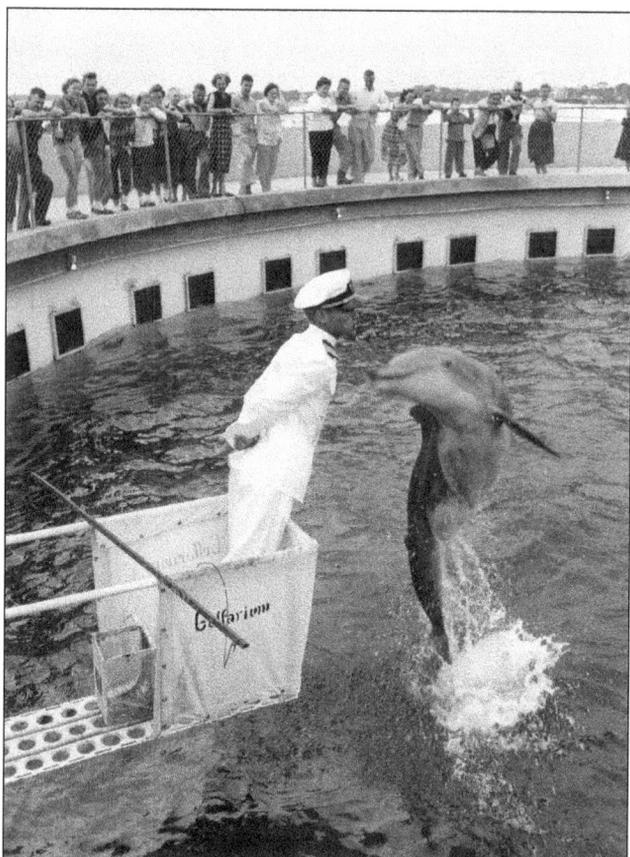

James Kline, pictured in 1955, was the Gulfarium's first dolphin trainer, making only $35 per week training animals, diving in underwater scuba shows, and performing with the jumping porpoises. A veteran of the US Navy, Kline wore pieces of his own uniform on stage in keeping with the Gulfarium's nautical theme. Employed by the Gulfarium for only two years, Kline went on to work at the Seaquarium in Miami, where he was involved with training dolphins for television shows such as *Flipper* and *Wild Kingdom*. Kline's secret to training animals was to give them a routine. If a dolphin did not know how to perform, he would ask the animal to do the same series of behaviors several times per day, finding that if the animal knew what to expect, the routine would naturally develop. (Left, courtesy of the State Archives of Florida; below, courtesy of Gulfarium Marine Adventure Park.)

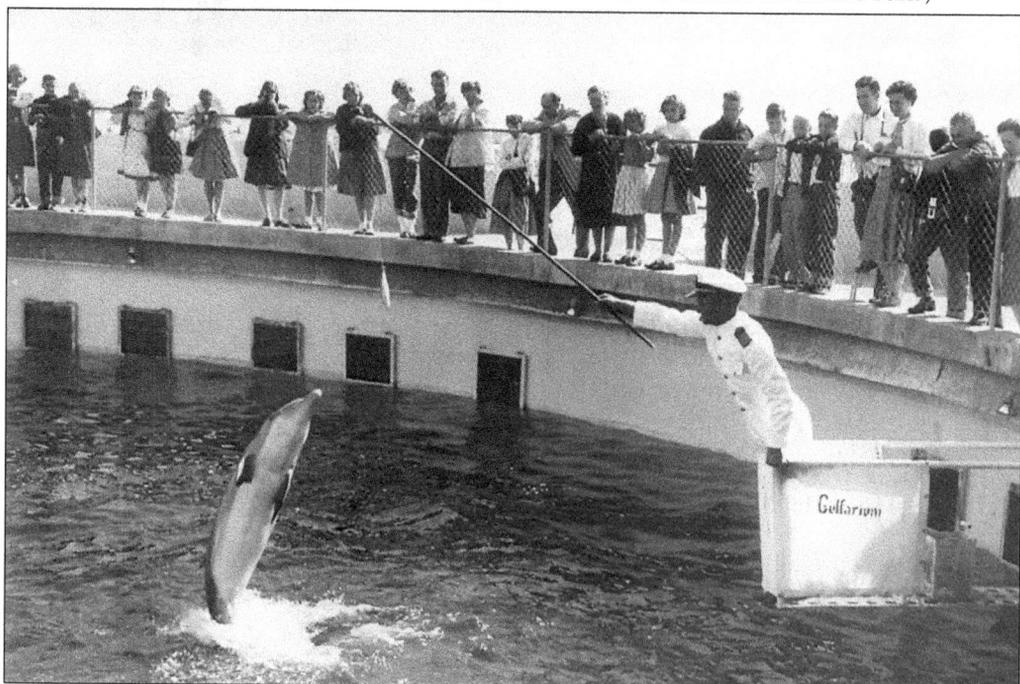

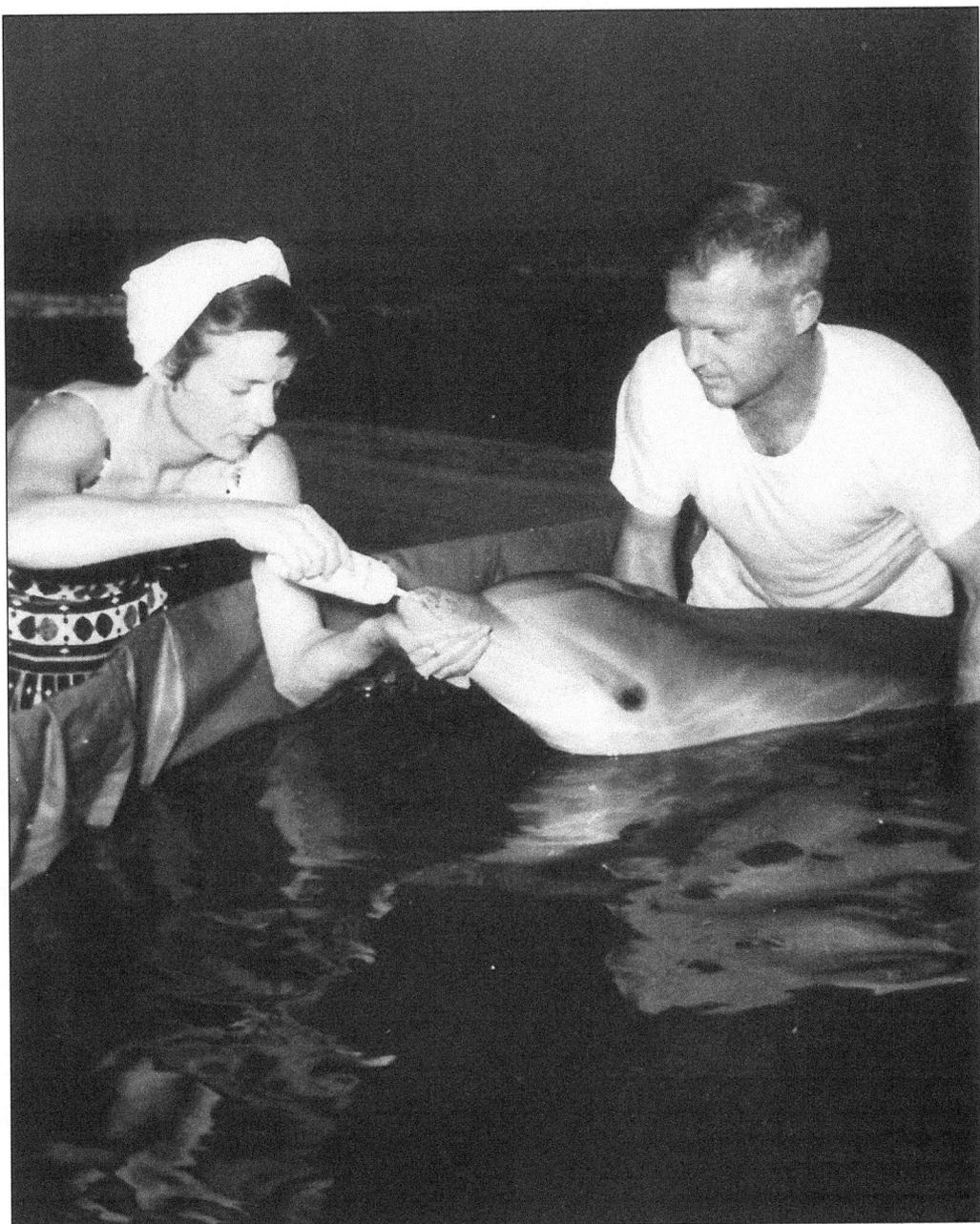

Due to a near drowning at age six, Marjorie Siebenaler (shown here with her husband, Brandy, feeding a baby dolphin in their backyard pool in the 1950s) grew up terrified of the ocean and the dark shadows within. Raised in Daytona Beach, she would avoid looking at the ocean and could not stand the sight of fish, even on her dinner plate. Even after marrying Brandy Siebenaler, an aspiring dentist at the University of North Carolina who suddenly decided to pursue marine biology, she did not disclose her fears. Years later, after Brandy's dream of a marine life center had come to fruition, Brandy and Marjorie stood together on the Gulfarium's dolphin observation deck, and he jokingly picked her up and dangled her over the water. To the amazement of her husband, it was then that Marjorie hysterically screamed, "I hate water! I loathe fish!" (Courtesy of Arturo.)

One afternoon soon after the Gulfarium's grand opening, Marjorie Siebenaler was left in charge of the ticket window while Brandy went to town. The 10 o'clock show was about to begin when the office manager came to Marjorie with bad news: the diver had quit, and they would have to refund the crowd's money. A stubborn Marjorie refused to accept this and surprised everyone by facing her fear of the water and donning scuba gear for the first time in her life. Marjorie described the experience, which included feeding the dolphins in front of visitors' faces pressed against each of the underwater viewing windows, as claustrophobic at first. Yet, eased by the presence of the dolphins, she pulled off a worthy dive show to the delight of all, thus beginning her prosperous animal care and training career. (Left, courtesy of Gulfarium Marine Adventure Park; below, courtesy of Arturo.)

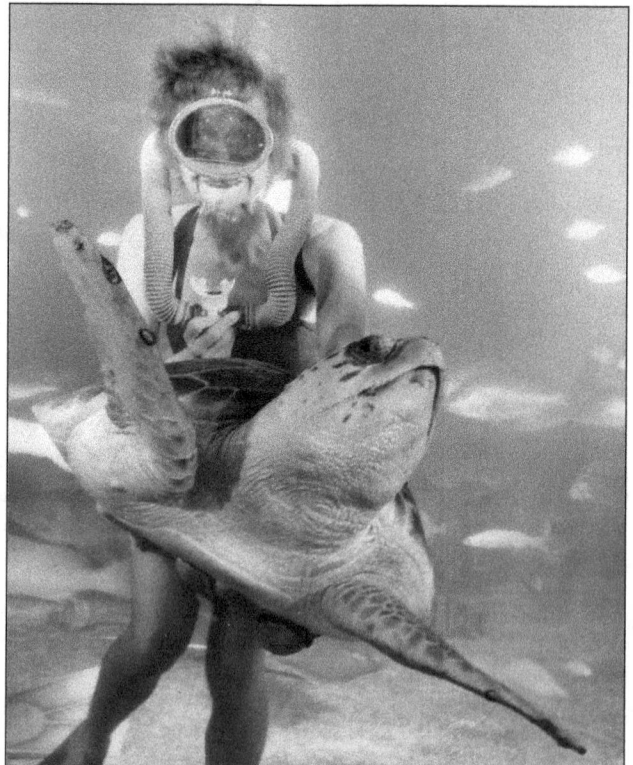

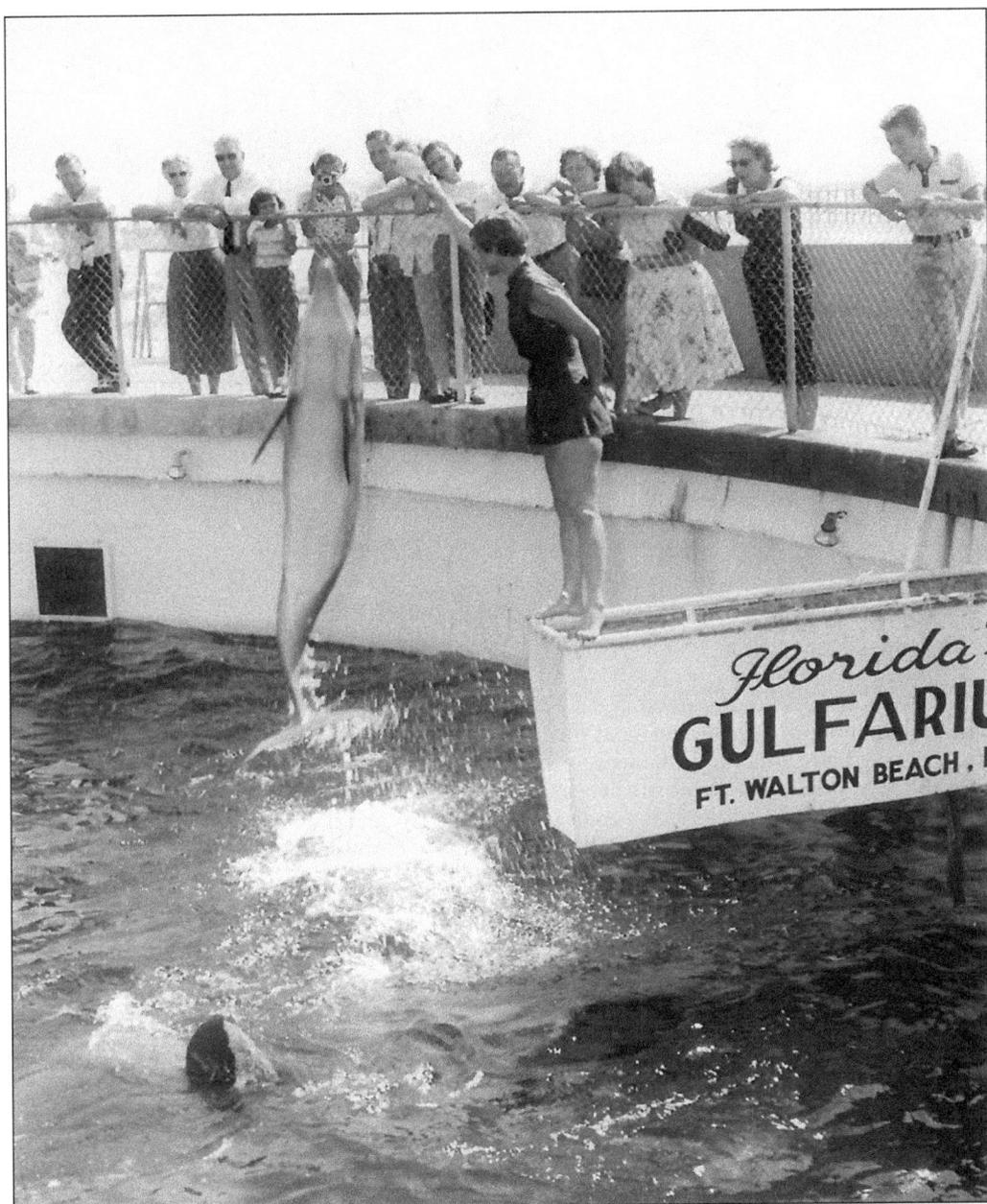

Marjorie Siebenaler often compared the intelligence of the porpoises to that of dogs and chimpanzees. Within a couple of weeks after capture, she could get any dolphin to take food from her hand. Dumpty was the first dolphin to retrieve a fish from her mouth, and as Marjorie reported, "You can't move or flinch or a porpoise might miss and take off part of your face." Marjorie developed a trust with the dolphins like no other, which is demonstrated in this photograph as a 500-pound dolphin nabs a fish from her hand while she stands precariously on the edge of the platform. While swimming with one of her favorites, Sam, Marjorie would often let him grab her gently by the thigh and drag her to the bottom of the aquarium, hovering over her tauntingly. Marjorie would simply wait him out, knowing he would tire of his game and let her surface shortly thereafter. (Courtesy of Arturo.)

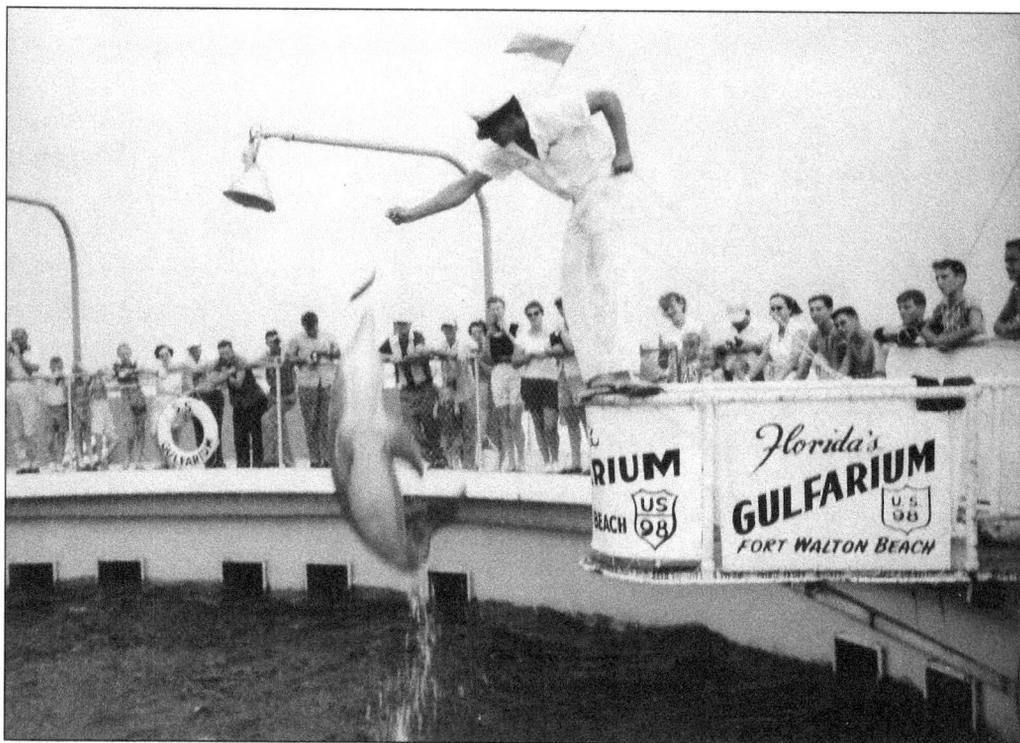

The Gulfarium's early era and nautical theme is captured in this photograph of a dolphin show. Trainers wore white uniforms with sailor caps, and the pool was decorated with nautical flags strung from the show pool's mast. A life ring labeled *S.S. Gulfarium* hangs from the fence, completing the ambiance. Brandy and Marjorie Siebenaler ran a tight ship, and trainers were expected to display excellent showmanship to match the dolphins' energetic enthusiasm. (Courtesy of Arturo.)

A highlight of the main tank show came at its conclusion, when a scuba diver would locate one of the giant loggerhead sea turtles, hook his or her hands around both ends of the carapace (or shell), and hold on for a ride around the pool. It was not uncommon for a turtle to turn on its hitchhiking rider, aggressively snapping its enormous beak. (Courtesy of the State Archives of Florida.)

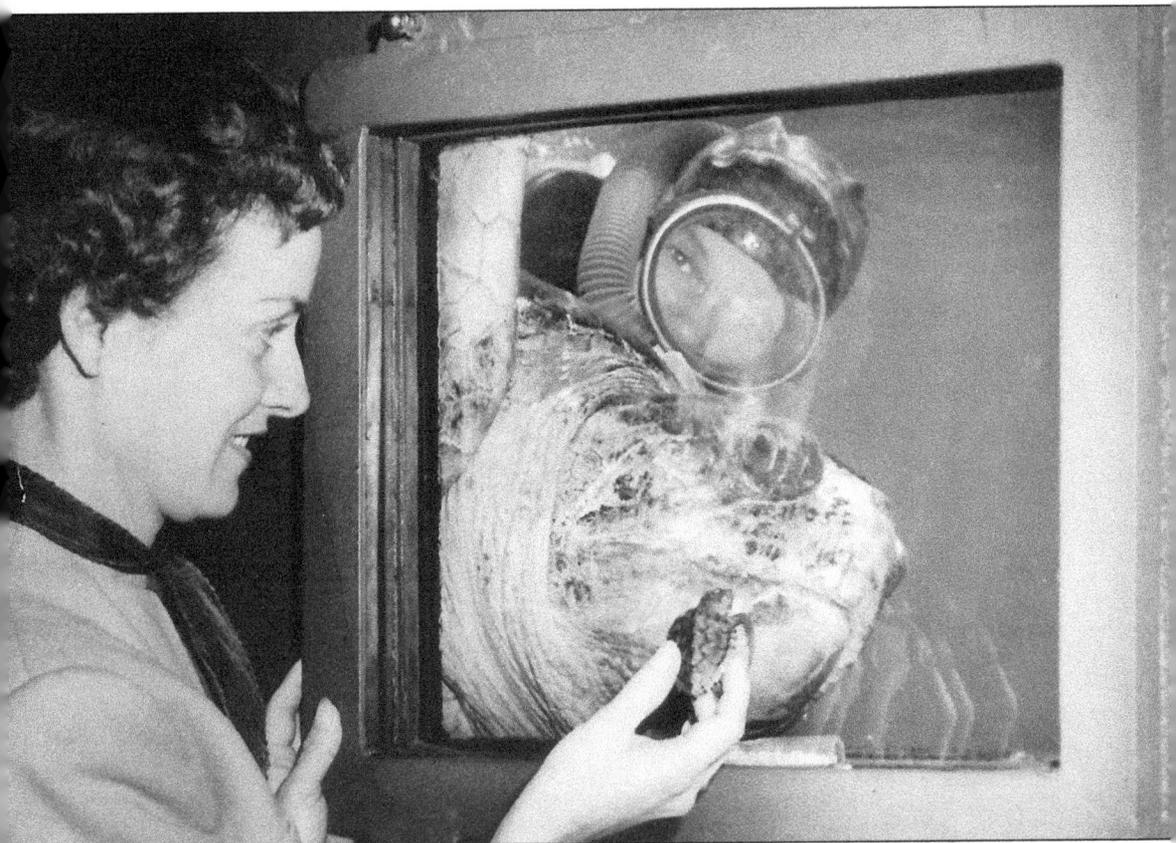

One day prior to the grand opening, the Gulfarium experienced its first sea turtle birth when a tiny two-inch loggerhead hatchling, shown here held by Marjorie Siebenaler, emerged from its incubating shell. The baby turtle's mother, pictured here with an unidentified diver, was affectionately known as "Mama." Weighing over 400 pounds, Mama and her eggs had been collected from a nearby Gulf beach by general manager Brandy Siebenaler during the stocking phase of the Gulfarium. On opening day, Siebenaler proudly displayed the hatchling, dubbed "Junior," in a small gallery aquarium so that visitors could marvel at the achievement. (Courtesy of the State Archives of Florida.)

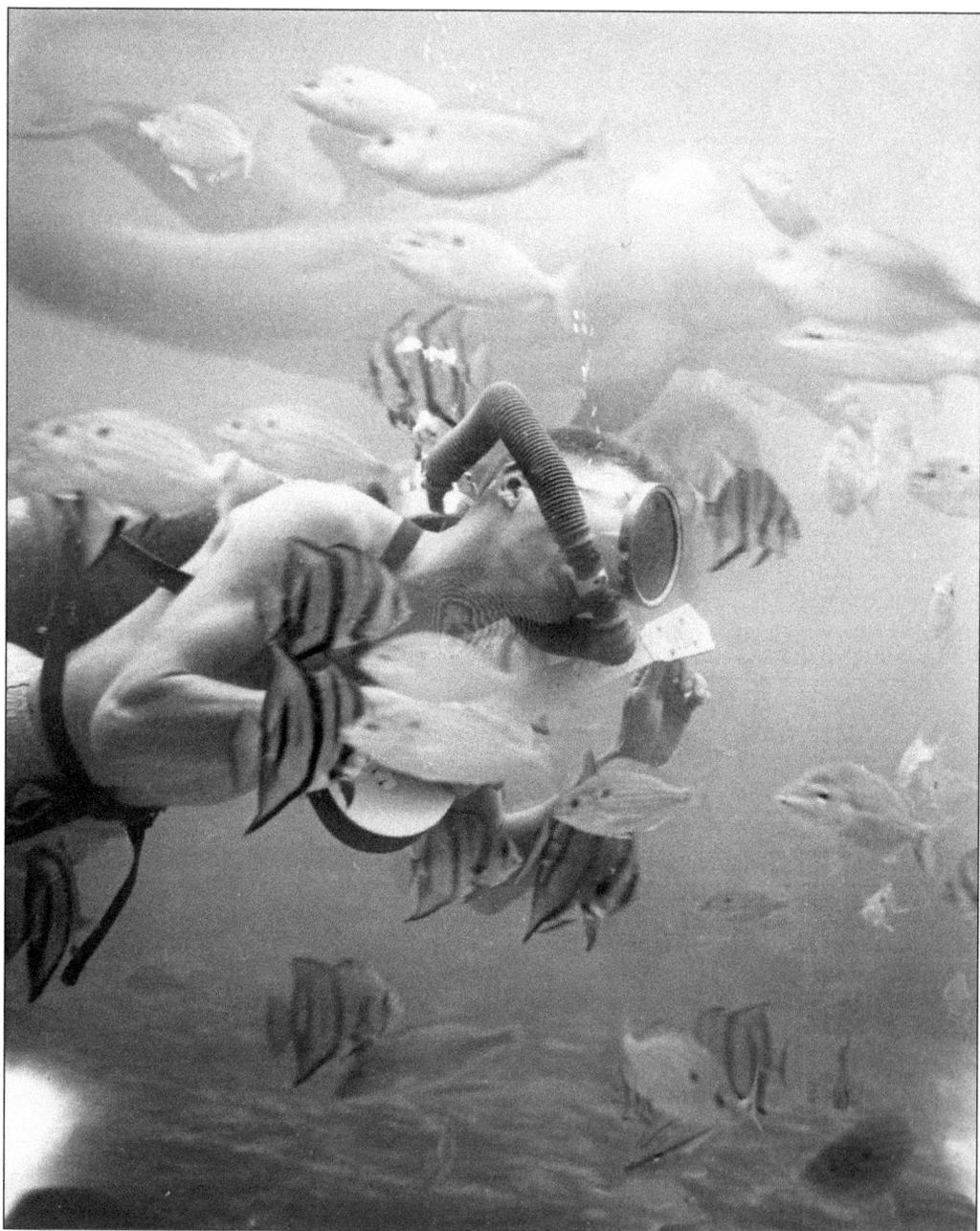

A ukulele-playing scuba diver swims with a variety of marine species in the Gulfarium's main habitat during an underwater show in 1955. All dolphin trainers were hired first as divers who performed underwater feedings and scuba demonstrations while a narrator, and later a recorded announcer, called the action for guests peering through windows around the tank. It was during one of these demonstrations just one month after Gulfarium's opening that spectators were unfortunate witnesses to a gruesome incident in which three porpoises attacked and killed 15 sharks. The next day, the local newspaper reported the dolphins had sighted the sharks, new to the exhibit, during the 11 o'clock feeding, and the battle for survival began, the dolphins coming out without a scratch. (Courtesy of Arturo.)

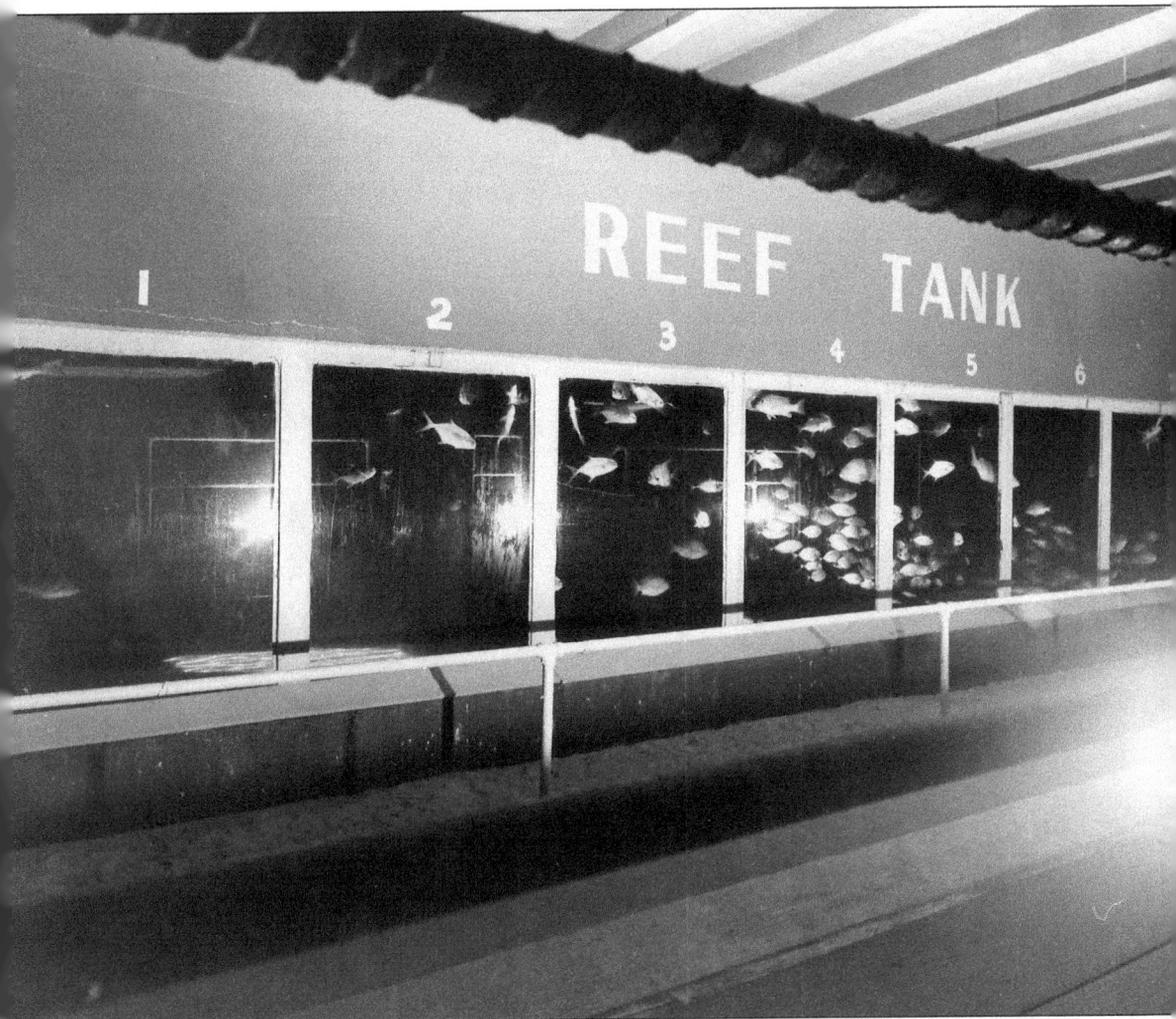

The mass casualty of sharks in the main tank shortly after the Gulfarium's opening led Brandy Siebenaler to quickly complete a second exhibition aquarium, appropriately named the Reef Tank. Built in October 1955, this 50,000-gallon marine exhibit afforded onlookers a view of the ocean bottom through seven huge windows made from Herculite glass, a special tempered plate glass resistant to breakage. The windows stretched from the undersea floor of the exhibit to the water's surface, displaying a wide variety of fish species all native to Florida's Gulf Coast: saltwater catfish, spadefish, triggerfish, black drum, red drum, and numerous snapper and grouper species. Commonplace in aquariums today, floor-to-surface windows of this magnitude were featured here for the first time in an exhibition tank. Later referred to as the Living Sea exhibit, this aquarium is still in existence and remains a popular feature of the Gulfarium. (Courtesy of Arturo.)

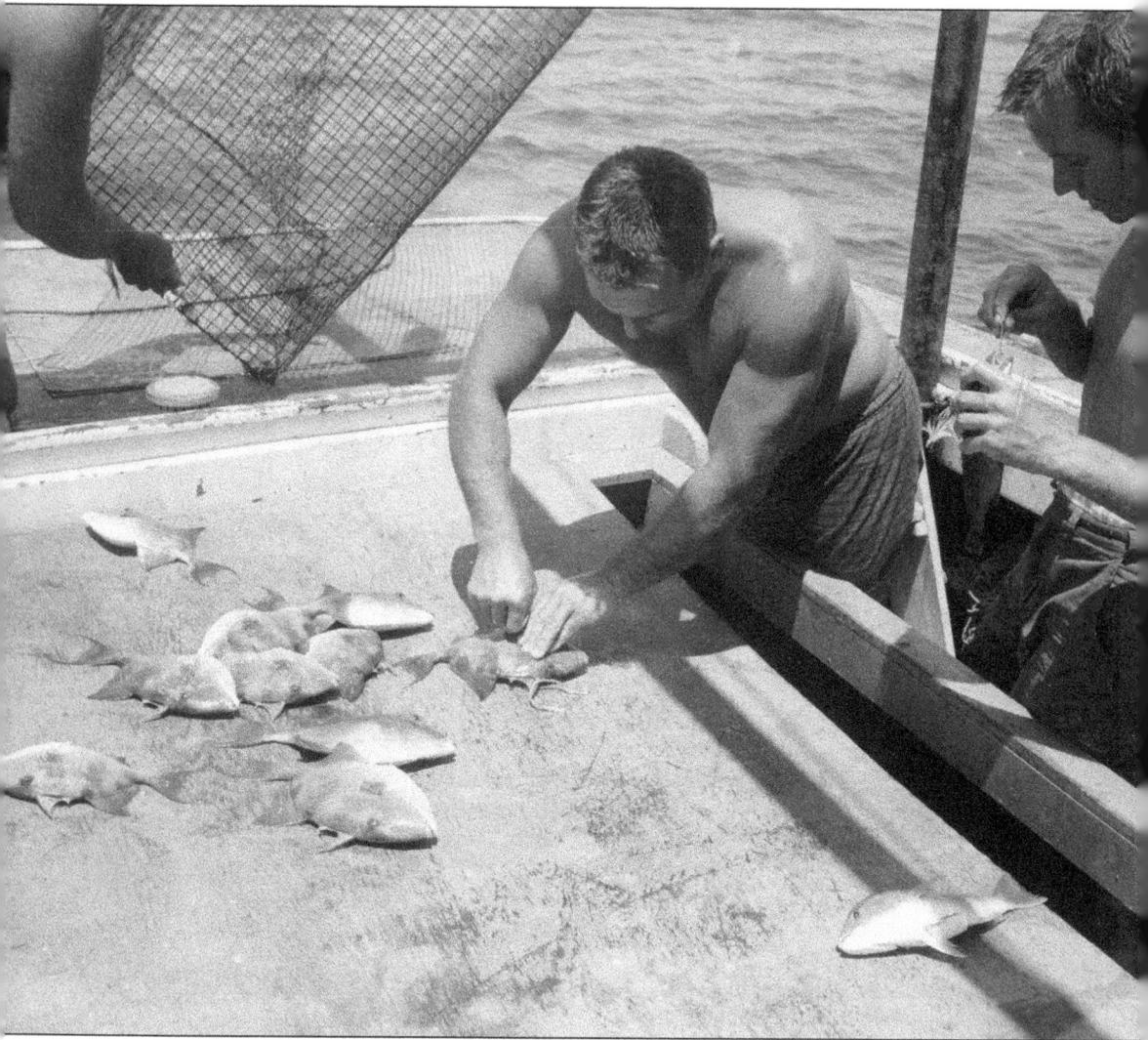

Dr. Winfield Brady, fellow University of Miami alumnus and best friend to Brandy Siebenaler, was hired in 1954 as Gulfarium's fish biologist, in charge of collecting specimens for display. Shown here in 1958 aboard the *Fish Hunter*, Brady (center) and his unidentified assistant depressurize several triggerfish after a successful trap. The hoisting process from the deepwater catch causes the fish's swim bladder to inflate, making it difficult to swim properly. If not released, the pressure can lead to death. Brady expertly inserts a needle, puncturing the swim bladder and depressurizing the triggerfish before placing it in the boat's live well for transport to its new home in a Gulfarium display aquarium. (Courtesy of the State Archives of Florida.)

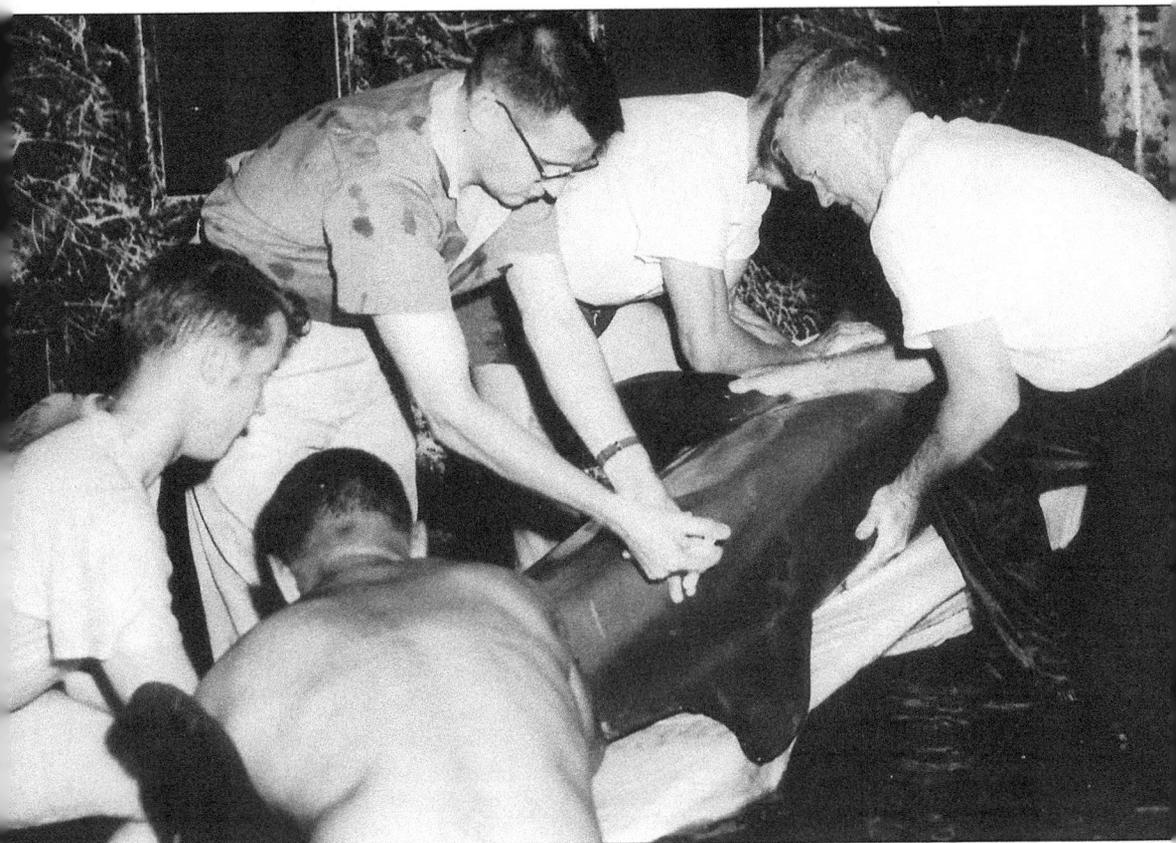

From the Gulfarium's first days, Dr. Winfield Brady was the park's primary expert in medical procedures. Marine mammal medicine was only in its infancy at the time, with today's top cetacean veterinarians still only part of the second and third generations of this highly specialized field of study. Husbandry, research, and data collected at the Gulfarium since the mid-1950s has contributed volumes to the veterinary community's growing understanding of marine mammals. Here, Dr. Brady is seen sans shirt in the foreground restraining a dolphin with Brandy Siebenaler (far right) while an unidentified assistant administers an injection. (Courtesy of Arturo.)

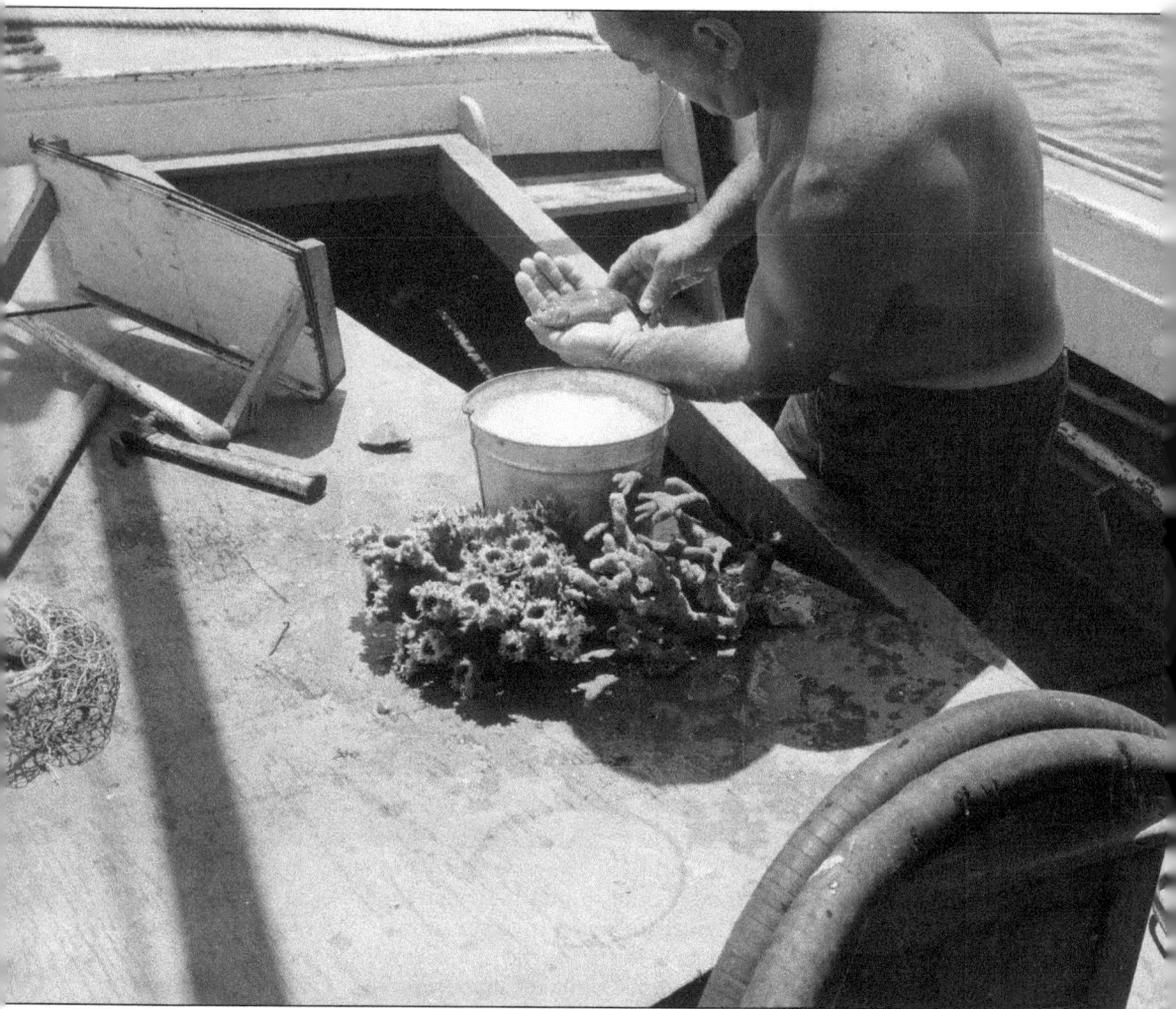

A marine enthusiast, avid scuba diver, and passionate biologist, Dr. Winfield Brady (shown here in 1958 collecting specimens on the Gulfarium's *Fish Hunter*) often sought opportunities beyond the confines of his curator title to share his love of the sea. On the evening of September 2, 1957, Brady and two fellow Gulfarium divers, Charles Emmett and Howard Greenman, donned their scuba gear and entered the main tank with one goal—to break the world's underwater-swimming distance record. All three men knew that just to match the current record of seven miles meant 235 circuits of the main tank, but with the support of hundreds of onlookers and several months of training under his belt, Brady shattered the record, swimming a total distance of 12 miles. (Courtesy of the State Archives of Florida.)

The Gulfarium's intent was to stress originality in presentations, becoming the first major marine attraction to feature divers wearing scuba gear rather than a conventional full helmet. This gave the diver increased flexibility and maneuverability, relying almost entirely on his or her flippered feet for propulsion and leaving the arms free to present marine life. Here, a diver handles an impressive sturgeon fish during a 1955 Reef Tank demonstration. (Courtesy of the State Archives of Florida.)

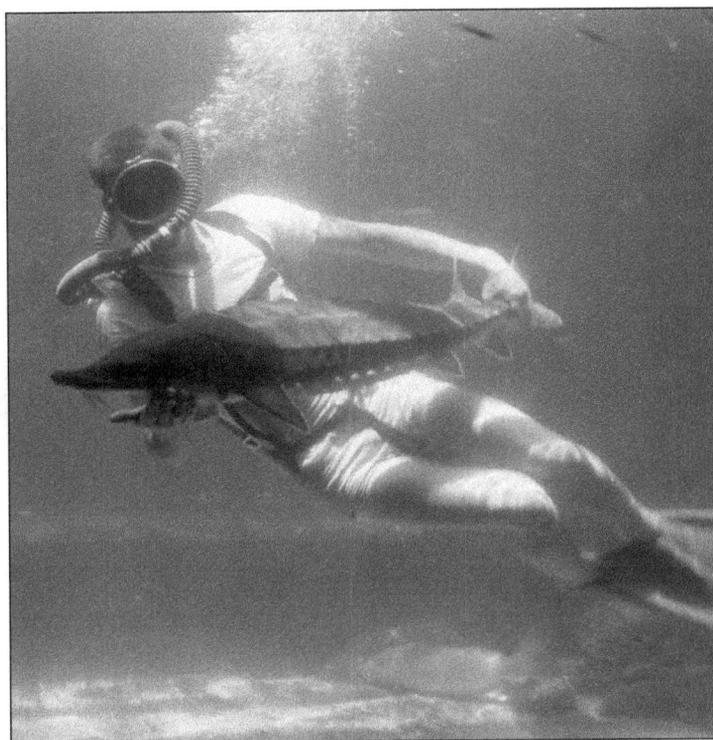

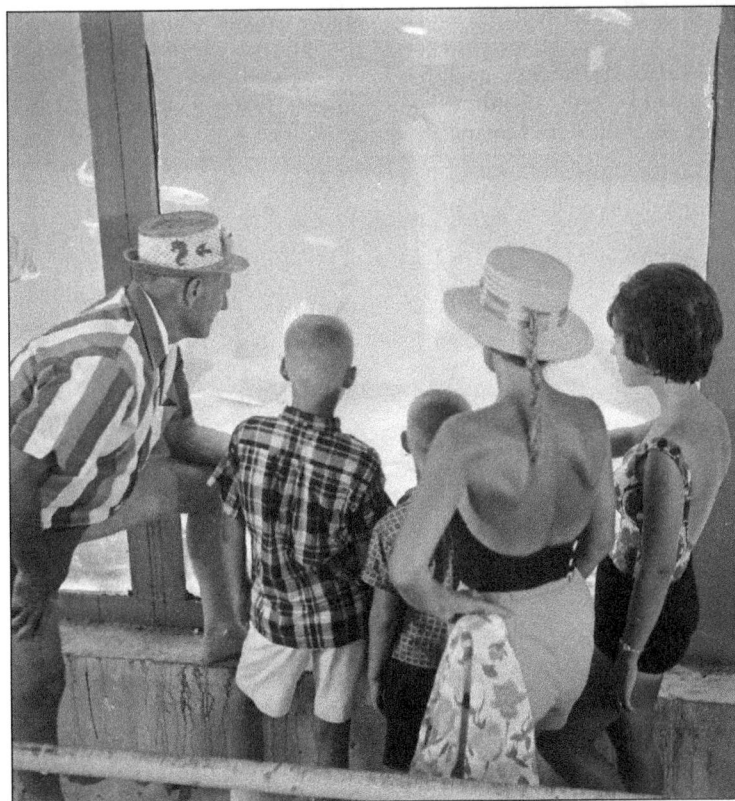

A family takes in the Living Sea reef aquarium in 1963. Once the Living Sea exhibit was completed and stocked in 1956, guests could view sharks, fish, sea turtles, and rays living together in a true oceanarium with floor-to-ceiling windows— an industry first. The exhibit provided the window into the sea that Brandy Siebenaler had described in his initial vision for the park. (Courtesy of the State Archives of Florida.)

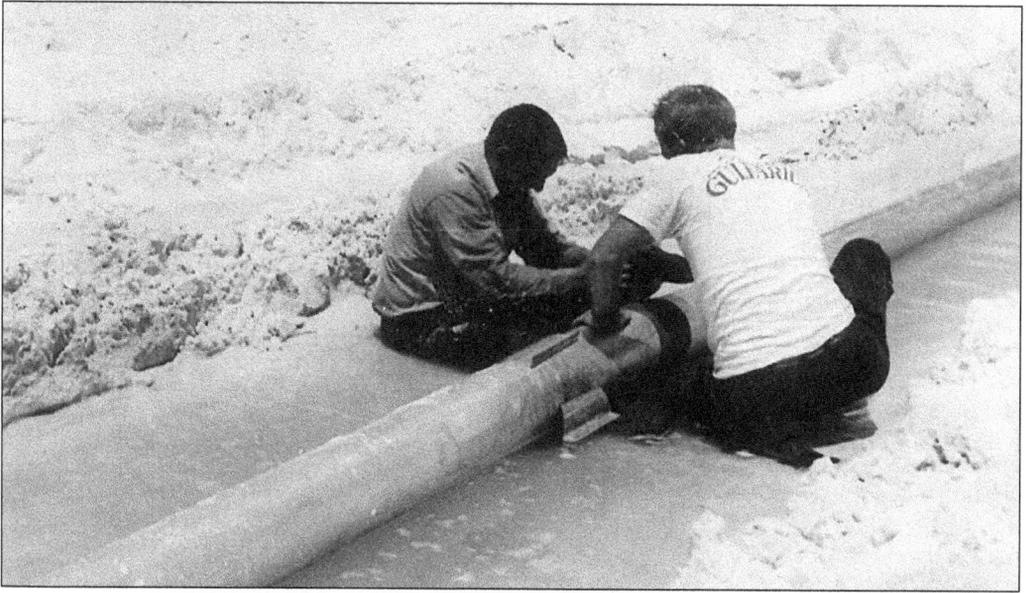

Above, in 1958, two unidentified workers maintain the pipe drawing water into the Gulfarium's filtration system. Below, the exposed pipe is shown extending over 100 yards from the Gulfarium to the sea. In early interviews, Brandy Siebenaler stated that he had selected the Okaloosa Island location for his marine attraction due to the favorable water conditions along this stretch of shoreline. Miles from the nearest freshwater drainage, this area's salinity stays relatively constant throughout the year. Water is still drawn directly from the Gulf to fill the Gulfarium's pools, meaning that the park truly has a stake in the stewardship of the marine resources it strives to educate the public about daily. Although the pipe itself has been replaced over the years, it still extends across the beach, concealed by only a shallow trench until it reaches water just below the low-tide line. (Both, courtesy of Gulfarium Marine Adventure Park.)

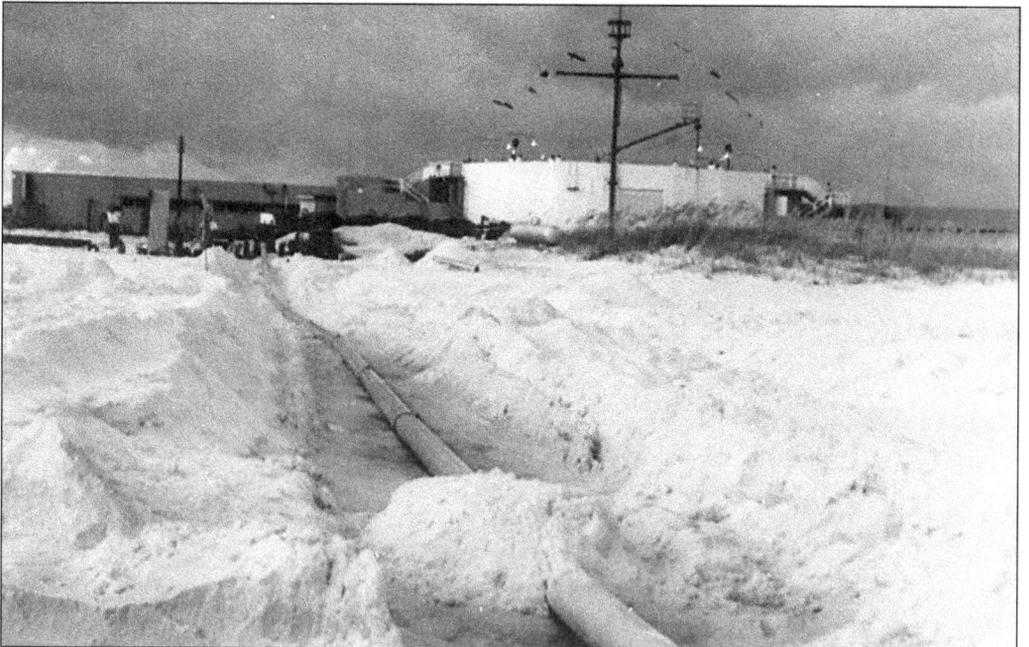

At right, Tom Pianoswki prepares to take a dive in the main habitat in 1957; below, on the same day, Budd Gorsuch smiles for a popular photo opportunity alongside a deep-sea diver replica. Though neither of these men worked at the Gulfarium, they were close friends of Brandy Siebenaler, a relationship sprinkled with perks, including permission to occasionally dive in the dolphin habitat. Brandy Siebenaler likely took these photographs himself, as he often walked around with camera in hand. (Both, courtesy of Mary Jim Pianowski.)

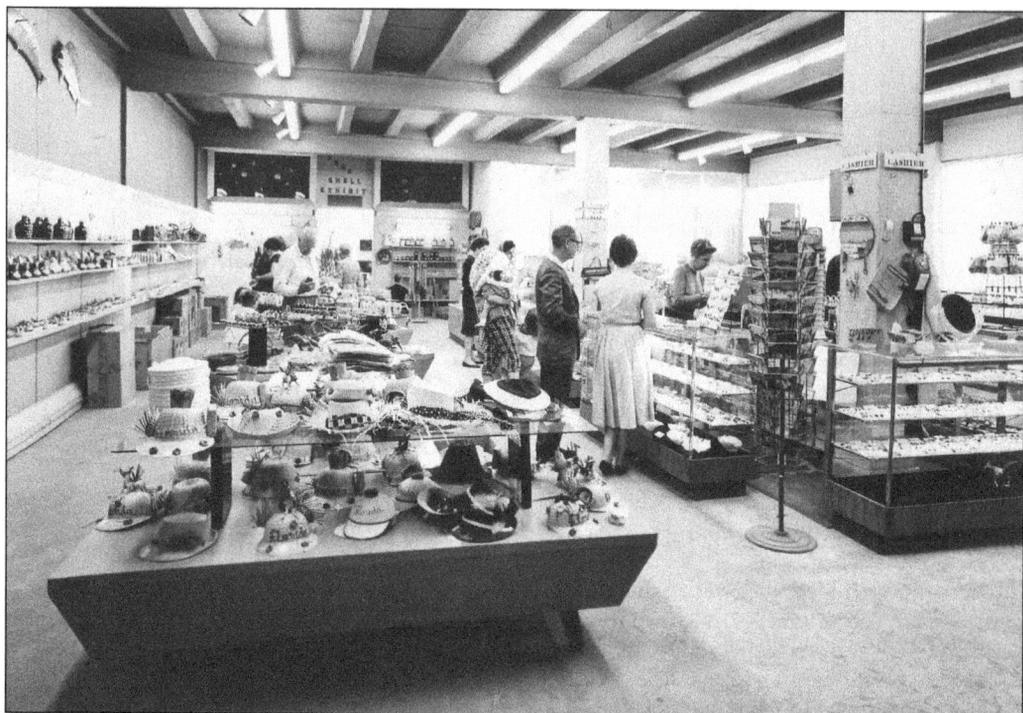

While live animals were always the main attraction, the Gulfarium featured several attractions, including the popular gift shop (seen above around 1956) and the expansive shell exhibit (below), loaned to the Gulfarium by Brandy and Marjorie Siebenaler, which could be visited without paid admission. Not pictured, the snack bar had an exterior window facing the beach, accessible not only to Gulfarium patrons but also to famished beachgoers. Without any other options for refreshments along the barren coastline, the Gulfarium's concessions proved to be a very successful source of revenue. (Both, courtesy of Arturo.)

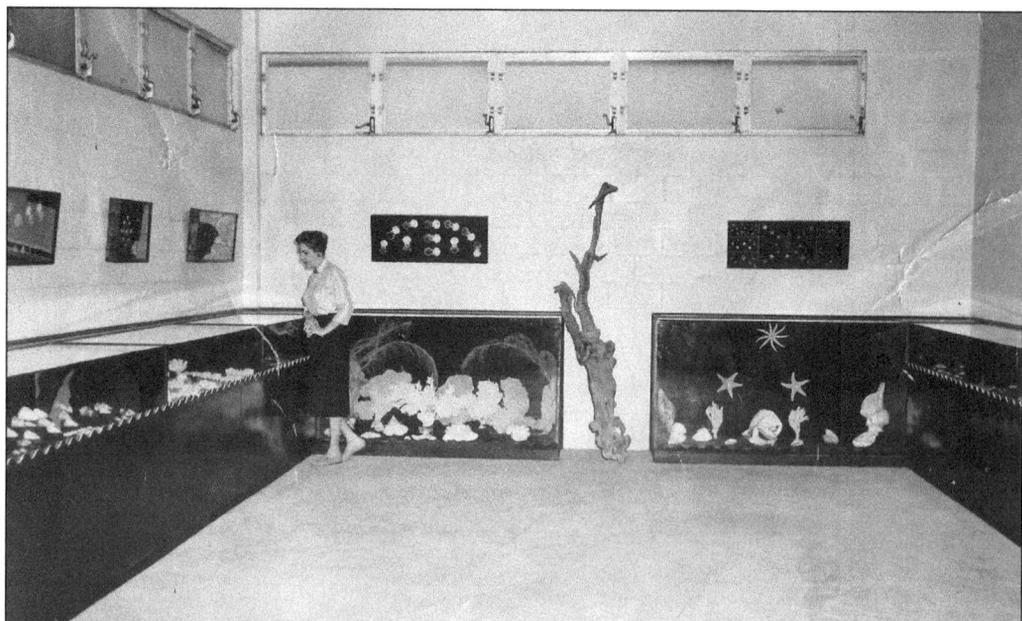

Two

HIGH-FLYING JUMPS AND UNDERSEA ADVENTURES

Brandy Siebenaler's initial vision for the Gulfarium was to exhibit deep-sea creatures seldom encountered by humans, but it was clear from the start that dolphins were the animals that captured the public's fancy. Guests flocked to the park daily to witness the incredibly high leaps and stunning agility of these animals. The show culminated in a spectacular high jump, with a dolphin snatching a fish from a trainer perched high over the water. It was all about the high jump, but the dolphin show and the entire Gulfarium began to evolve during the 1960s.

Marjorie and her dedicated team of trainers quickly discovered just how intelligent, curious, and playful the dolphins were, and they began training the animals a variety of behaviors beyond the high jumps around which the park's early dolphin shows centered. The crowd cheered as dolphins played volleyball, rescued an endangered baby doll, and snapped a photograph of the audience. The playfulness of the dolphins and their trainers rivaled the jump platform, which now had to share the spotlight with a waterside deck stocked with countless toys and props.

As the Gulfarium, and particularly Marjorie Siebenaler, gained fame as a top dolphin-training facility, the Siebenalers began partnering with other dolphin shows. Each year, the Siebenalers would transport their own dolphins to and from a marine exhibit in Rapid City, South Dakota, at the beginning and end of the summer season. Lessons learned through these routine transports prepared the staff very well for transporting stranded and distressed animals in extremely difficult scenarios during the Gulfarium's animal rescue and collection operations.

The Living Sea diver show also saw several changes and improvements after the park's first season. Initially, the fish, rays, sea turtles, and other sea life inhabited the main tank with the dolphins, but they were all moved to a separate Living Sea tank shortly after the park opened when it was discovered that the sharks were not safe with the dolphins. This move allowed the Living Sea to develop into its own feature attraction in which divers demonstrated scuba equipment while a professionally produced show narrated the action.

DON'T MISS SEEING

Florida's
Gulfarium

Living Sea

GULFARIUM

UNDERWATER PORPOISE FEEDING

US 98

...In the Heart of the
"MIRACLE STRIP"
—at—
FORT WALTON BEACH, FLA.

Your Opportunity to Witness
the Drama of . . .

Florida's
GULFA
US 98 FT. WALTON

the **Living Sea**

"The Living Sea" is just that . . . Imagine a little part of the Gulf of Mexico with all its various forms of life, transferred to shore and placed in tanks. Enclose these tanks in a spacious building with large outstretched wings housing a gift shop, snack bar, free and extensive shell exhibit, a registration desk and large, roomy hallways, then convert your imagination into reality and there it is! The huge, main tank at Florida's Gulfarium is a 500,000-gallon fish bowl where the jumping porpoises cavort. The colorful Coral Reef Tank holds 60,000 gallons of water and thousands of species such as turtles, rays, octopi, crustaceons, etc. Small aquaria and the beautiful "Jewel Tanks" with their rainbows of color contain more minute specimens of Gulf life .

US 98

...In the Heart of the
"MIRACLE STRIP"
—at—
FORT WALTON BEACH, FLA.

The front and back covers of a 1950s park brochure feature the underwater stars as well as the Gulfarium's ideal location on the Miracle Strip, a coastal stretch of US Highway 98 that spans Destin and Fort Walton Beach, known then as the Playground of Northwest Florida. Contained within the pages are several exhibit descriptions that served to supplement the guest experience, including details in regard to how the aquarium water was kept clean and an explanation of the "fish talk" sounds that occasionally could be heard over the public address system from underwater hydrophones. (Both, courtesy of Gulfarium Marine Adventure Park.)

A diver enters the water as Greg Siebenaler (left) and Ron Bradford (right) look on. By this time in the mid-1960s, only dolphins lived in the main show pool, with the rest of the Living Sea specimens residing in the separate oceanarium tank, but divers still had to enter the dolphin habitat for cleaning and other maintenance tasks. All divers from this era remember Herman the dolphin as a particularly difficult animal with which to scuba dive. Some of his antics included pinning divers to the bottom and snatching their fins. Trainers Ron Bradford and Terry Watkins both preferred having a separate diver enter the water to keep Herman occupied so the other could focus his attention on the maintenance tasks. (Courtesy of Arturo.)

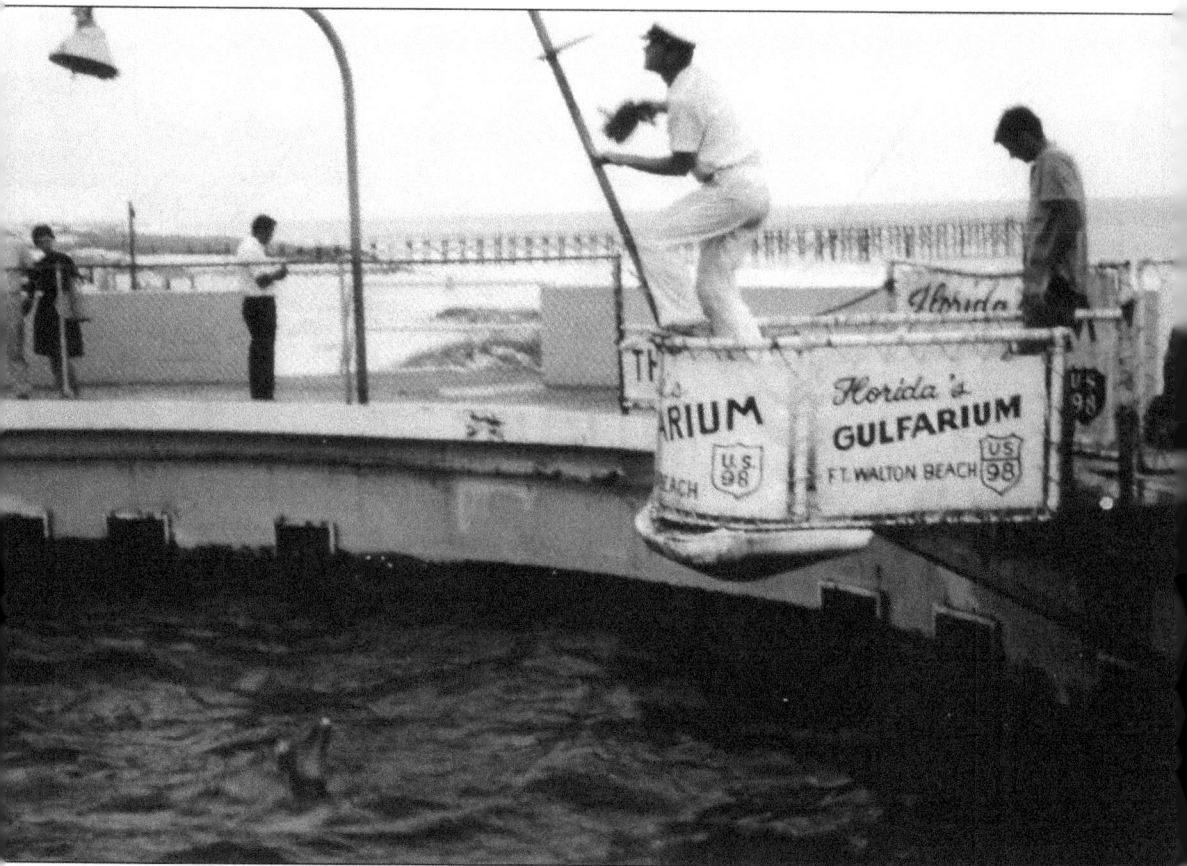

A trainer prepares the high feed ladder for a dolphin show in 1962. Indicative of this first era of the Gulfarium's history is the nautically inspired white uniform. The Okaloosa Island pier is also seen in the background, its wooden pilings visible. Today, the pier features stronger concrete pilings, after decades of hurricanes necessitated its refurbishment time and time again. Aside from the pier, the beachfront in this photograph lacks development. Over the years, as the Gulfarium gained notoriety and Fort Walton Beach became a major destination for motoring tourists, development followed, with restaurants and hotels springing up on both sides of the park. (Courtesy of the Merrill family.)

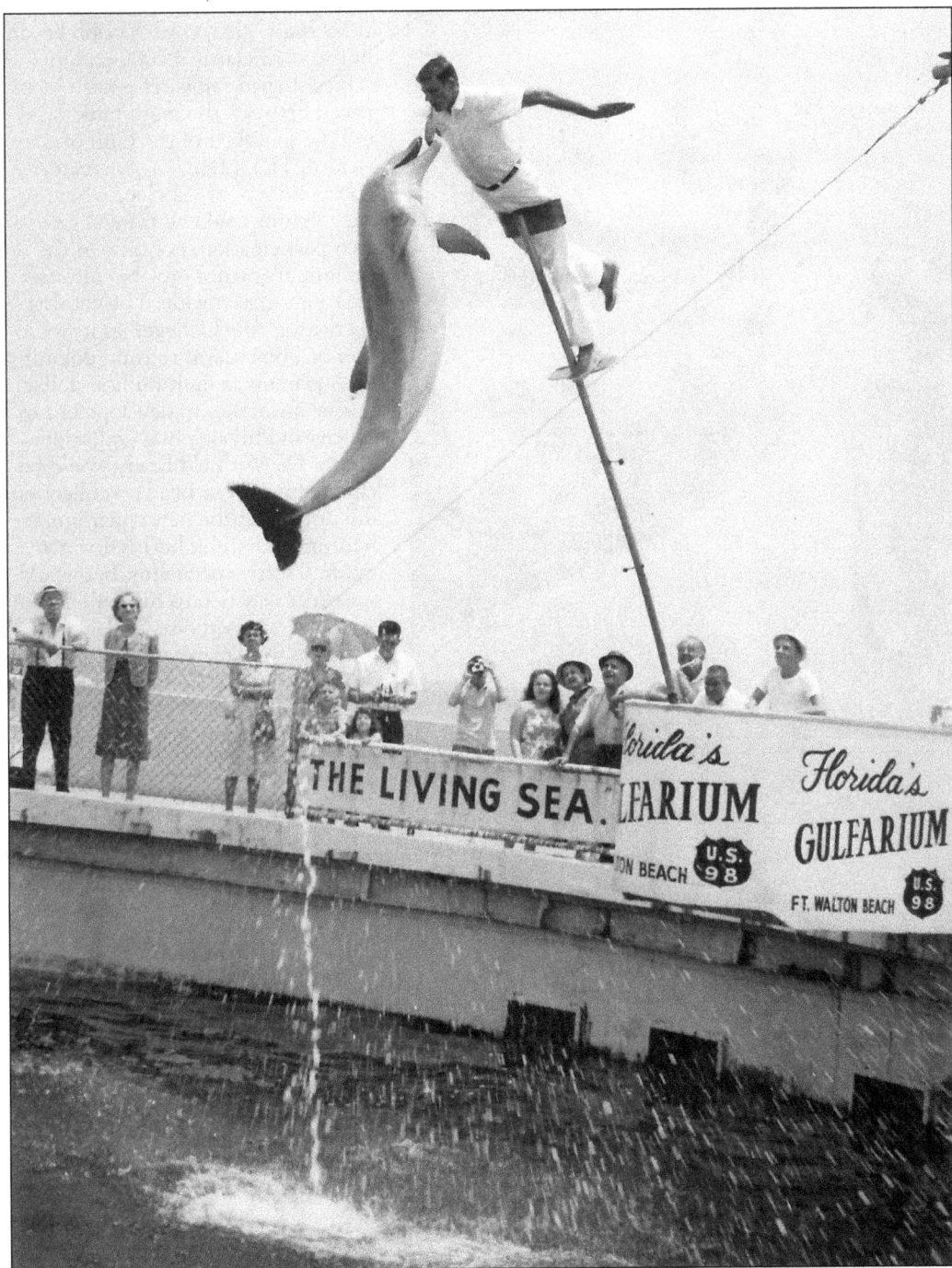

In a show featuring multiple aerialist dolphins flying through the air with ease, it may have been difficult for some to stand out, but Streak the dolphin did just that. As the highest jumper, Streak (shown here in 1964) regularly leapt to a height of over 21 feet. To prepare for this impressive feat, trainers installed a removable ladder extension brought out only at the show's finale. Seeing the trainer reach for this extension pole, audience members squealed in anticipation of what was to come, and with amazing agility and precision, Streak was not one to disappoint. (Courtesy of Arturo.)

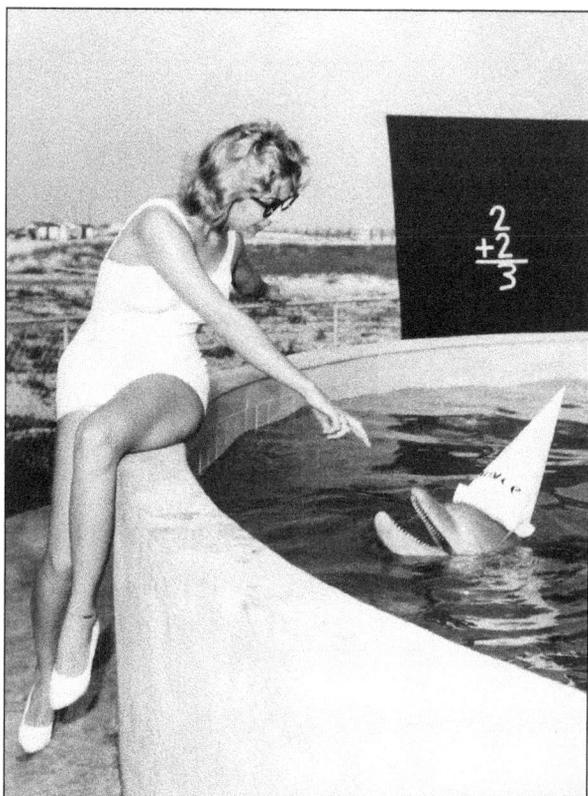

In February 1962, construction began on two connecting 35,000-gallon kidney-shaped saltwater pools, placed between the main tank and the shoreline of the Gulf of Mexico. The intent was to create a porpoise school—a place where the dolphins could be trained for their participation, not only in the Gulfarium's own shows, but also for aquariums nationwide. The catalyst in creating "the College," as it would later be known, was to train dolphins for Aquarama, a multimillion-dollar marine attraction in development in the city of Philadelphia. Gulfarium curator Dr. Winfield Brady would be leaving his post to head up collections and displays at the new aquarium, planning to exhibit both saltwater and freshwater specimens, but would remain closely tied to his Gulf Coast beginnings as Porpoise College graduates were regularly transported to their new home in Pennsylvania. (Left, courtesy of Arturo; below, courtesy of Gulfarium Marine Adventure Park.)

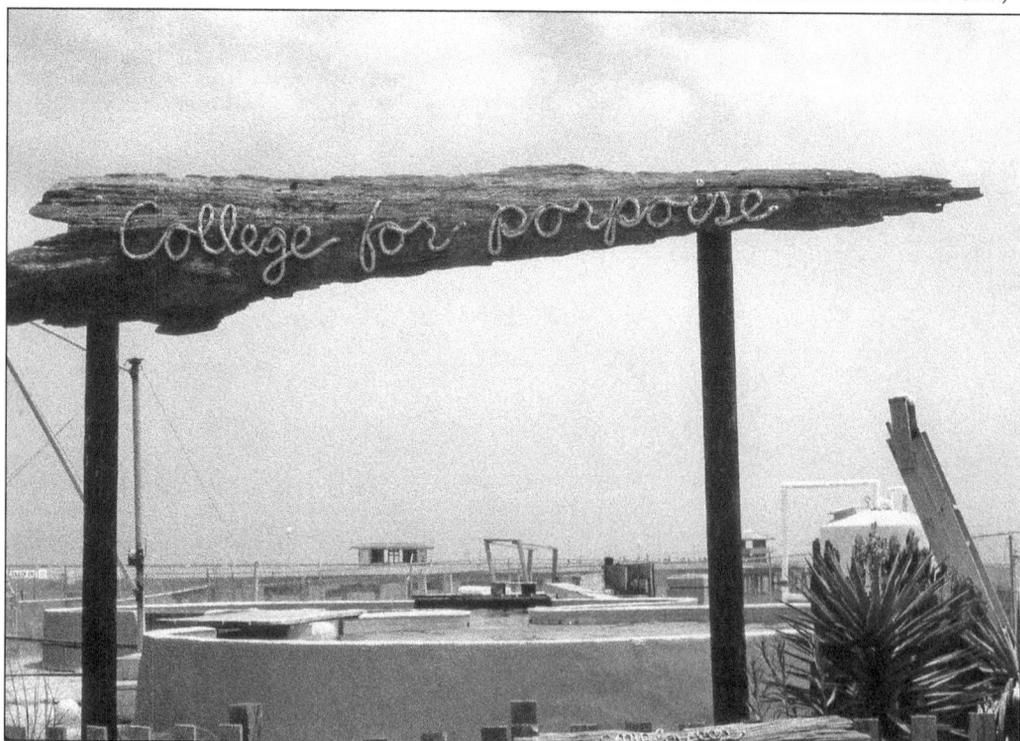

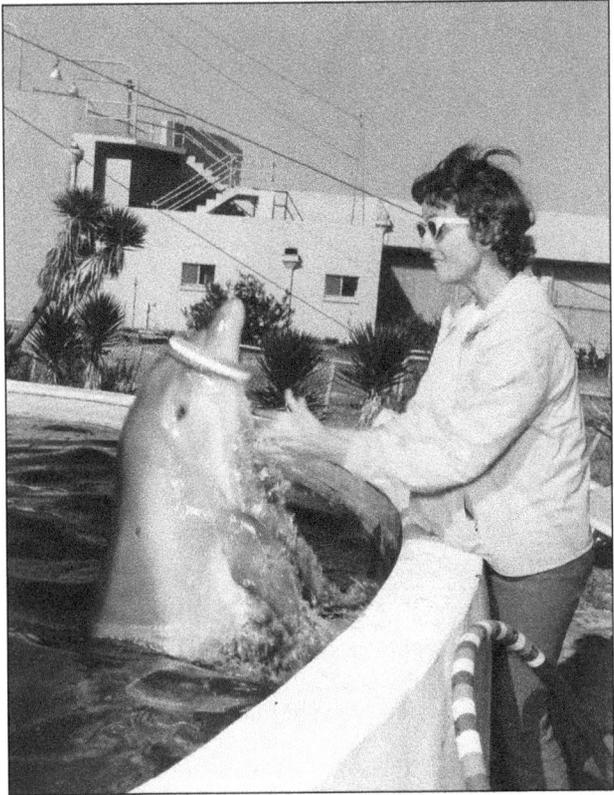

Many early Gulfarium trainers had the pleasure of working with Herman, a clever but temperamental dolphin; however, none had a relationship with him quite like trainer Marjorie Siebenaler. Shown at right in 1964 performing a ring toss routine and below in the same year demonstrating a high-feed behavior, Marjorie shares two special training moments with her favorite dolphin. Other trainers, all of whom were male, often speculated that Marjorie's high-pitched voice and baby talk afforded her a special affinity with the dolphins. Marjorie felt such a deep love for Herman that she was often heard proclaiming, "If he dies, put me in the hole with him." (Both, courtesy of Arturo.)

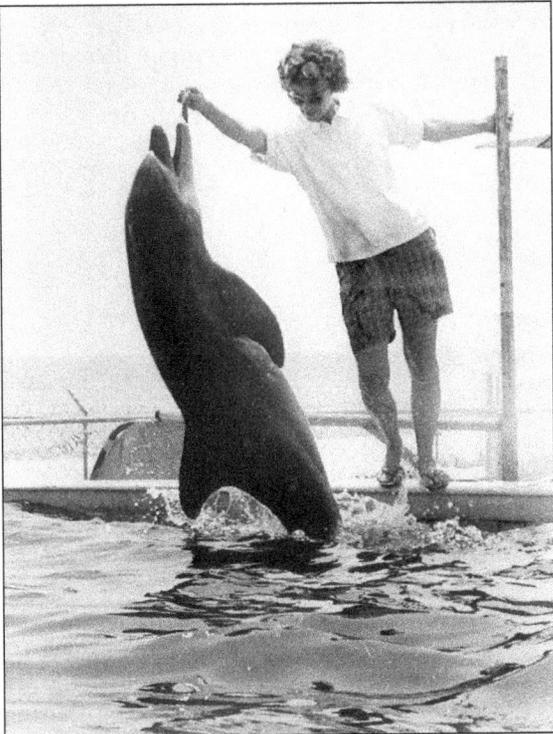

Above, the Merrill brothers—(clockwise from top) Burney, Collier, and Will, grandsons of Gulfarium's longtime president Burney Henderson—observe a dolphin in the College in 1967. Below, the brothers, who would later serve on the Gulfarium's board of directors, look on as a trainer works a dolphin's pole-jump behavior. Dolphins were first trained in this smaller pool, where trainers could easily approximate from easy-to-achieve behaviors, like jumping over this low pole, to the higher, more spectacular behaviors featured in the dolphin show. Once Brandy and Marjorie Siebenaler were satisfied that an animal was ready to perform in shows, that dolphin would be hoisted into the main tank. Originally, the College was intended to train dolphins for other facilities as well, but this plan never fully materialized because most facilities preferred to train their own dolphins. (Both, courtesy of the Merrill family.)

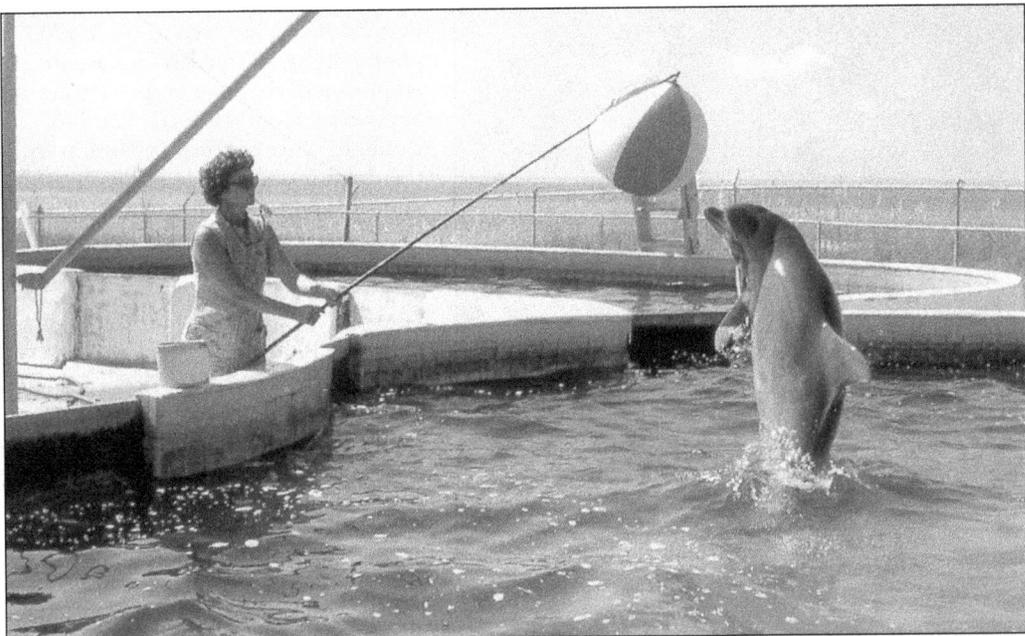

Above, Marjorie Siebenaler uses a beach ball attached to a stick as an early version of a target pole. In the 1960s, much of the training taking place in the Porpoise College centered on preparations for eventual participation in the main tank show. To train the dolphins for the featured mouth-feed behavior, the staff built poolside ladders to encourage height and accuracy. Below, trainer Art DeSonia extends a fish as the dolphin succeeds in lifting nearly all its body above the surface of the water. Former trainer Terry Watkins recalls breaking the backbone of the fish prior to placing it in his mouth so that the dolphin would only get a portion, the rest to be delivered after the completion of the behavior, ensuring the dolphins would always return for their payoff. (Both, courtesy of Gulfarium Marine Adventure Park.)

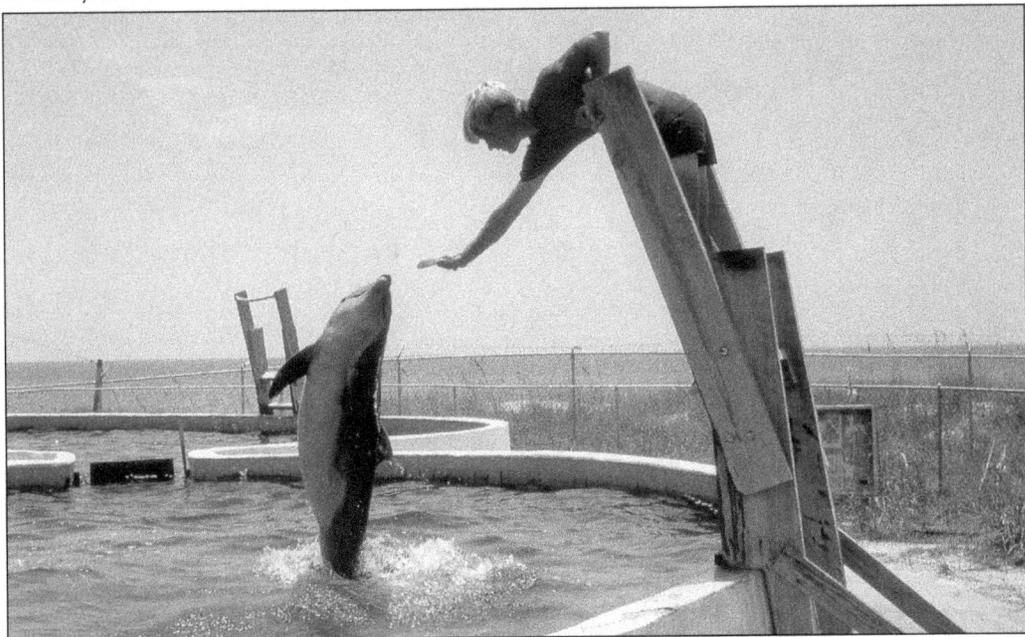

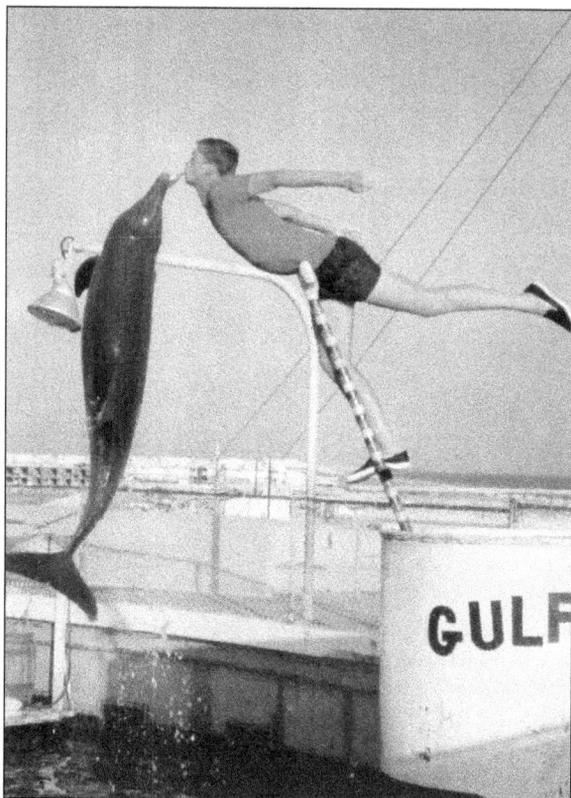

Ron Bradford, featured in these 1968 photographs, started his Gulfarium employment during a porpoise training apprentice program in the late 1960s. Bradford's first opportunity to star in the dolphin show came suddenly after another trainer was fired unexpectedly. Excited and nervous, Bradford executed the show well, asking each dolphin to perform its designated behavior. Hovering from the highest feed platform, Bradford placed a fish in his mouth and extended his neck, confident that Belinda the porpoise would expertly leap and retrieve it as she had done so many times before. From his perch, Bradford remembers seeing a frightening sight as a "gray torpedo" headed straight for him. Remaining professional, Bradford held still for the fish retrieval, only to get popped in the face by Belinda. Despite a bloody face and bruised ego, Bradford finished the show and later perfected the timing of the mouth feed with a slight head tilt at the moment of contact. (Both, courtesy of Ron Bradford.)

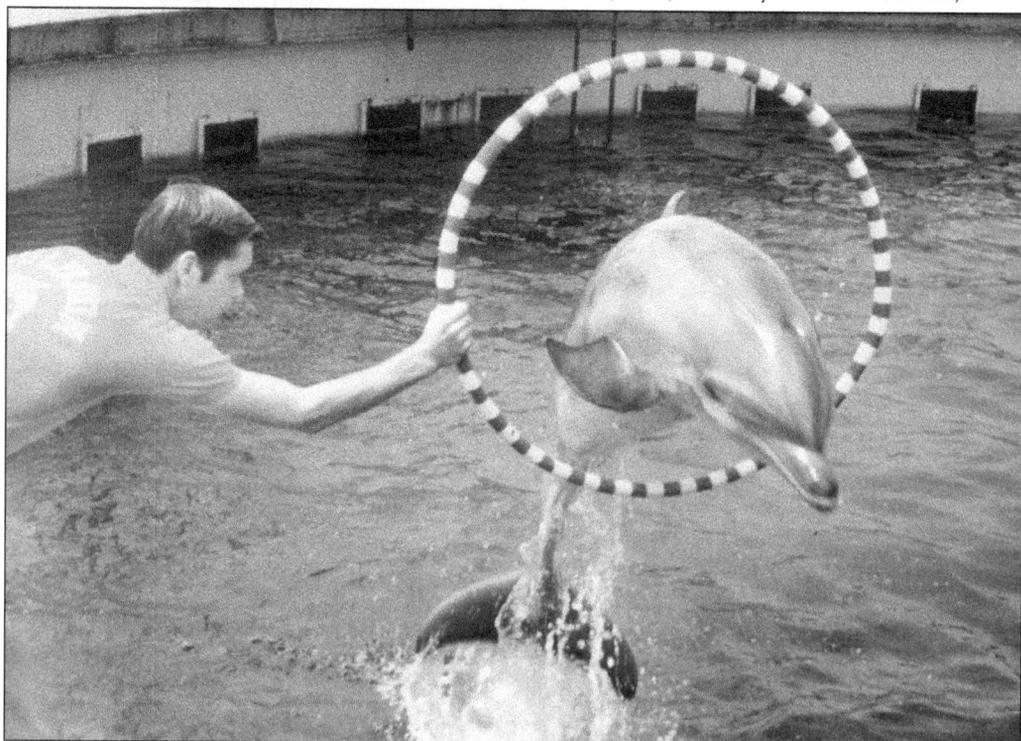

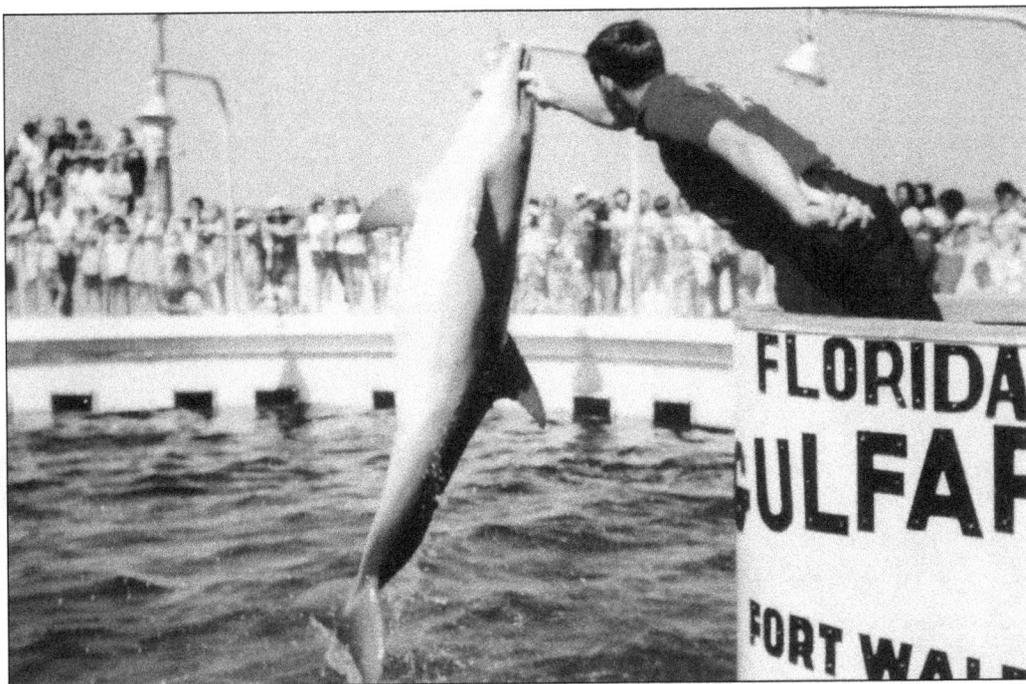

This 1966 photograph of an unidentified trainer feeding a leaping dolphin in front of a packed house shows several changes around the Gulfarium since its first decade. The trainer wears the red Gulfarium polo, which became the uniform throughout the rest of the 1960s and into the 1970s. Also, block lettering emblazons the trainer's platform in this photograph, replacing the stretched canvas and script font of the platform's original look. (Courtesy of the Merrill family.)

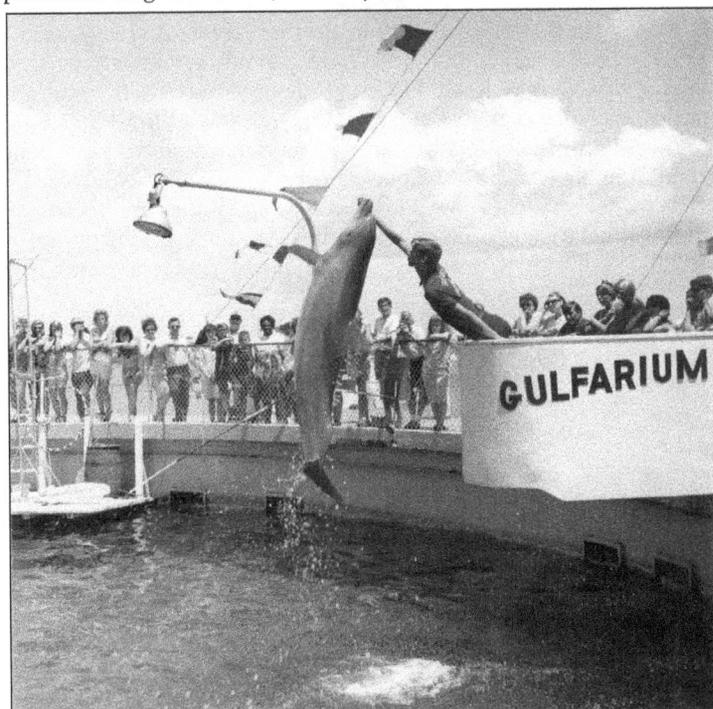

Ron Bradford performs the dolphin high jump around 1967. Although this show takes place on a sunny day, the addition of lighting around the dolphin habitat allowed for evening shows as well. The many props, such as hula hoops and toys, visible on the platform to the left reveal a few surprises guests would see in a dolphin show. (Courtesy of the State Archives of Florida.)

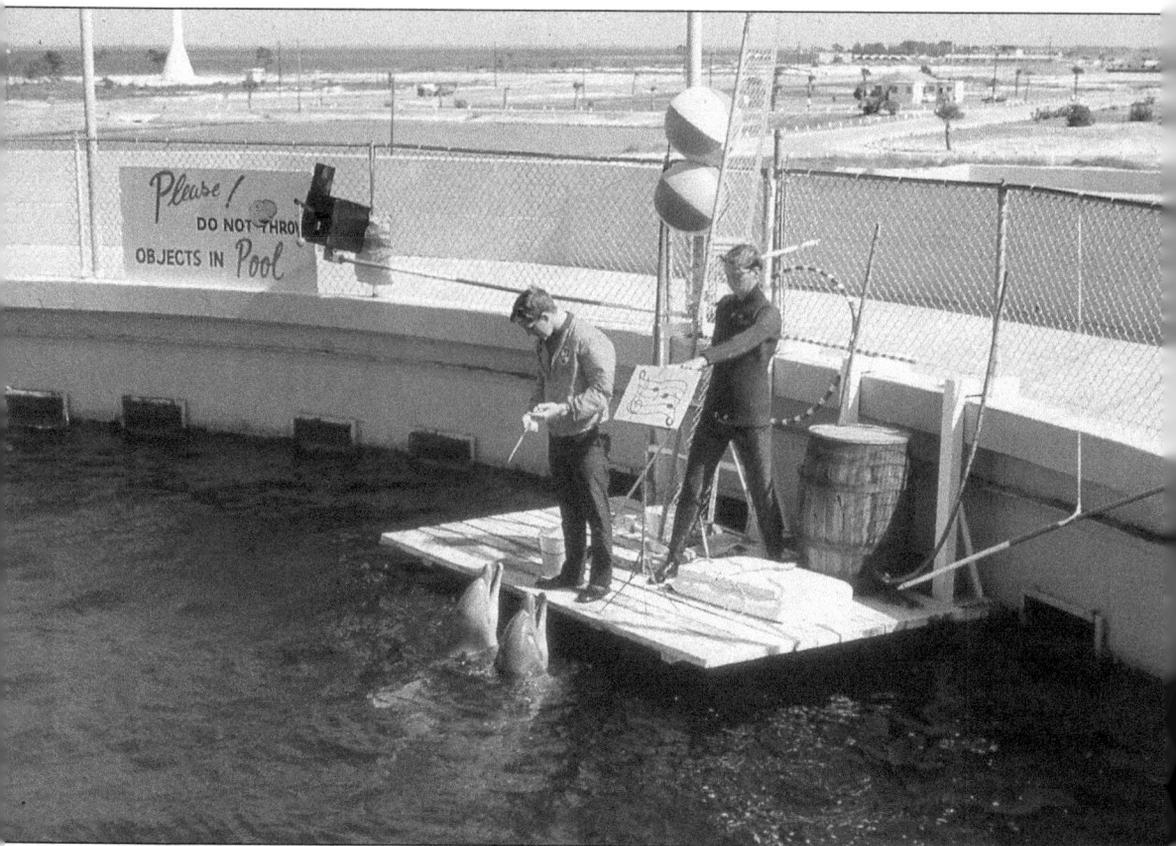

The low feed section of the main tank presentation showcased several amusingly humanlike behaviors with each dolphin specializing in one or two activities. Shown here in November 1967, dolphins Belinda (left) and Herman demonstrate their vocal abilities in the form of dazzling musical melodies orchestrated by trainer Terry Watkins. On this particularly cold and windy day, Watkins is assisted by fellow trainer Ron Bradford, who conspicuously keeps both sheet music and stand from blowing into the pool. Years later, Bradford and Watkins described this dolphin duo as an unlikely pairing. While Belinda, the alpha animal, was adored for her sweet and lovable disposition, Herman's sly and cunning ways challenged the trainers as they struggled to stay one step ahead of him. (Courtesy of Gulfarium Marine Adventure Park.)

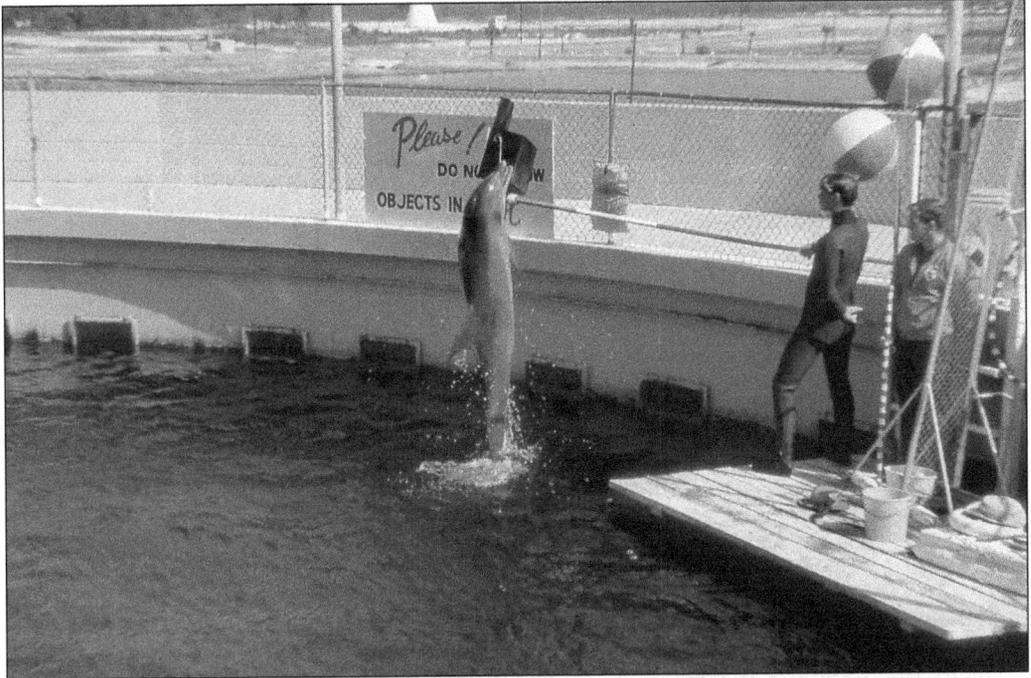

This show segment gave the dolphins a chance to turn the tables on the camera-happy crowds. In November 1967, dolphin Herman demonstrates dexterity and precision as trainer Ron Bradford (above, left, aided by Terry Watkins) swings a large-scale replica Kodak box camera out over the pool. With the crowd across the way prepped and ready to say "cheese," the dolphin expertly grasps the dangling red ball, triggering the fake photograph and eliciting applause from the eager subjects. Many of the show sequences were trained using mimicry, with one dolphin performing nearby the other. If the second dolphin made any attempt to perform the correct behavior, it was quickly rewarded with a fish. (Both, courtesy of Gulfarium Marine Adventure Park.)

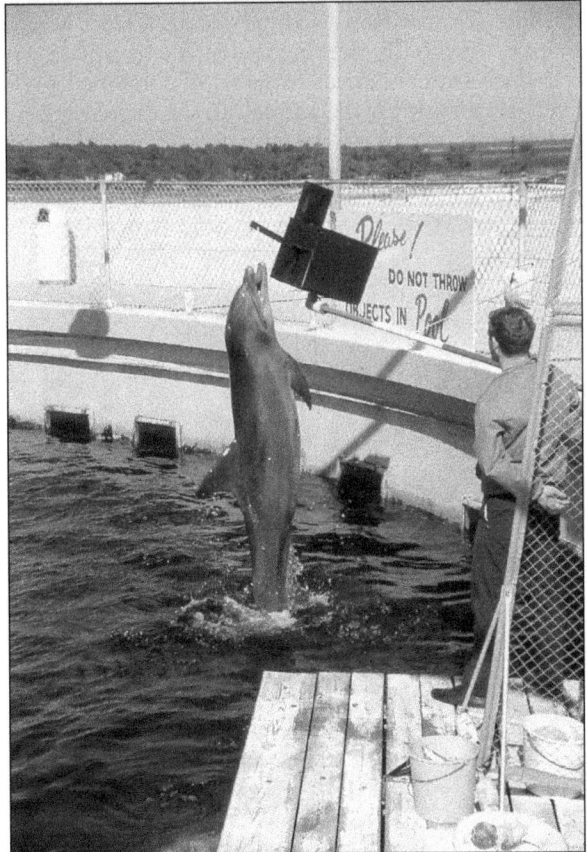

Above, around 1962, Belinda the dolphin offers some degree of proof to the old sailors' belief in the lifesaving abilities of dolphins, as she rescues a drifting baby doll by pushing the life ring to shore. Trainer Ron Bradford recalls a time when another dolphin, Pebbles, attempted this routine, only to flip the ring upside down and "drown" the baby. This early show routine played into the seemingly altruistic nature of dolphins, or porpoises, as they were referred to at the time. Even while knowing the animals in their care were Atlantic bottlenose dolphins, it was standard industry practice to use the term *porpoise*, so as not to confuse the public with the dolphin fish, or mahimahi, on their dinner plates. Below, Karen Siebenaler brings the routine to life as a dolphin pulls her across the College pool. (Both, courtesy of Arturo.)

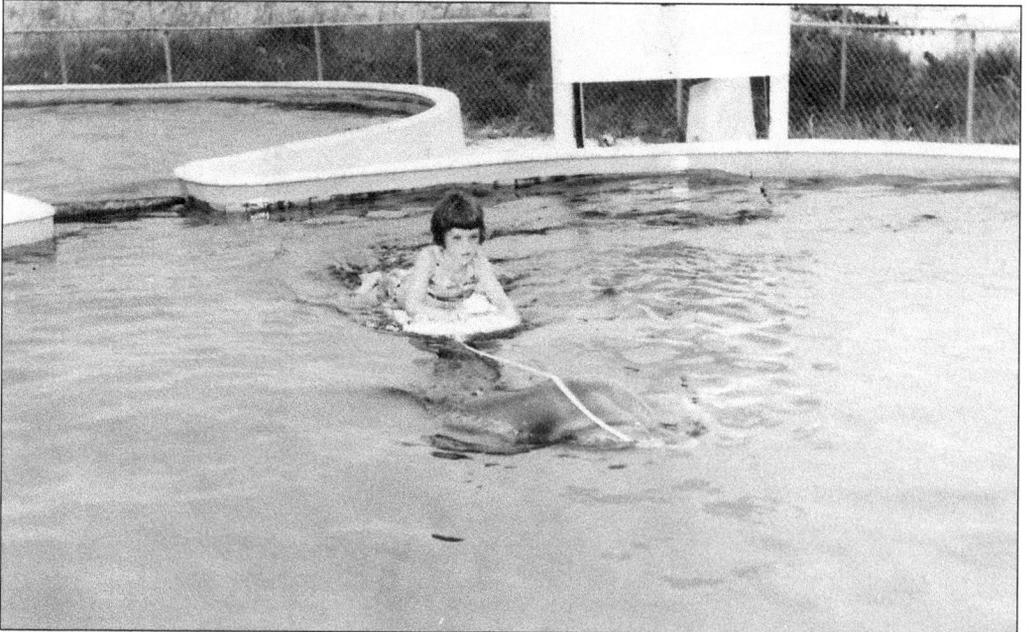

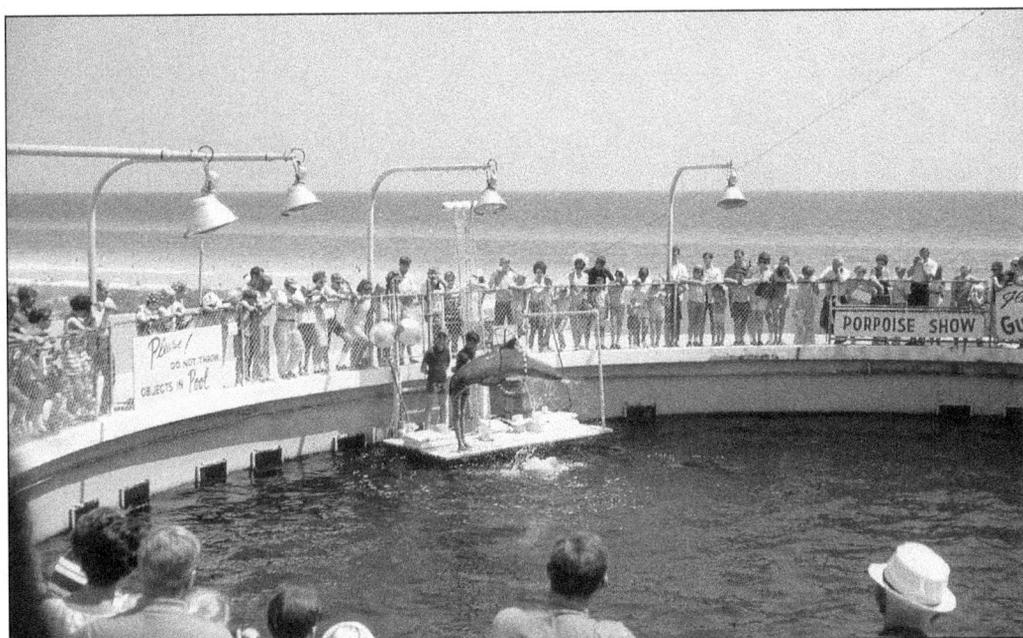

In 1969, a young Greg Siebenaler flawlessly coordinates a dolphin hoop jump in front of scores of onlookers. With just a chain-link fence separating the crowd from the pool's edge, possessions and debris landed in the water on a consistent basis. Gulfarium divers were vigilant in scouring the habitat floor to retrieve coins, glasses, hair combs, and other items before the dolphins could potentially ingest them. (Courtesy of Lisa Blake.)

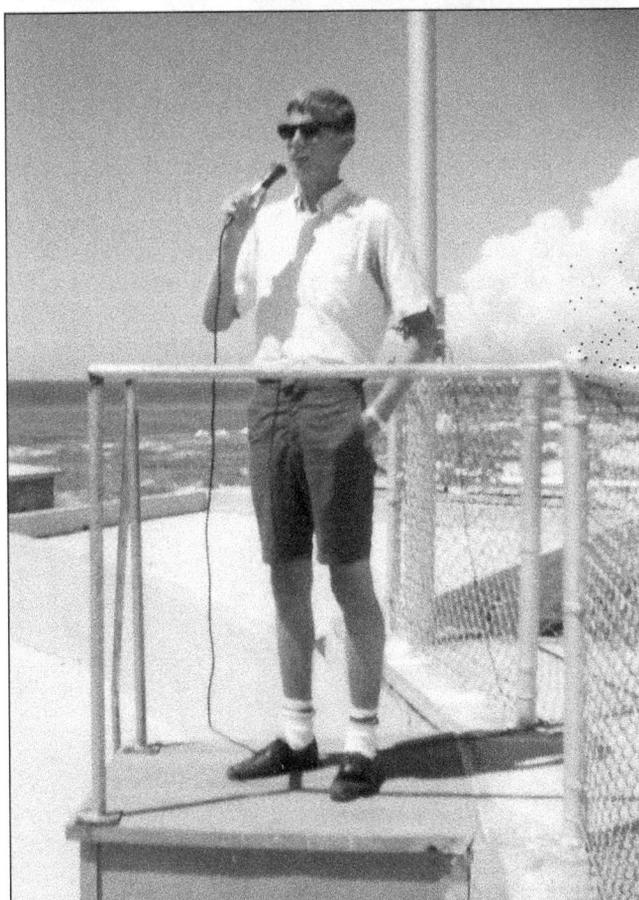

At age 16, Michael Murphy narrates the dolphin show from the announcer's perch in the summer of 1974. During the busy season, tourists were treated to a live commentator who called out the action, but as soon as the slow winter months rolled around, this luxury was pared back to a taped recording. (Courtesy of Dorothy Murphy.)

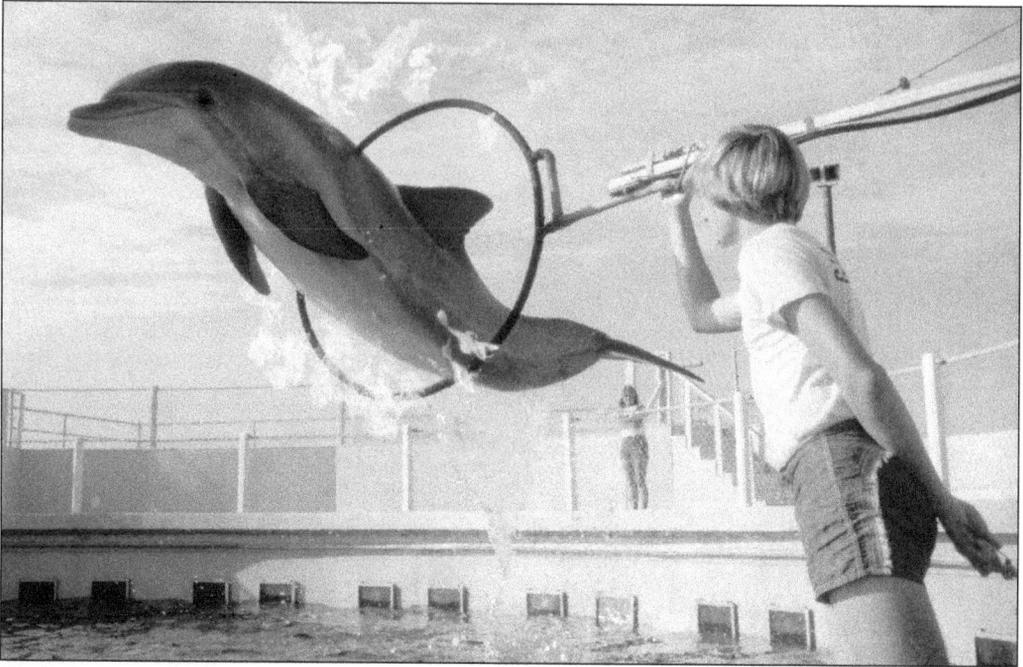

By the late 1970s, the dolphin show, continuously running for over 25 years, needed a little "spark." Creative, and some might say crazy, trainers introduced the ring of fire, an impressive jump through a custom-built fiery hoop. Above, around 1979, trainer Gary Jennings steadies the hoop as Princess leaps through the fire with ease. Later, trainer Steve Shippee expressed his dislike for this behavior, as it proved more dangerous to the trainers than the dolphins. The flames worked off a small propane tank and were supposed to light by an igniter, but all too often they had to use a spark striker, as seen in Jennings's left hand, leaving the trainers with no hair on their forearms. Below, kids watch in delight as Princess performs the blazing behavior again in May 1980. (Above, courtesy of Steve Shippee; below, courtesy of Gulfarium Marine Adventure Park.)

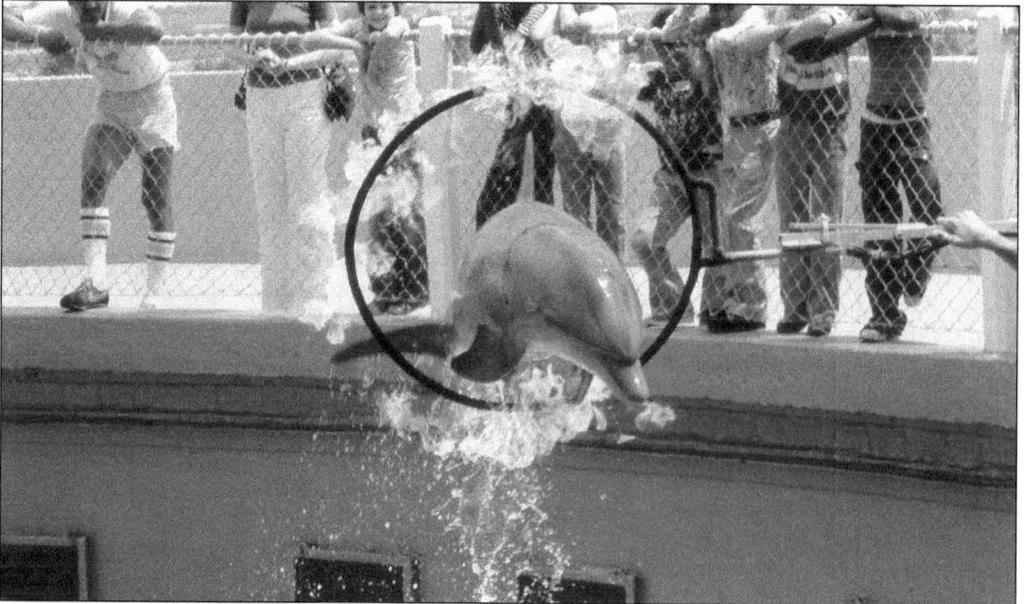

On December 8, 1964, Marjorie Siebenaler and daughter Karen accompanied four Atlantic bottlenose dolphins on a journey from the Gulfarium to a new, yet unopened 80-acre aquatic facility in Cape Coral, Florida. Placed on their sides on foam mats, the dolphins were first transported by truck to the local airport, then via airplane for nearly 450 miles, and again by truck for the remaining few miles to Cape Coral Gardens. A practiced expert in dolphin transports, Siebenaler stayed with the animals for the duration of the trip, monitoring their behavior and keeping them wet to prevent skin damage. Prior to their journey, the four dolphins spent 11 weeks with Siebenaler in Gulfarium's Porpoise College for intensive training, learning behaviors that would prepare them for show life at Cape Coral Gardens, including bursting through a raised hoop covered with paper. (Courtesy of Gulfarium Marine Adventure Park.)

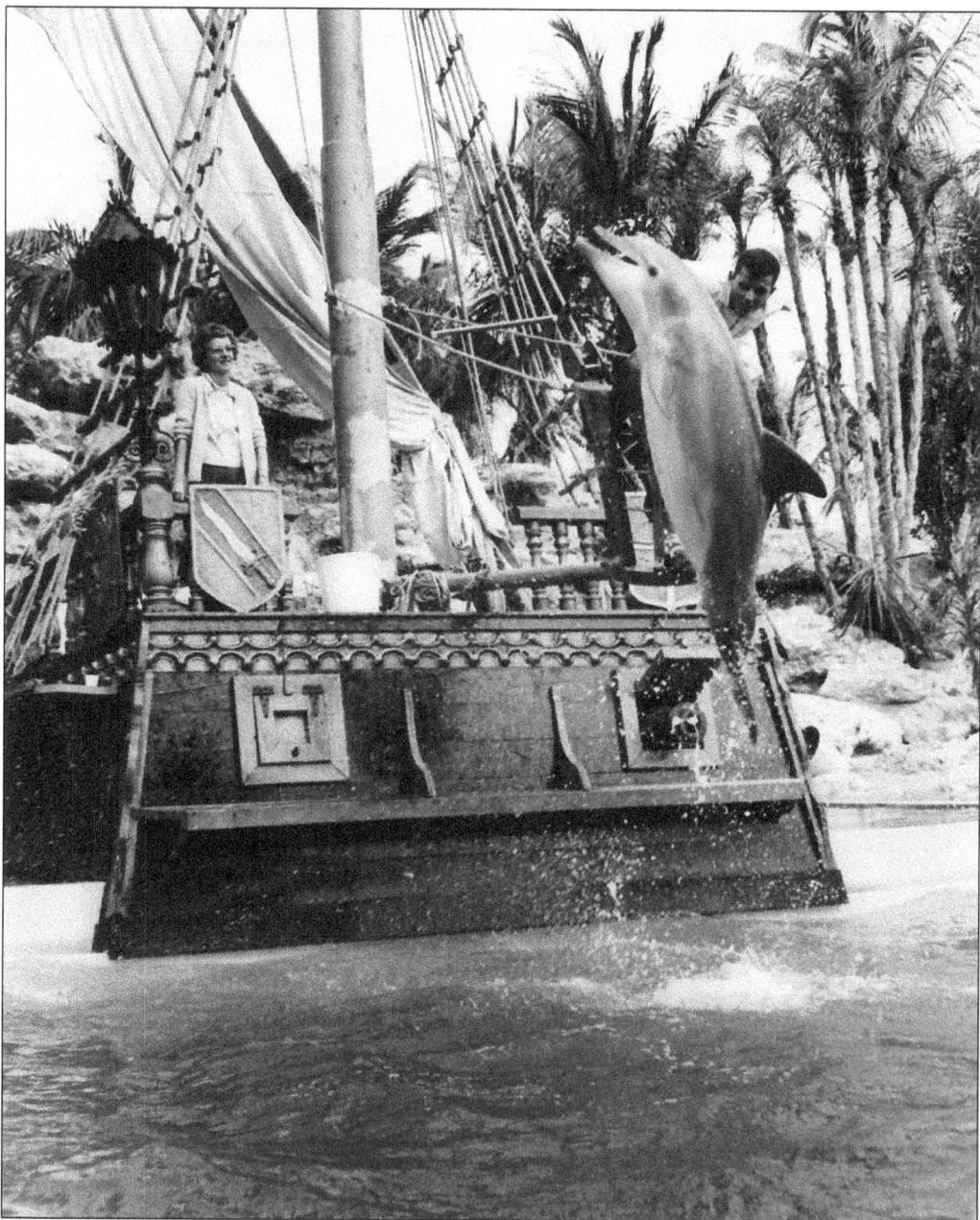

This photograph, dated December 11, 1964, shows one of the four dolphins acclimating to its new habitat at Cape Coral Gardens, three days after its transport from the Gulfarium. Dumbo the dolphin leaps high into the air to nab a herring from trainer Tim Johnson as Gulfarium's Marjorie Siebenaler looks on. Expected to be the most popular park attraction, the 220,000-gallon Dancing Porpoise Paradise exhibit contained three holding areas. Visitors could watch regular performances of the playful sea mammals singing, dancing, and playing ball against the backdrop of a shipwrecked Spanish galleon replica. While the multimillion-dollar 80-acre facility boasted a 10,000-bush rose garden and the picturesque Waltzing Waters dancing fountains, the unprofitable Cape Coral Gardens closed after only six years. (Courtesy of Gulfarium Marine Adventure Park.)

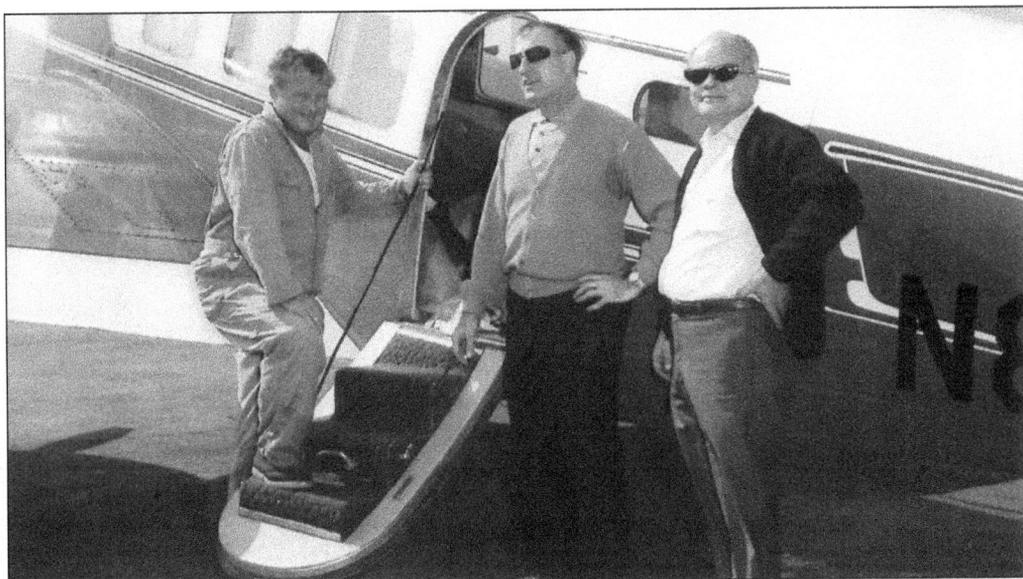

Dolphins were transported at the beginning of each summer season to perform in shows at Marine Life, a theme park in Rapid City, South Dakota, with which the Siebenalers had partnered. Above, Brandy Siebenaler (left) prepares to board the transport aircraft, a twin-engine Beechcraft owned by a Rapid City charter service. At right, Siebenaler settles in for the ride. Many factors had to be considered when transporting the large marine mammals by air. For example, the altitude ceiling with dolphins on board was 5,000 feet—above that, the dolphins, adapted for life at sea level and below, could suffer life-threatening injuries in the unpressurized cabin. The animals also had to be kept cool and wet to maintain their core temperature and prevent their sensitive skin from drying. The journey from the small Destin airport to Rapid City included just one stop for fuel in St. Louis, Missouri. Despite the challenges, the Siebenalers had great success with their air transports, never losing a single dolphin in some 20 years of sending them to Rapid City every summer. (Both, courtesy of Gulfarium Marine Adventure Park.)

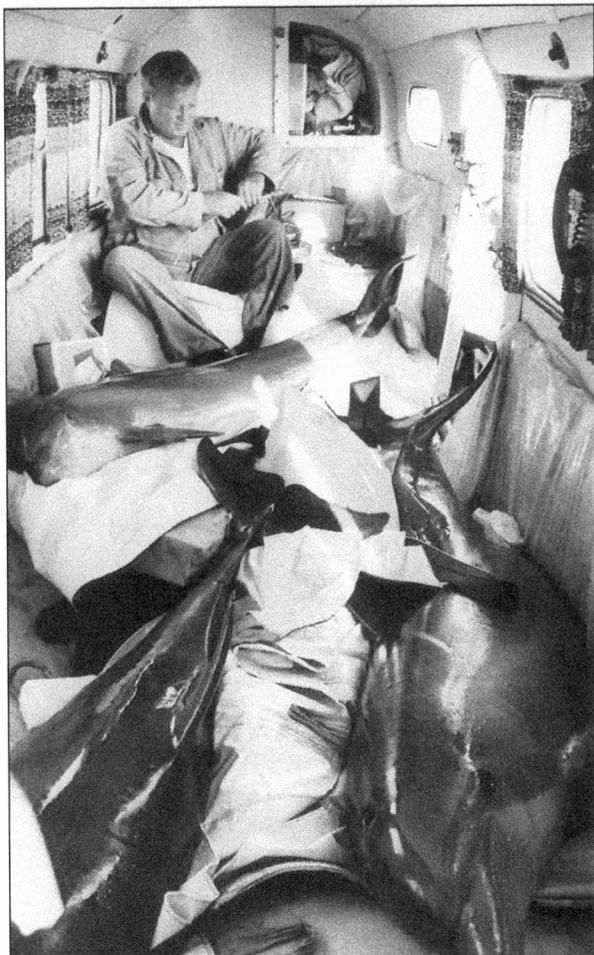

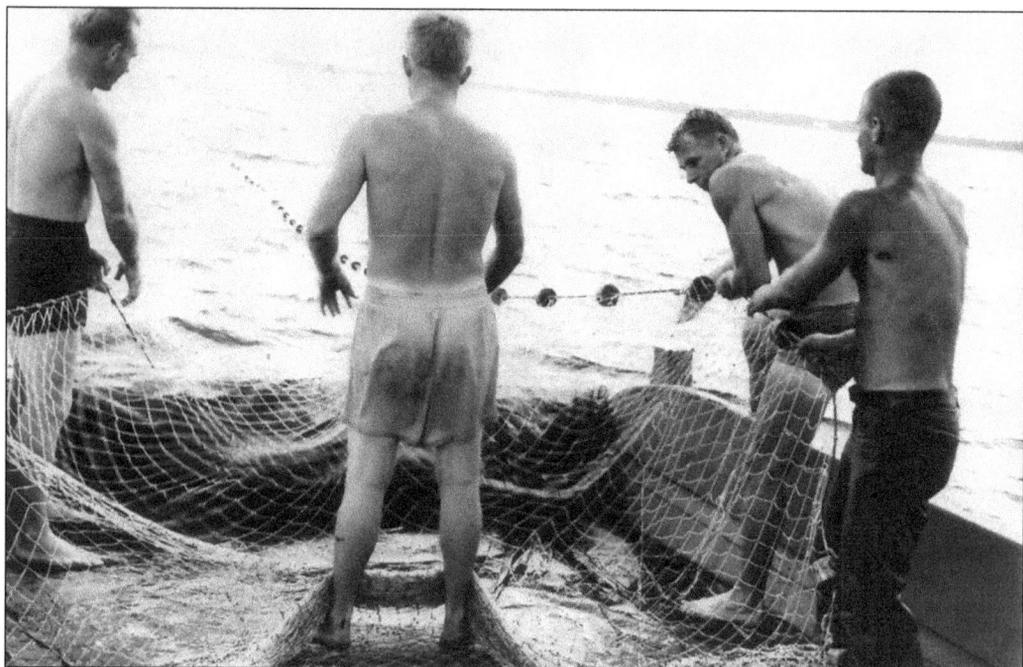

Above, in the late 1950s, the crew of Buck Destin, great-grandson of famed fishing captain Leonard Destin, after whom the Florida city of Destin is named, was an essential part of the Gulfarium's operation, collecting display specimens, including dolphins, from the local waters and providing the dolphins' sardine diet for decades. What began as a side project to Destin's regular fishing operation quickly blossomed as he developed a skill for selecting the perfect dolphins for aquariums nationwide. Below, clockwise from top left, John Gunter, Captain Dewey "Buck" Destin, Greg Glenn, Dewey Destin, Greg Siebenaler, and George Gray handle two netted bottlenose dolphins in the shallow waters of the Choctawhatchee Bay around 1979. (Both, courtesy of Gulfarium Marine Adventure Park.)

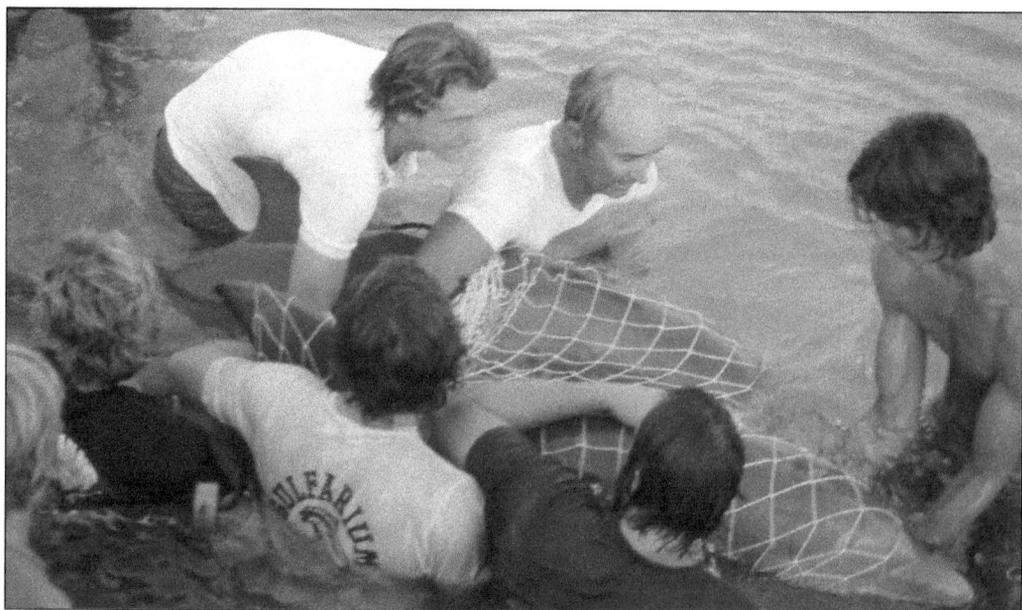

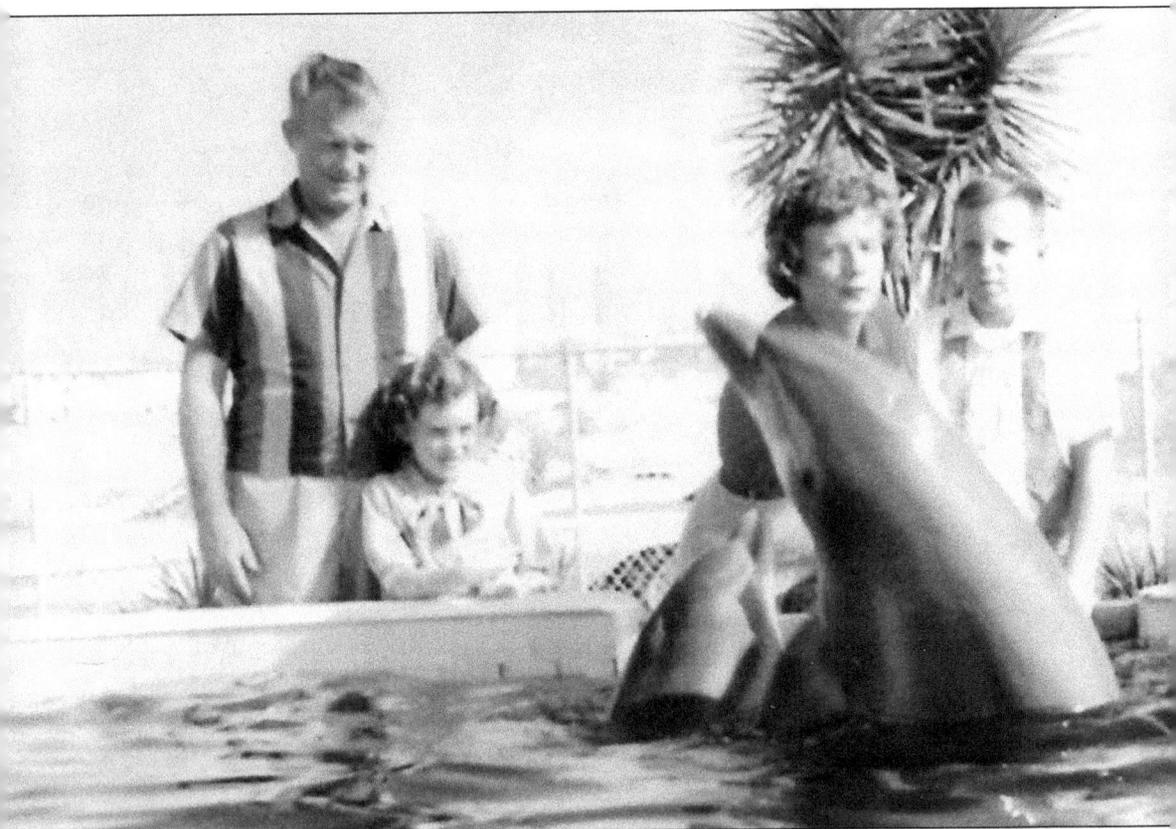

The Siebenaler family poses for their Christmas card photograph in the late 1960s. From left to right, Brandy, daughter Karen, Marjorie, and son Greg stand at the edge of the Porpoise College. The Gulfarium truly was a family affair for the Siebenalers. Following in his parents' footsteps, Greg became curator of the Gulfarium, while Karen would raise the park's first river otter by bringing it home with her. Throughout his childhood, youngest son Brandon (not pictured) assumed naming rights for all the Gulfarium's animals. (Courtesy of Gulfarium Marine Adventure Park.)

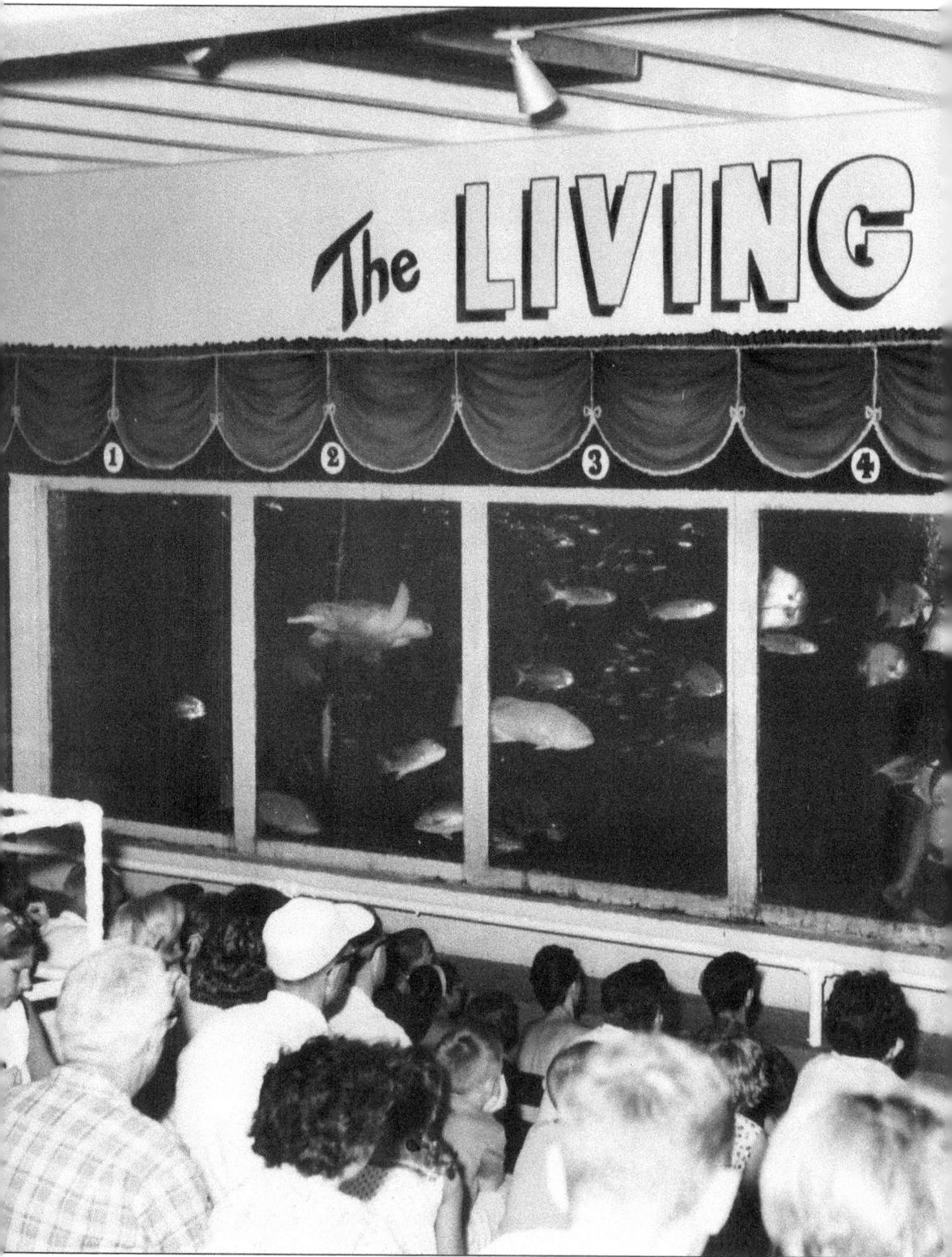

"Splash! The diver has entered the tank" began each recorded narration of the Living Sea Reef Tank presentation, signifying the ceremonious descent of the scuba diver. A partially submerged upside-down trash can encased a speaker that allowed the diver to hear the focused sound underwater. Throughout the show, staff would often play jokes on each other, the audience none the wiser. It was not uncommon for the show's star to reach above the water's surface, retrieve the fish bucket, and thrust in his or her hand, just to get bit by a blue crab, which a sneaky colleague had strategically placed, of course. Toward the end of every show came a dramatized version of a diving emergency in which the submerged star would ditch his gear and wait for the narrated countdown, signaling his ascension to the surface for air. This often provided the perfect opportunity for a devious workmate to hit the pause button on the tape just long enough to watch his or her colleague squirm. (Courtesy of Arturo.)

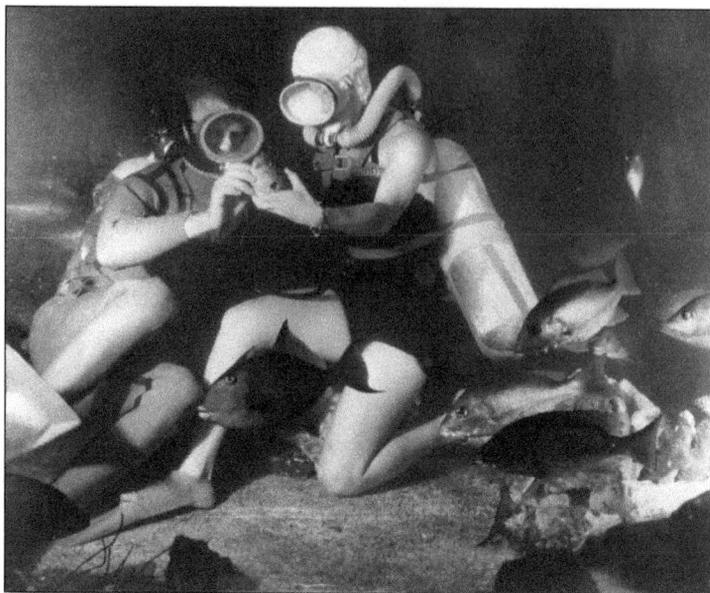

Brandy and Marjorie Siebenaler examine an inflated puffer fish at the bottom of their Living Sea exhibit. Other fish species in the photograph include, from left to right, a striped grunt, a triggerfish, and several snapper. Many former divers and trainers interviewed for this book immediately recognized the two-hose scuba regulator as an early form of Jacques Cousteau's underwater breathing technology (Courtesy of Arturo.)

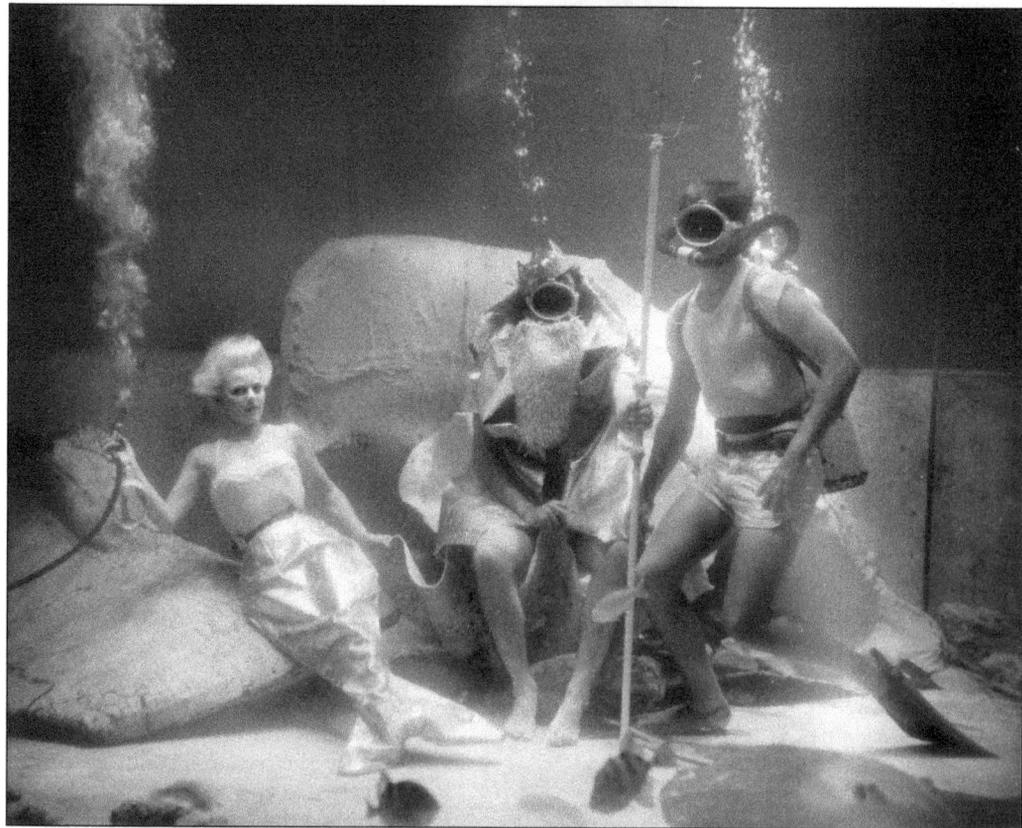

In May 1958, the Reef Tank became the stage for a theatrical production titled "Raptures of the Deep" in which a reckless scuba diver is overcome with hallucinations due to his quick decent into the depths. During the intoxicating fantasy, the diver stands trial by King Neptune for his careless behavior, only to be saved by the pleas of the king's mermaid daughter. (Courtesy of Arturo.)

Like the sawfish held by an unidentified diver at right, many species of fish identified by Gulfarium divers during the Living Sea show would likely never be seen in their natural habitat by park visitors. A ray closely related to sharks, this gentle giant of the sea had become quite rare by the mid-1950s, and today, humans seldom sight this fish. Below, the loggerhead sea turtle General Lee was a main attraction of the Living Sea for most of the Gulfarium's history. He was touted as being "older than the US Civil War." General Lee was part of the Living Sea diver show until the taped narration rolled for the last time. Exhibiting rare species not only provided a window into the underwater world that kept eager guests coming back every year, but it also helped foster a love and respect for the fascinating life below the waves—Brandy Siebenaler's stated mission when he hatched his idea to build the Gulfarium. (Right, courtesy of the State Archives of Florida; below, courtesy of Steve Shippee.)

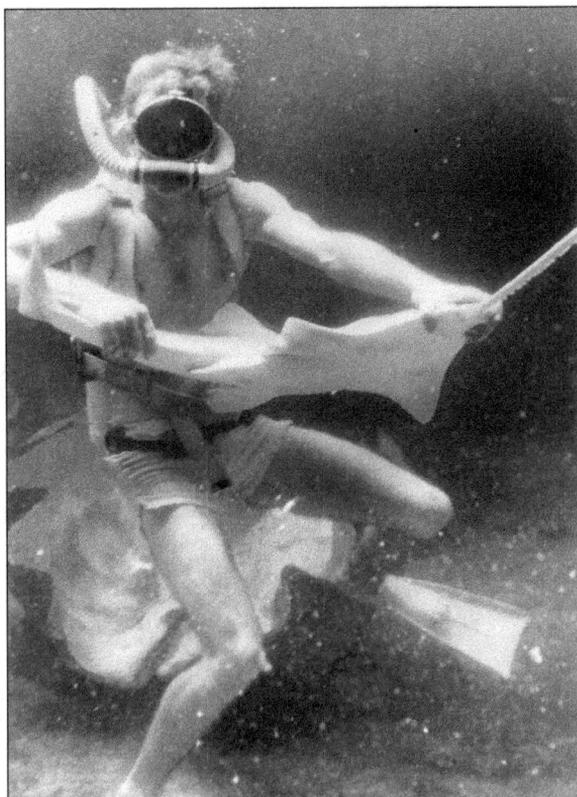

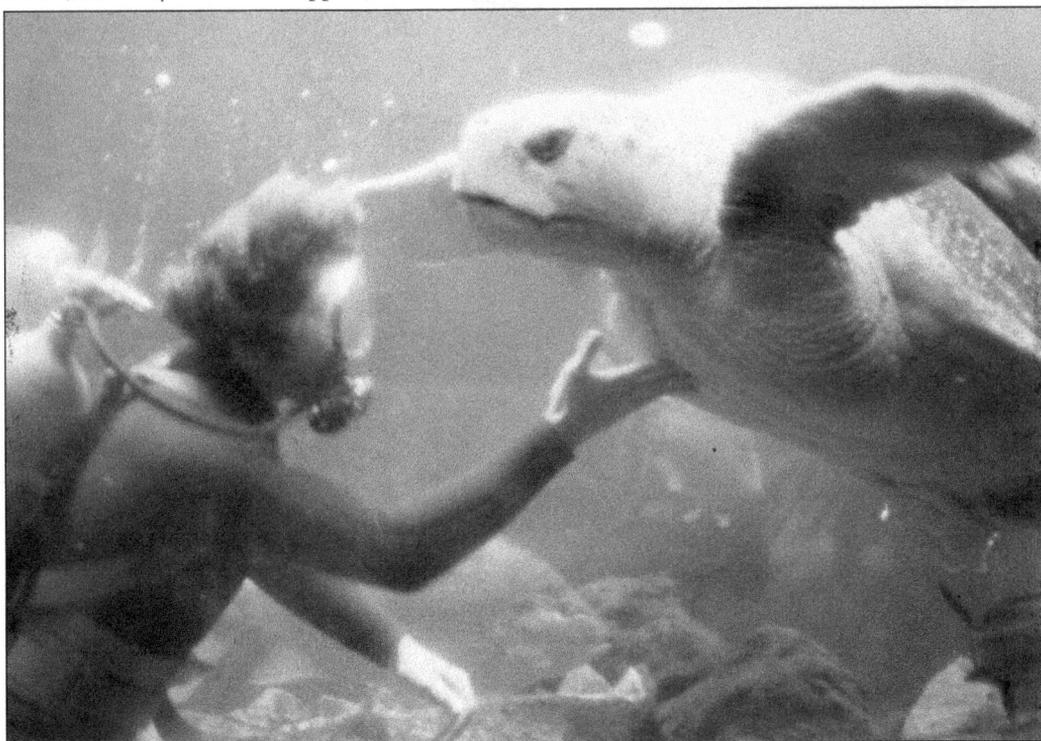

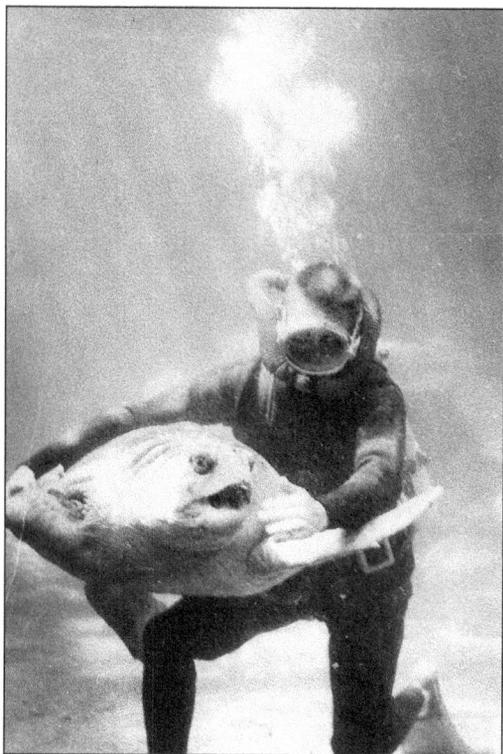

A Gulfarium diver presents Zorro, a white loggerhead sea turtle, to the audience during a Living Sea show. Zorro was a large male turtle with a reputation for leaving his mark on every diver who entered his habitat, just like the famous masked hero. Former trainer Terry Watkins recognized Zorro in this photograph and revealed the scar on his hand he still bears from when Zorro latched on with his powerful beak. Former trainer Ron Bradford also recalled the time Zorro latched onto his backside during a Living Sea show, instantly veering the show off script and leaving Bradford with a torn wet suit. (Both, courtesy of Arturo.)

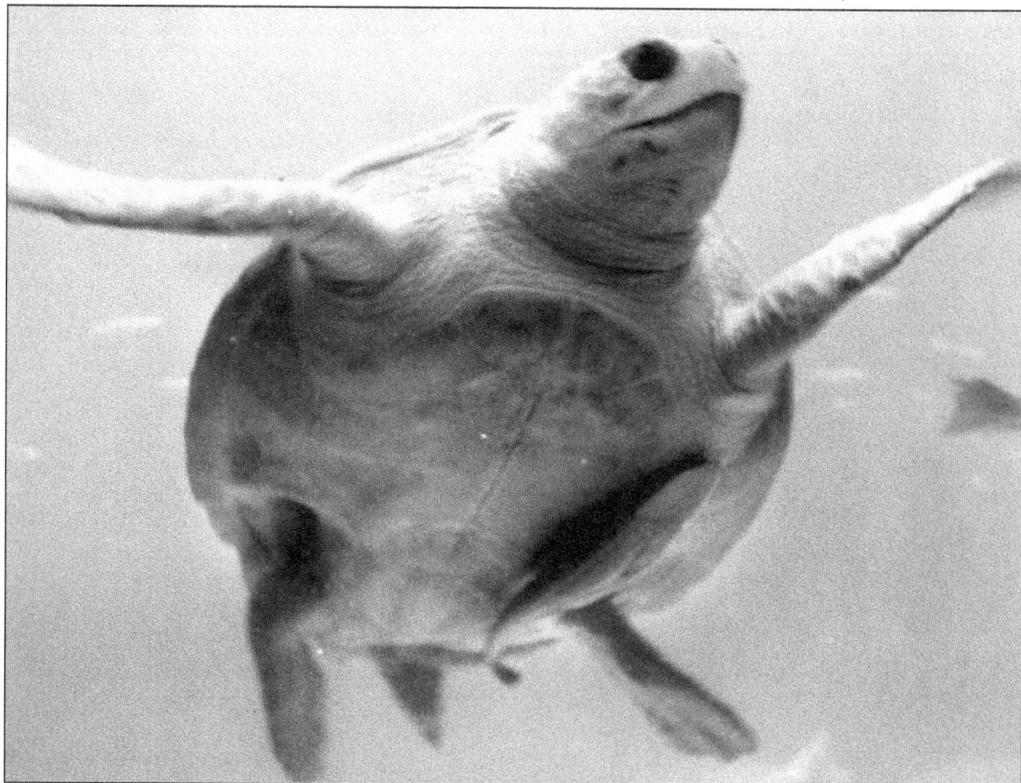

Three

THE GROWING MENAGERIE

As the Gulfarium gained popularity through the success of its beloved dolphin shows and exhibition of local marine life, Brandy Siebenaler's mission to bring the sea to the public expanded to include more local marine life and some species that even locals had never seen before. As the Gulfarium continued to grow, sea lions and harbor seals from California and penguins native to Africa joined an expanded collection of local marine life, including sharks, alligators, and freshwater fish and turtles.

Exhibiting all these new species required new habitats to house them. Pools and enclosures were designed from the ground up, with the direct input of Brandy Siebenaler. The Shark Moat was designed to allow the large animals a continuous circular swimming pattern to keep oxygenated water flushing over their gills. The sea lion and seal habitats were built to provide plenty of space for the animals to haul out and bask in the Florida sun, and later, the Multi-Species Pool was constructed with sufficient depth and space for dolphins and sea lions to perform together.

The artistry of local painters and trainers themselves went into the backdrops and murals that gave each new exhibit just the right ambiance. Trainers even worked to build sea lion seats, otter dens, and penguin huts to provide the animals with prime living conditions.

During this period of expansion, the Gulfarium grew beyond its original fences at the east and west edges of the park. By the 1980s, the park had more than doubled in size to include at least a half dozen feature exhibits constructed after the gates first opened in 1955. Tourism had boomed all along the Emerald Coast, and restaurants, hotels, and a thriving new fishing pier now flanked the Gulfarium on both sides. With the Gulfarium as its flagship attraction, Okaloosa Island became the tourism hot spot that its founders and president Burney Henderson had envisioned.

The Gulfarium's original street sign, seen above around 1960, featured a blue-and-yellow design and big block letters—a bold statement along an otherwise undeveloped stretch of land. Passersby could not help but be lured in to see dolphins and turtles. Eventually, this sign was taken down and sunk into the Gulf of Mexico half a mile out to sea from the Gulfarium to create an artificial reef habitat for fish. Below, a more modern sign from the 1980s highlights the Gulfarium's expansion of animal exhibits to include seals, otters, and penguins. An exciting feature of this sign was the rotating neon dolphin, flashing through three stages to make it appear as if the dolphin were jumping through a hoop. (Above, courtesy of Arturo; below, courtesy of Gulfarium Marine Adventure Park.)

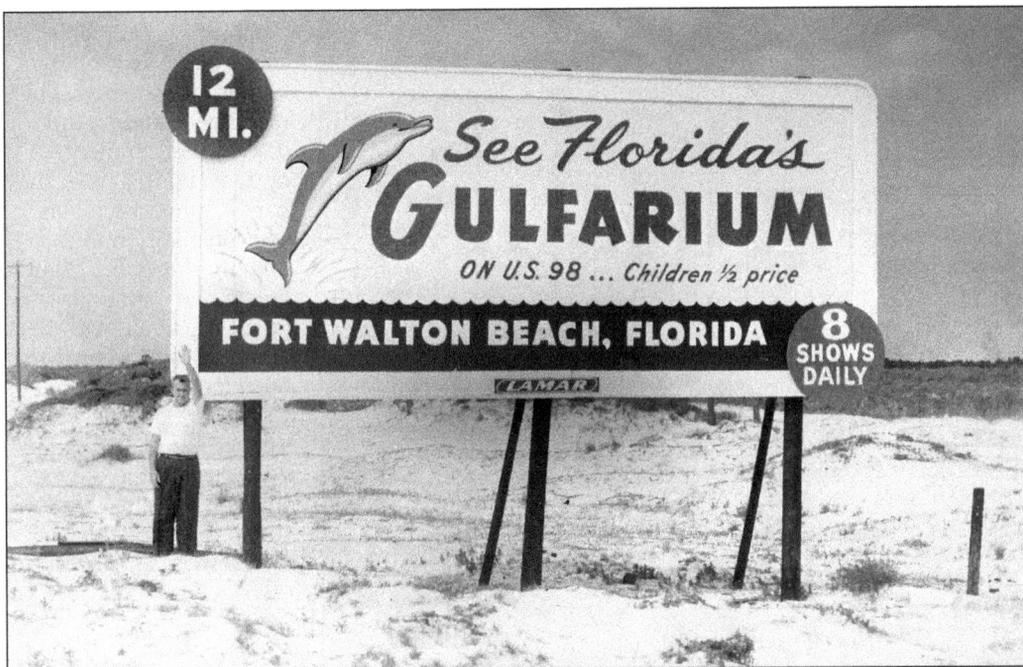

Brandy Siebenaler poses next to beachside and countryside Gulfarium billboards in the late 1960s. Advertisements such as these targeted Gulf Coast tourists from near and far. While Okaloosa Island was still growing into the travel destination that it has become today, the nearby cities of Pensacola to the west and Panama City Beach to the east provided a steady stream of vacationers, particularly during the spring and summer months. Advertisements from this time generally highlighted the jumping porpoise show, the Gulfarium's most popular attraction. (Both, courtesy of Gulfarium Marine Adventure Park.)

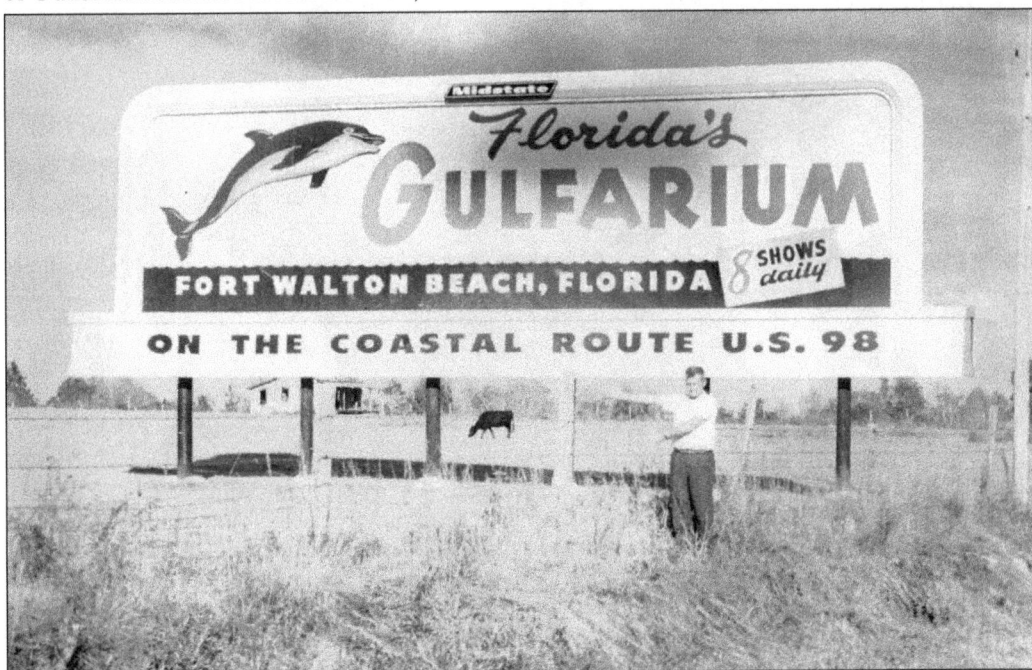

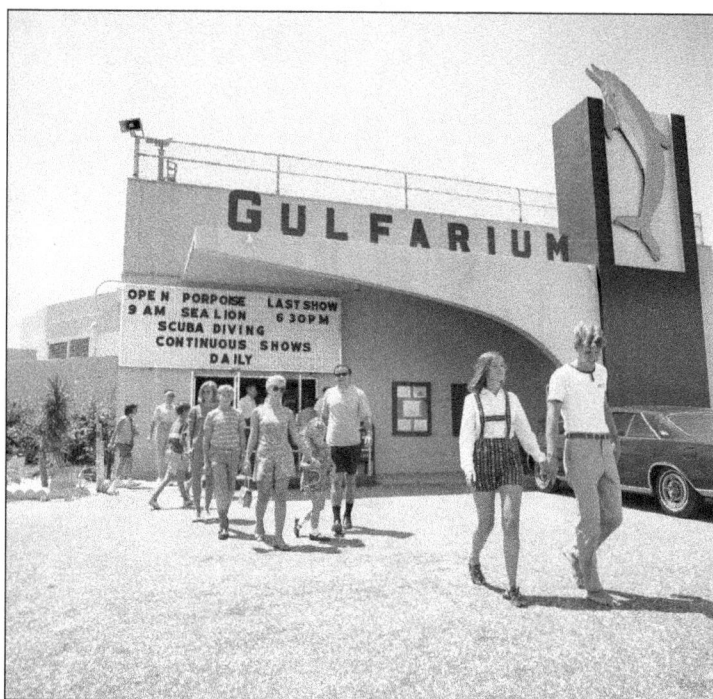

This 1969 photograph shows guests exiting the Gulfarium gift shop. The marquee features a full day of entertainment options. By this time, the park featured a sea lion show in addition to the dolphin shows. For many guests, the Gulfarium was an all-day affair, with the gift shop routinely staying open for hours after the last show. Although the signage has changed, guests still enter and exit through the same building today. (Courtesy of the State Archives of Florida.)

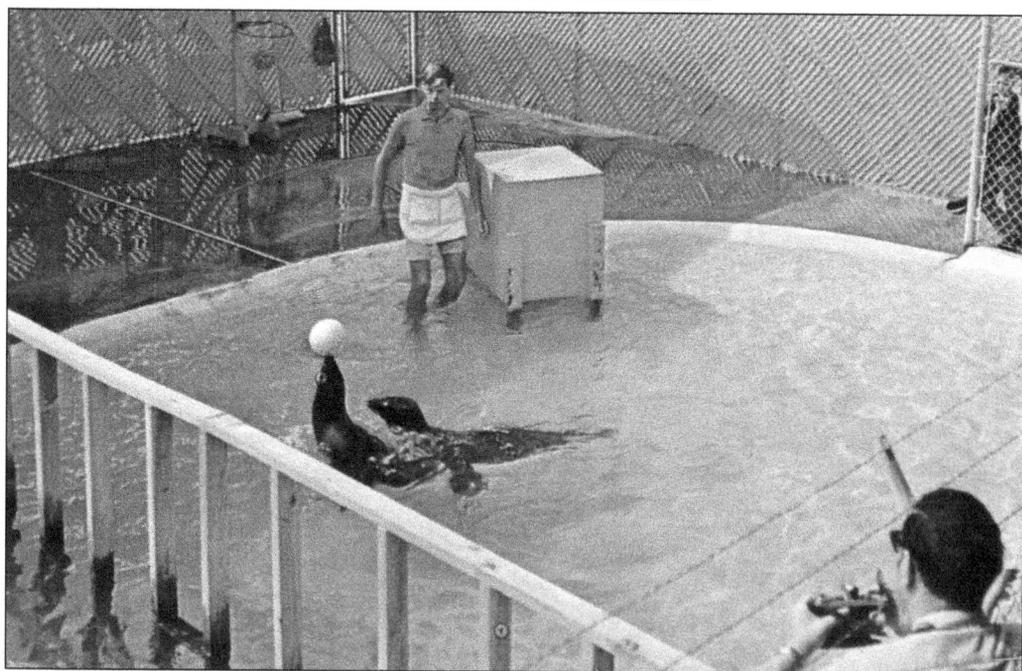

This postcard from the mid-1960s shows trainer Ron Bradford conducting the sea lion show. Sea lions quickly became a main attraction at the Gulfarium. Their comical antics and playful, doglike behavior captured the fancy of guests of every generation. Here, a man snaps a photograph while a young member of the audience watches from the side for a closer view. This postcard image proves that many felt the sea lion show truly was an event worth writing home about. (Courtesy of Stephanie Link.)

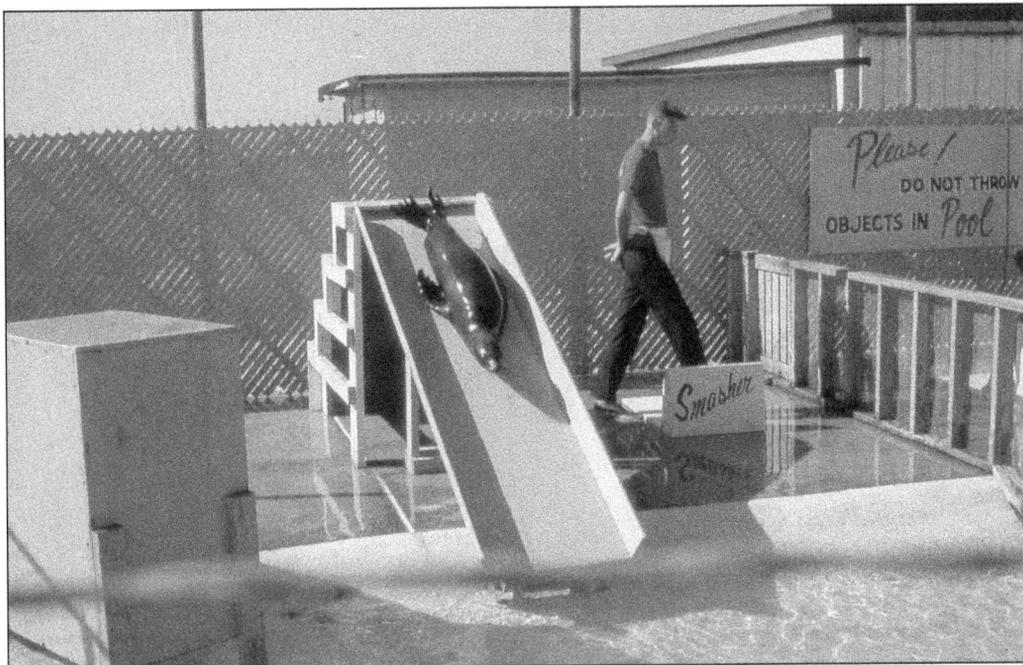

In December 1966, three young sea lions arrived at the Gulfarium, and within a few months, they were charming audiences during the humorous and entertaining sea lion show. Impressive front flips and comedically timed barks and smiles were among the behaviors typically performed. Above, sea lion Smasher slips down the slide, as directed by trainer Ron Bradford. Below, trainer Greg Siebenaler looks on as Skipper balances a ball on his nose with ease. While Smasher and Skipper were equal stars in the show, Bradford and fellow trainer Terry Watkins describe Smasher as the demanding diva, often barking and nipping at his trainers should reinforcement not come quickly enough. (Both, courtesy of Gulfarium Marine Adventure Park.)

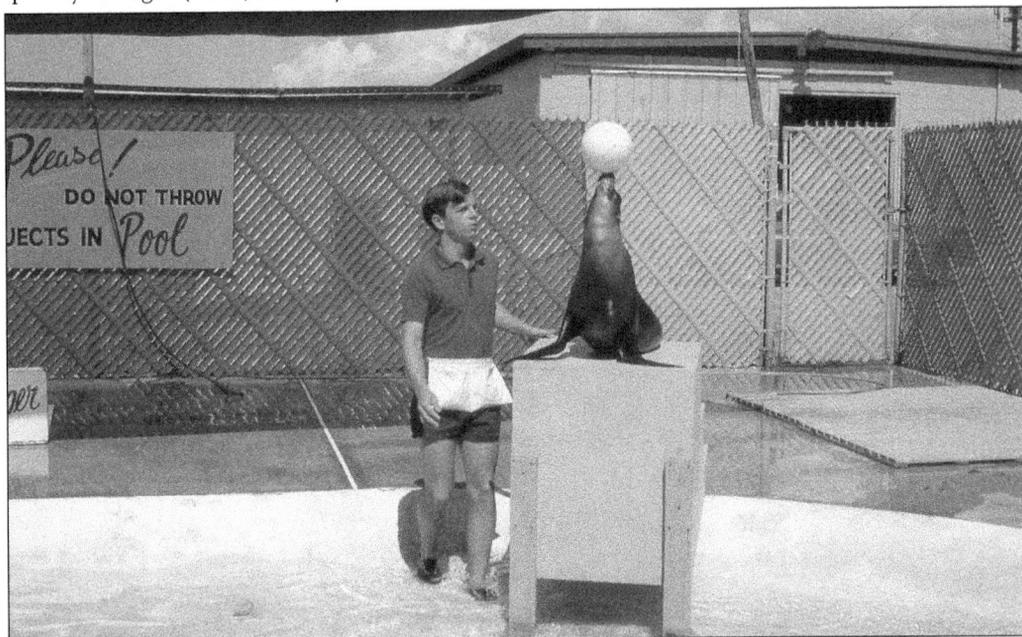

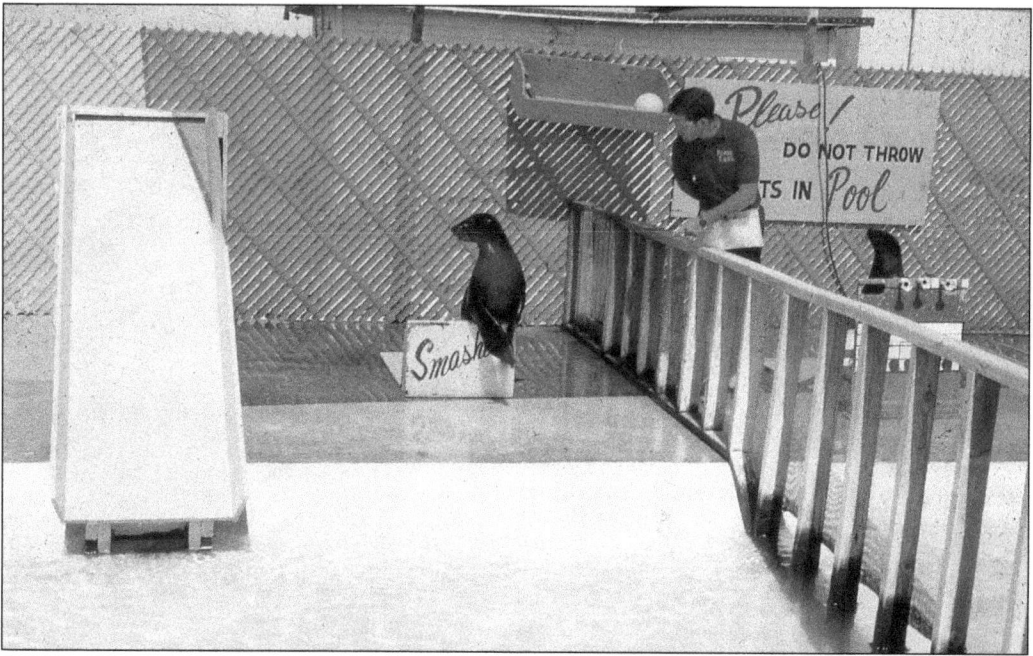

Smasher and Skipper, the young male sea lion stars, were quickly discovered to be incompatible poolmates, and a dividing fence was built halfway across the deck and pool for a peaceful coexistence. Above, in 1968, trainer Terry Watkins leads both sea lions through a musical routine from a central spot on the stage. While Skipper (right) honks each horn in a particular order, Smasher applauds the sea lion serenade. Below, at the end of the show, each sea lion would give Watkins a kiss on the cheek to say good-bye. Trainers kept fishy treats in their apron for quick rewards during the show. (Above, courtesy of Gulfarium Marine Adventure Park; below, courtesy of Terry Watkins.)

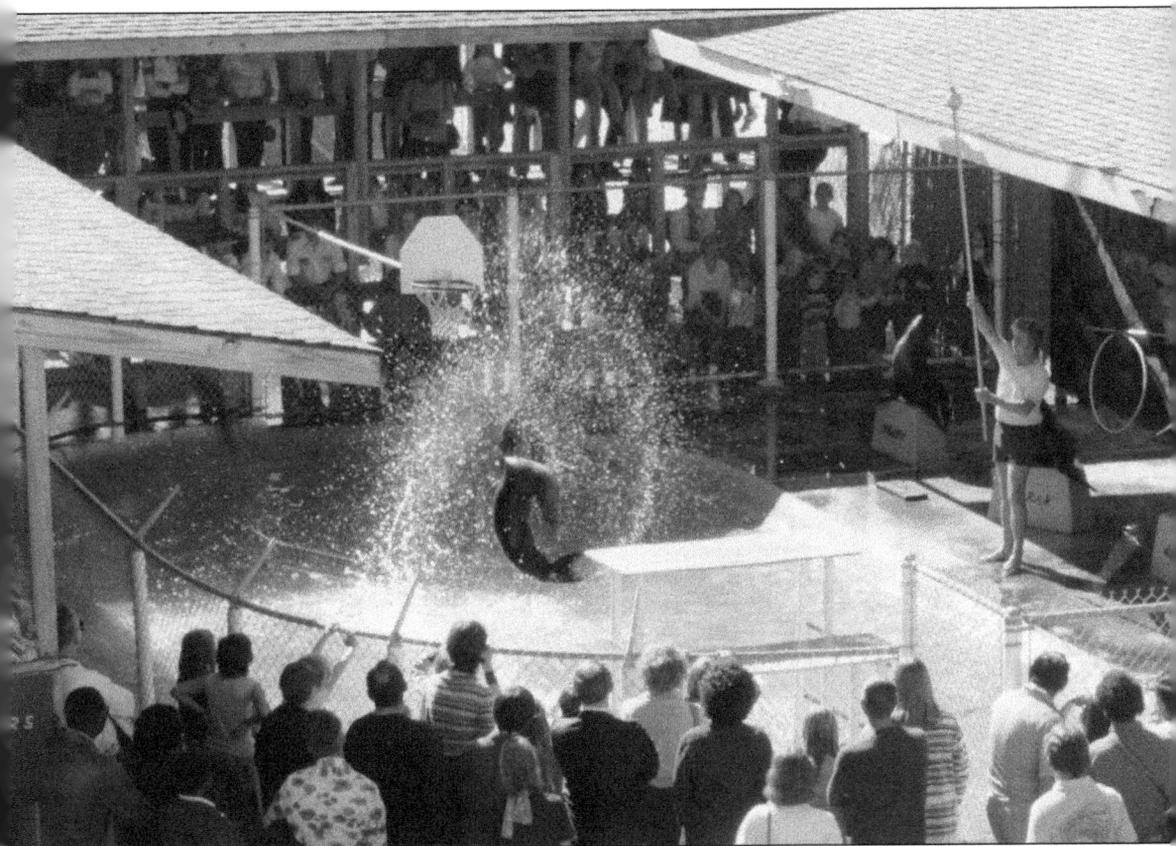

Led by show director George Gray, a sea lion entertains a packed house with a dazzling display of agility around 1978. This fast-paced show involved only one trainer and four sea lions, including Kelly, Corky, Cricket, and Sally. The trainer was responsible for orchestrating the sea lions in their performance of various behaviors, such as front flips, hoop jumps, and a never-miss basketball dunk, while simultaneously entertaining the crowd with witty banter and descriptive narration. A special skill of sea lion Corky was the ability to catch a disc thrown from any distance and speed, then toss it back with equally incredible accuracy. For over 20 years, Gray demonstrated exceptional showmanship with a flair for building suspense and keeping the audience engaged. The animals returned the enthusiasm with energy and vigor, guaranteeing a dynamic performance sure to delight tourists from around the world, many of whom had never before observed sea lions from such a close distance. (Courtesy of Gulfarium Marine Adventure Park.)

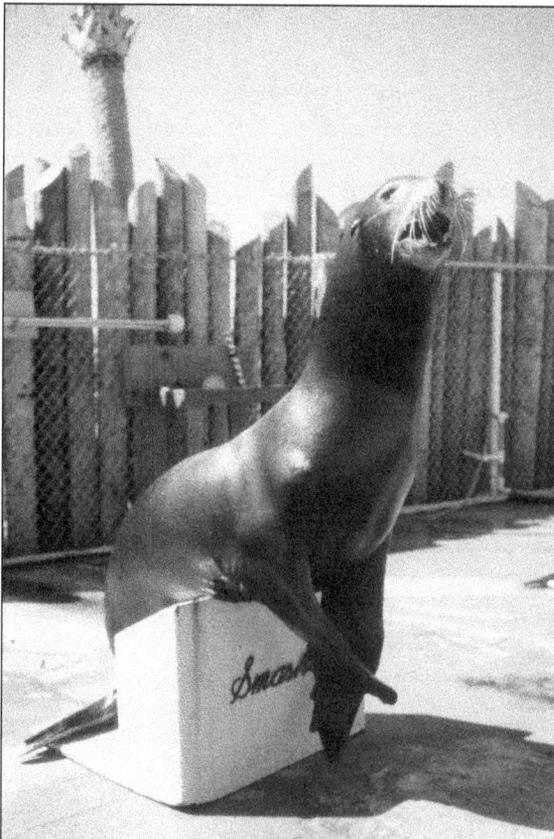

Gulfarium staff encountered a welcome surprise on the morning of June 23, 1977, when, after 11 years of sea lion display, Dolly gave birth to her first pup. While not confirmed, it was reported at the time as the first sea lion pup born under human care at any marine show facility. Not aware that Dolly had even been pregnant, manager Brandy Siebenaler called in renowned marine animal scientists Dr. David Caldwell and Dr. Winfield Brady for assistance, telling the local reporters they would have to play it by ear. "It's all kind of new to us and we're just going to let the mother lead us," stated Siebenaler. Proud mother Dolly demonstrated strong maternal instincts, and staff steered clear of the nursery compound, unable to tell whether the new pup was a male or female. At left, the pup's sire, Smasher, sits on his training seat. (Above, courtesy of Gulfarium Marine Adventure Park; left, courtesy of Steve Shippee.)

Trainer Lee Kellar, described by his Gulfarium colleagues as an exemplary pinniped trainer with unparalleled intuition, balances sea lion Corky on his rear flippers around 1978. A sea lion's anatomy does not lend itself to a standing position, yet Corky was able to maintain this behavior for an extended duration, even without Kellar's assistance. (Courtesy of Steve Shippee.)

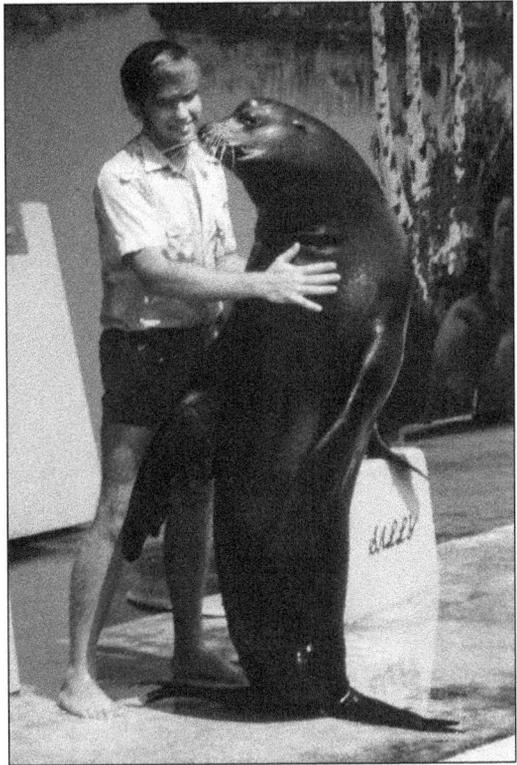

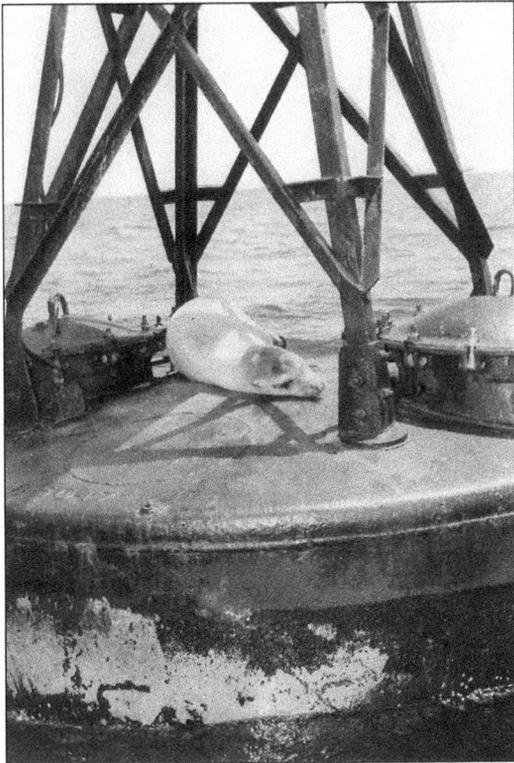

In April 1967, a sea lion resting atop the whistle buoy in Destin's East Pass surprised locals. Buck Destin's crew netted the nonnative 300-pound pinniped against the shore, but the sea lion simply walked onto the beach. Once captured and delivered to the Gulfarium, several theories developed about its mysterious origins. Later named Sam, he was assumed to be an escapee from a Gulfport, Mississippi, attraction that had a sea lion go missing seven years earlier. (Courtesy of Gulfarium Marine Adventure Park.)

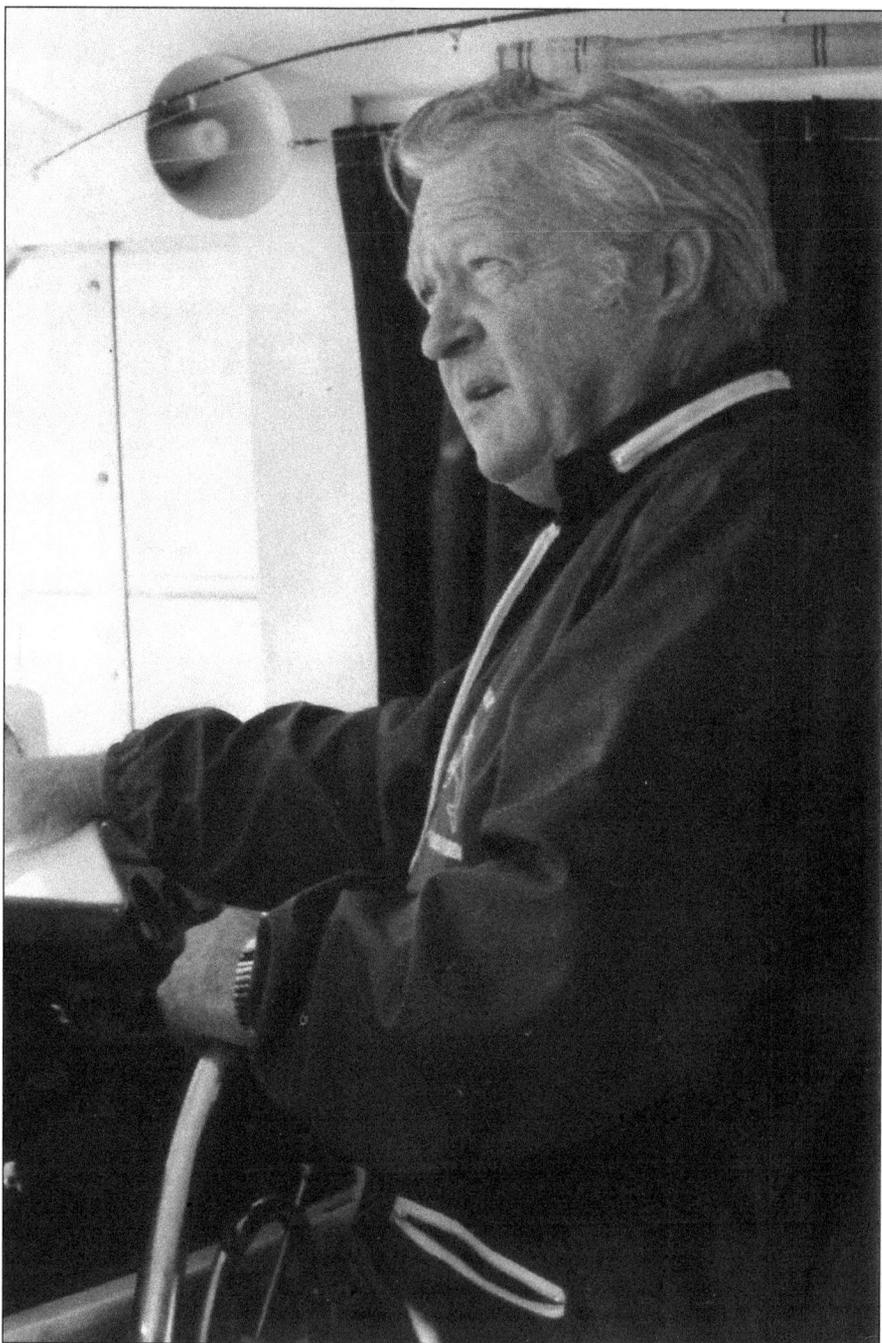

Brandy Siebenaler stands at the helm of his Chris-Craft Corinthian wearing a Gulfarium jacket. Siebenaler's personal vessel was used for collecting reef fish and other Gulf specimens for display in the Gulfarium's Living Sea and gallery aquariums. Former trainer Russell McLendon recalls a night excursion to capture flying fish, which involved rigging a sheet to hang from the boat's outrigger. By shining a light against the white sheet, flying fish were attracted to leap against it. The fish would then slide down the sheet into a net hung below it. Siebenaler's passion for exhibiting the sea's most curious creatures never waned. (Courtesy of Gulfarium Marine Adventure Park.)

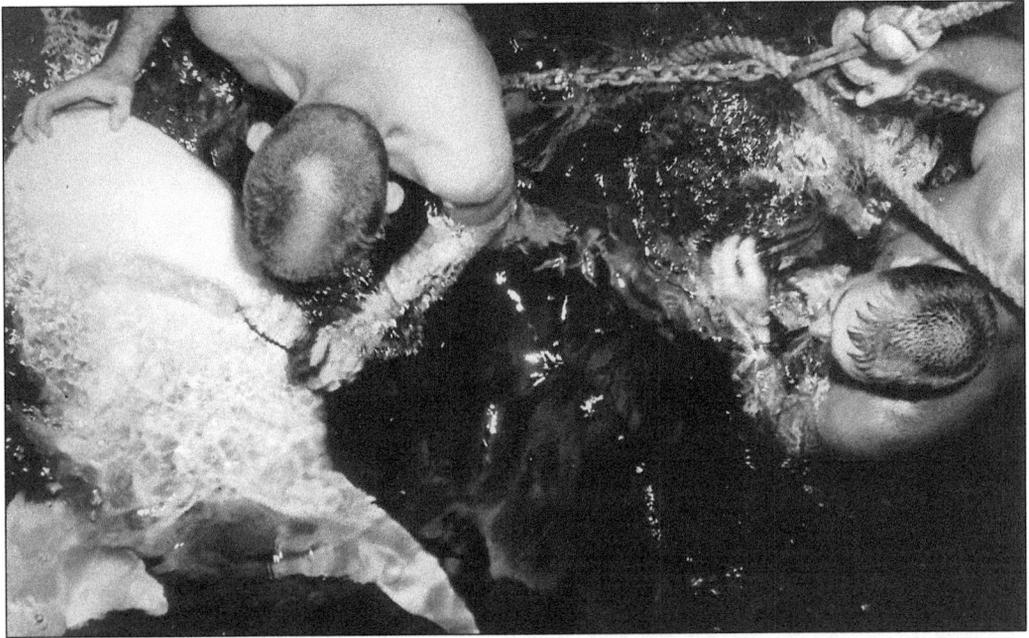

Above, a hook is removed from a large shark specimen collected for exhibition. Brandy Siebenaler wanted to exhibit large sharks at the Gulfarium, building a circular pool known as the Shark Moat, but providing a suitable habitat for the sea's most feared predators proved difficult from the start. Most sharks must swim constantly in order to breathe, meaning that a very large hammerhead, mako, or bull shark would require more space and current than the facility had available. However, some sharks, including nurse and lemon sharks, can pump water over their gills while lying stationary, and it was discovered early on that these sharks did well in the circular Shark Moat. Below, around 1997, a lemon shark with a large remora attached, two large nurse sharks swimming along the bottom, and an adult loggerhead sea turtle swim peacefully in the Shark Moat. (Above, courtesy of Gulfarium Marine Adventure Park; below, courtesy of Teri Horton.)

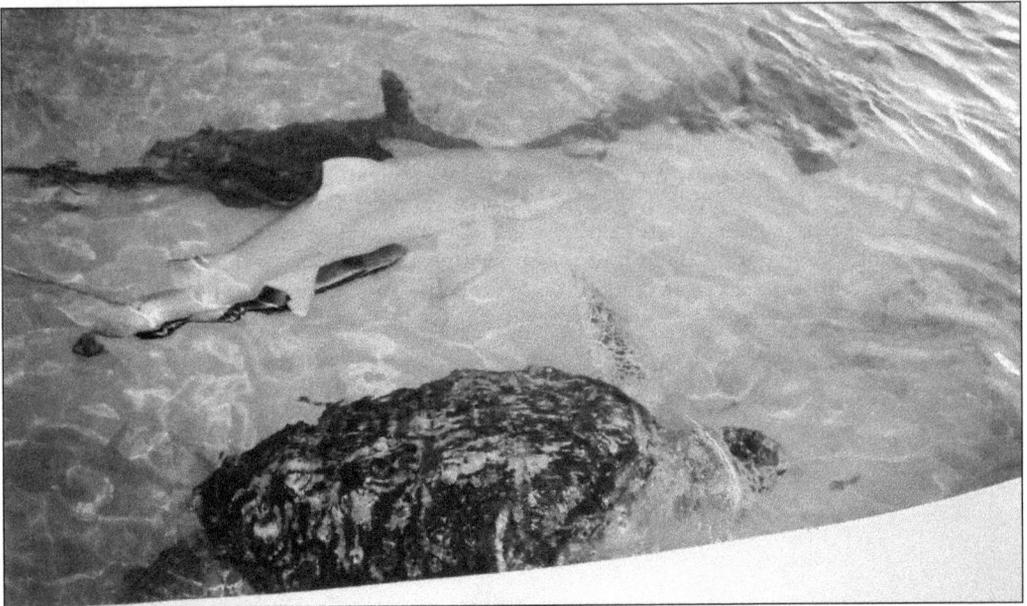

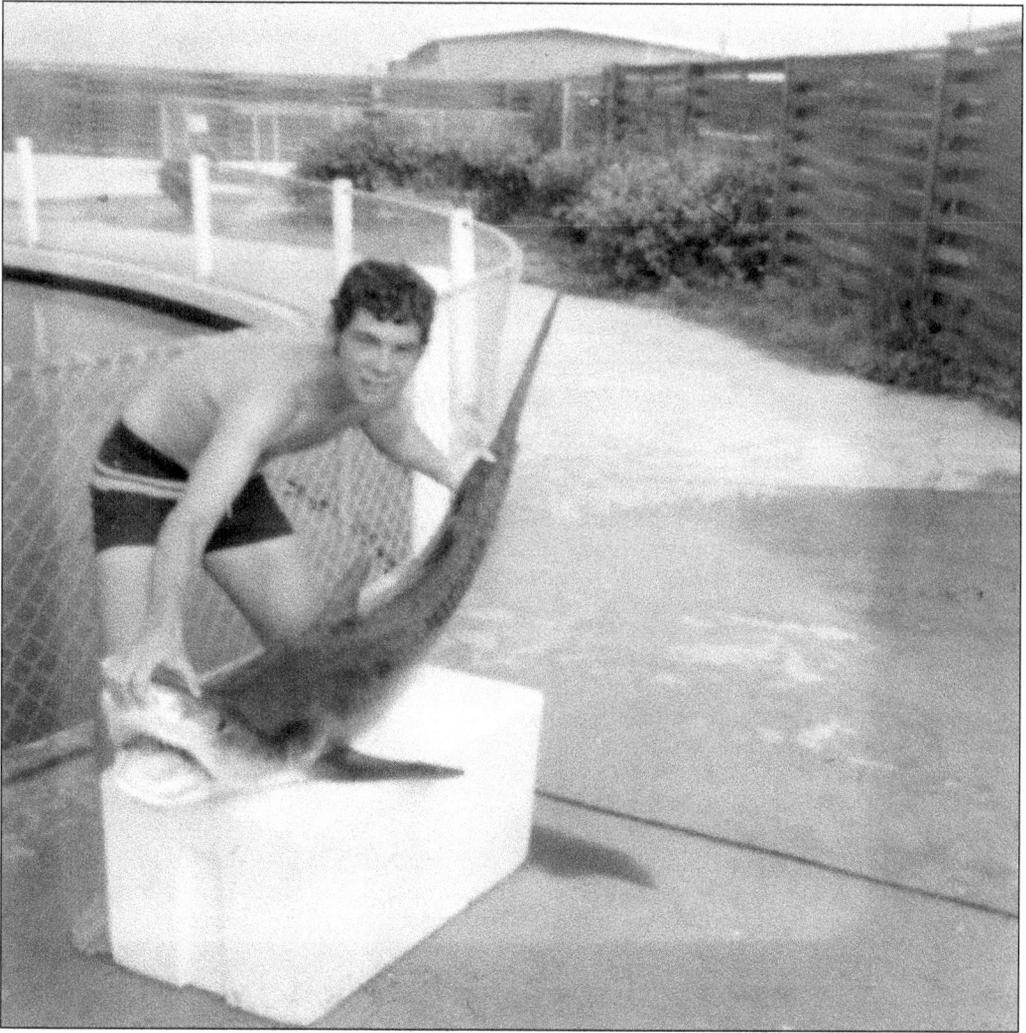

Gulfarium diver and specimen collector Doug Thompson displays the sharp teeth of a tiger shark next to the Shark Moat around 1971. When the Gulfarium's collection crew caught large sharks such as this, staff worked as quickly as possible to bring in the animal. The collection boat would pull right up to the Gulfarium beach while one crew member jumped ship, sloshing up to the beach yelling, "We got a shark!" In front of the astounded eyes of park visitors, the shark was then placed into a sling and loaded into a jeep for the short ride up to the Shark Moat. Some sharks, like this unfortunate tiger shark, did not make it, yet lemon sharks tended to do well in the Shark Moat. (Courtesy of Doug Thompson.)

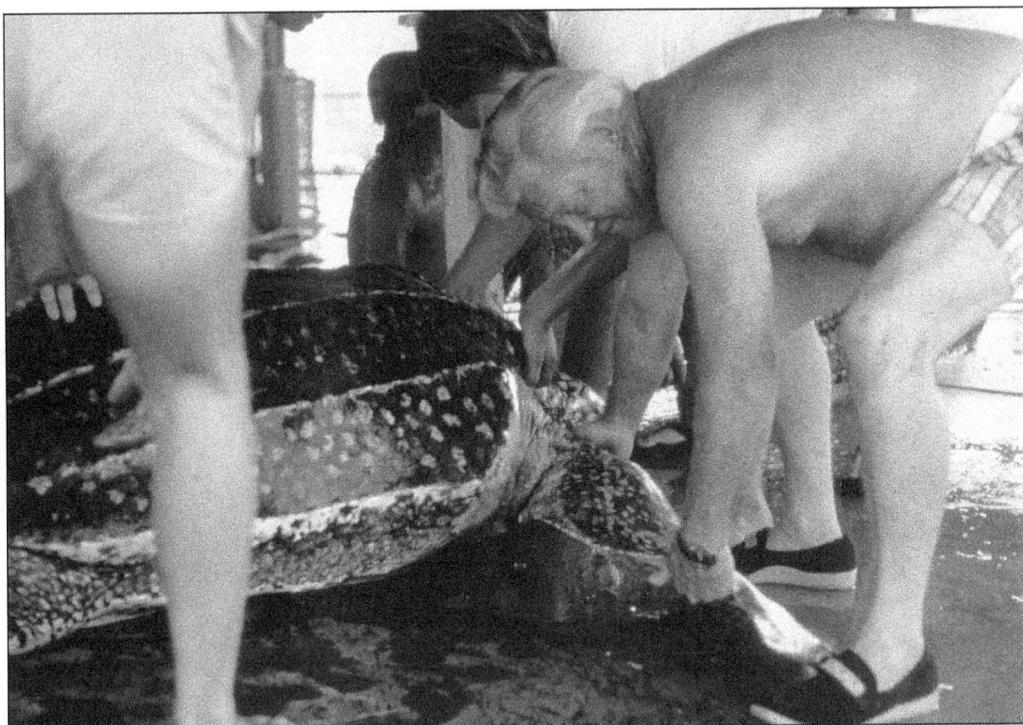

Brandy Siebenaler (above, right) and other unidentified crew lower a 1,300-pound leatherback sea turtle, injured by a boating survey crew, into the Shark Moat in 1977. Dewey Destin recalls the day he was asked to make the drive to the beach to collect the turtle. Pulling up in his pickup truck, Destin was shocked at the immense size of the leatherback but, with assistance, was able to load it in the back of the truck without an inch of room to spare. En route to the Gulfarium, Dewey heard familiar sounds of sirens, only to be pulled over by curious law enforcement. After a wisecrack or two ("Hey, how'd he get back there?"), Dewey pulled at the officer's heartstrings by describing the turtle's typical eye lubrication as "tears" in the eyes of the injured sea animal, resulting in a police escort the rest of the way back to the Gulfarium. (Both, courtesy of Gulfarium Marine Adventure Park.)

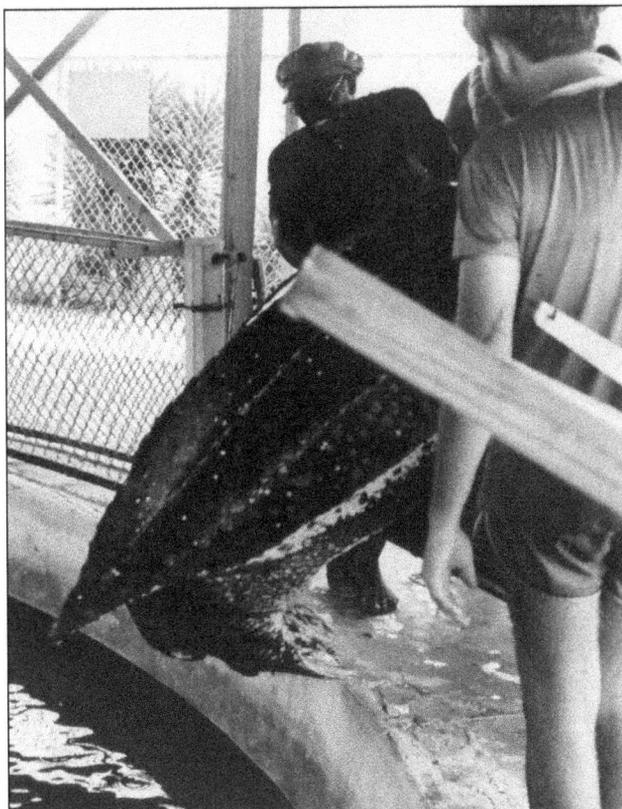

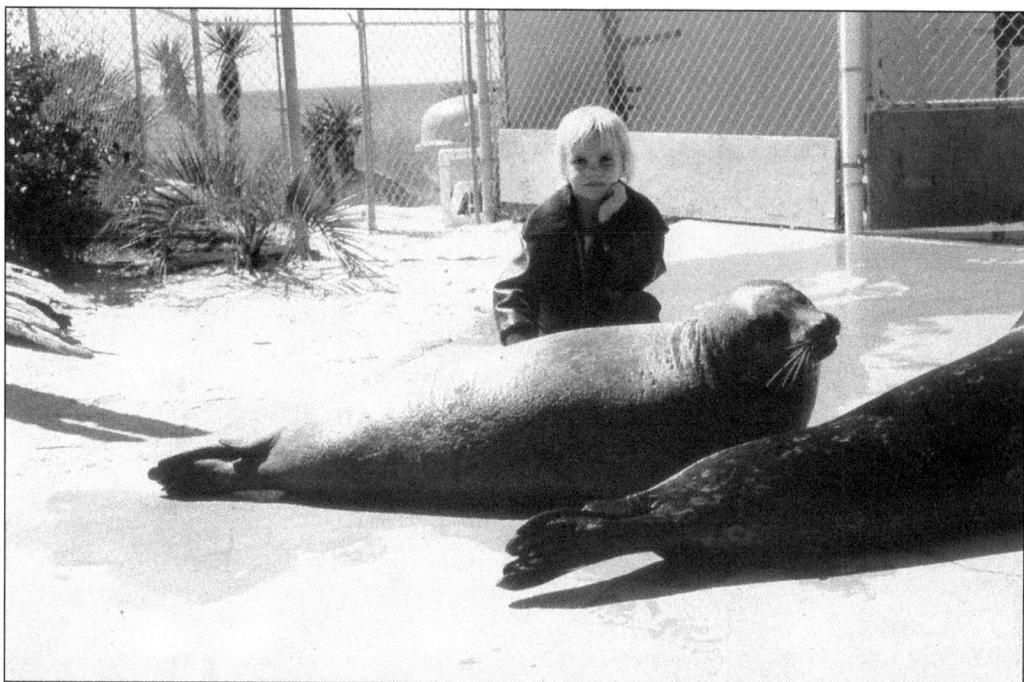

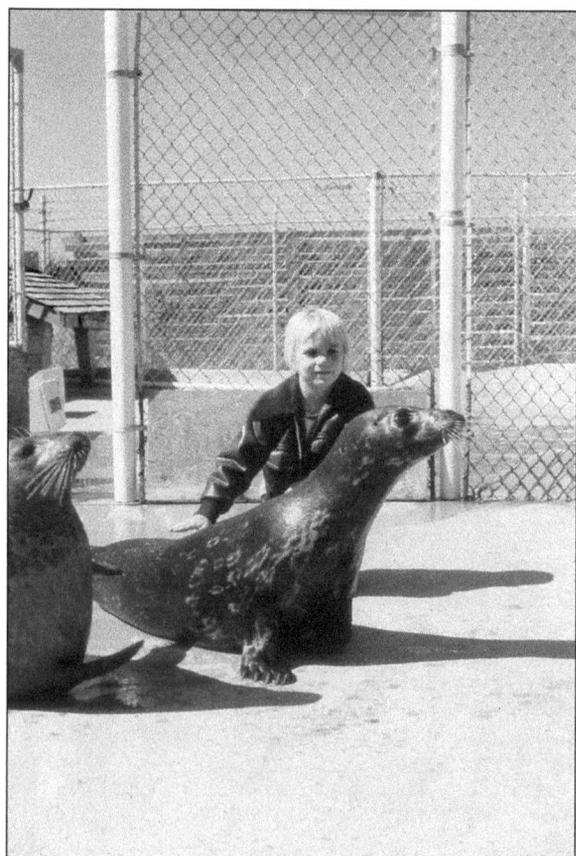

In 1973, the Gulfarium family grew to include a pair of harbor seals, the first of several over the years. Transported from the Marine Life Aquarium in Rapid City, South Dakota, Clyde (above) and Scooter (left), both pictured with an unidentified boy, adapted well and, at first, were simply display animals, trained for simple behaviors, such as waving a fin or retrieving rings. In 1974, trainer Doug Thompson asked for special permission from manager Brandy Siebenaler to begin a formal training program for Clyde and Scooter. Starting slowly, Thompson led the seals out of their habitat for brief periods, eventually working them up to remain stationary for an extended time while lines of schoolchildren came by for a touch. President Burney Henderson happened to see this one day and, while chuckling with delight, decided this was a great opportunity for extra revenue. Soon enough, a legacy of harbor seal interactions had begun at the Gulfarium. (Both, courtesy of Gulfarium Marine Adventure Park.)

Animal interactions continued over the years. In 1978, a visiting family meets a pair of adult harbor seals, led by trainer Frank Archuleta. Getting up close and personal with the animals of the Gulfarium has always been a fond memory of guests. (Courtesy of the State Archives of Florida.)

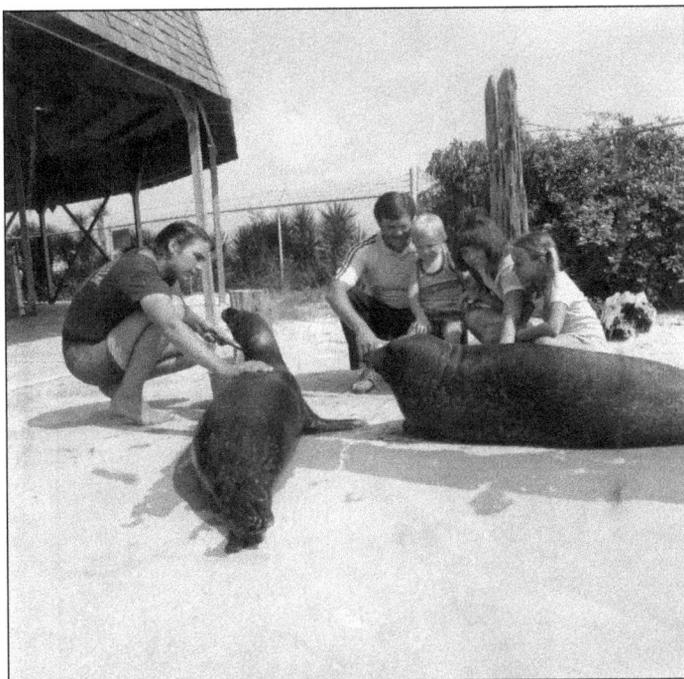

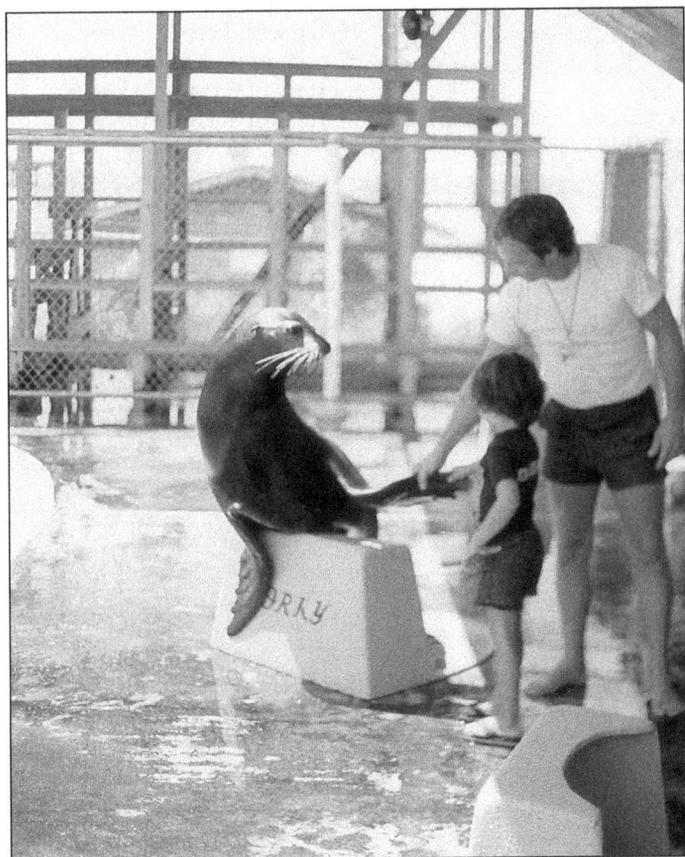

As a young boy in 1978, Derek DiDonato receives a handshake from Corky the sea lion, led by trainer Greg Siebenaler. DiDonato would later grow up to be Gulfarium's curator and life support technician, working with the animals that he loved and learned from as a child. (Courtesy of Phil DiDonato.)

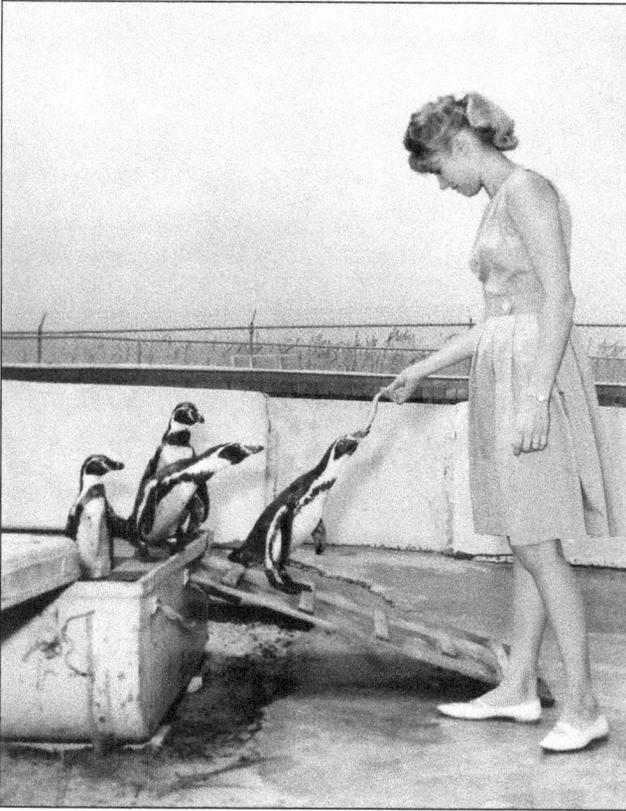

Of the many species exhibited at the Gulfarium over the years, many guests find themselves most surprised to see penguins living contentedly on the shore of the Gulf of Mexico. Humboldt penguins, seen at left with an unidentified guest feeder, were first exhibited at the park as early as the late 1960s, and to this day, the Gulfarium has maintained a successful breeding colony of African penguins. These relatively warm-climate species of penguin are adapted to water temperatures and weather similar to that of Florida's panhandle, making them a natural addition to the park. Below, a flock of African penguins walks nearly in step with keeper Doyle Horton around 1996. (Left, courtesy of Arturo; below, courtesy of Teri Horton.)

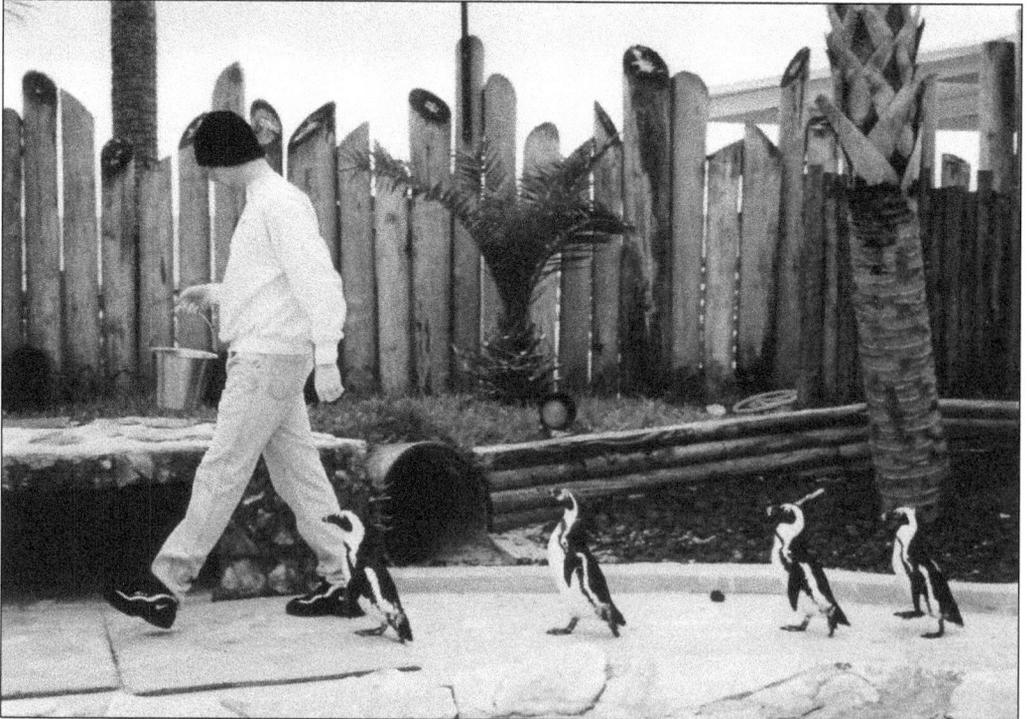

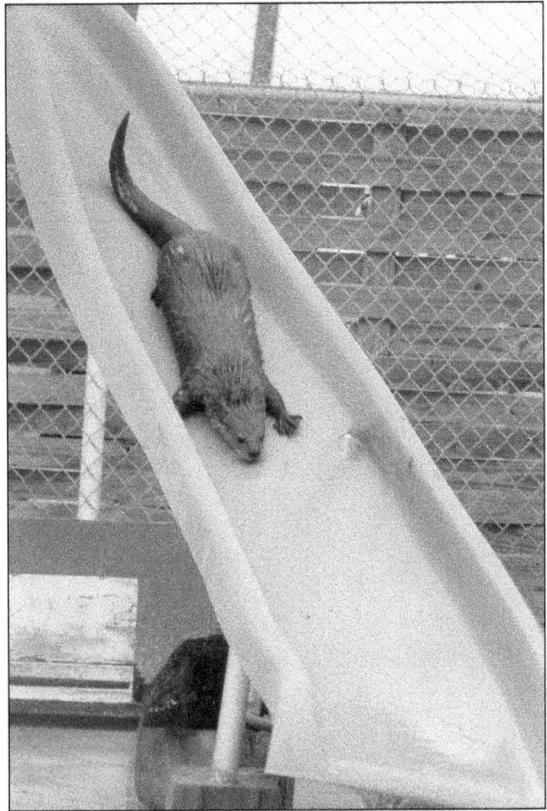

Otters, such as the North American river otters pictured at right in 1978 and below in the early 1990s, have been a staple at the park since Karen Siebenaler raised the first one by hand at the Siebenalers' home. Unlike the hand-raised otters featured today, these critters were originally caught locally in traps and thus largely maintained an unpleasant disposition, to say the least. Sinatra, Sable, Nasty, and Traveler, a group of otters in the early 1990s, were notorious for breaking out of their exhibit to wreak havoc around the park, even venturing as far as the neighboring hotel pool for a midnight swim. (Right, courtesy of Gulfarium Marine Adventure Park; below, courtesy of Teri Horton.)

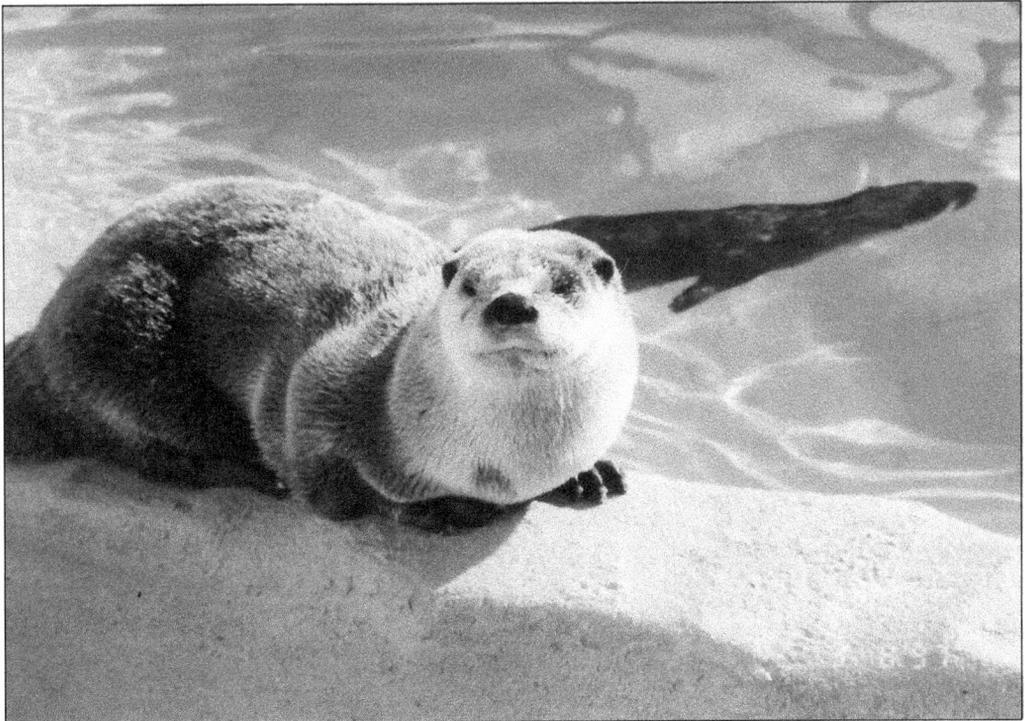

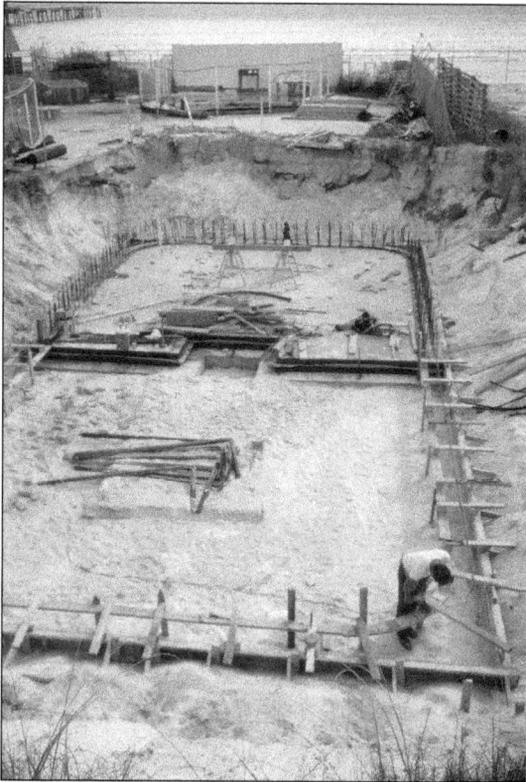

Expansion continued toward the west with the addition of the Multi-Species Pool in 1981. At left, wood framing is raised to create the pool walls with poured concrete. Below, the unusual construction process is evident as the two halves of the pool are erected independently, separated by a rubber gasket down the middle to allow for expansion. Known simply as "the new pool" in its early days, this habitat served a variety of purposes, including housing large stranded cetaceans and serving as a dolphin touch pool. The habitat is most well known for its long-running Multi-Species Show, featuring side-by-side performances of dolphins and sea lions. (Both, courtesy of Steve Shippee.)

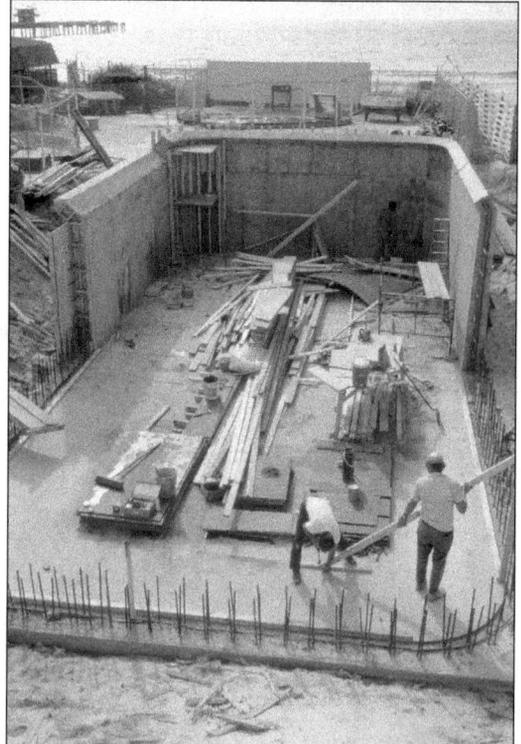

In keeping with the theme of the new Multi-Species Pool, Brandy Siebenaler brought in two Shetland ponies, Sugar (left) and Spice, with grand ideas of incorporating them into the show. While this act never came to fruition, the horses were provided care, mainly by Siebenaler's youngest son, Brandon. (Courtesy of Steve Shippee.)

The prevalence of alligators in Florida made these, exhibited as early as the mid-1960s, a natural addition to the Gulfarium. Trainer Terry Watkins recalls a gator by the name of Allie that could be turned upside down for a tranquil belly rub. Then, to impress onlookers, the keeper would slap the alligator's stomach and quickly jump out of the exhibit, narrowly escaping its snapping jaws. (Courtesy of Gulfarium Marine Adventure Park.)

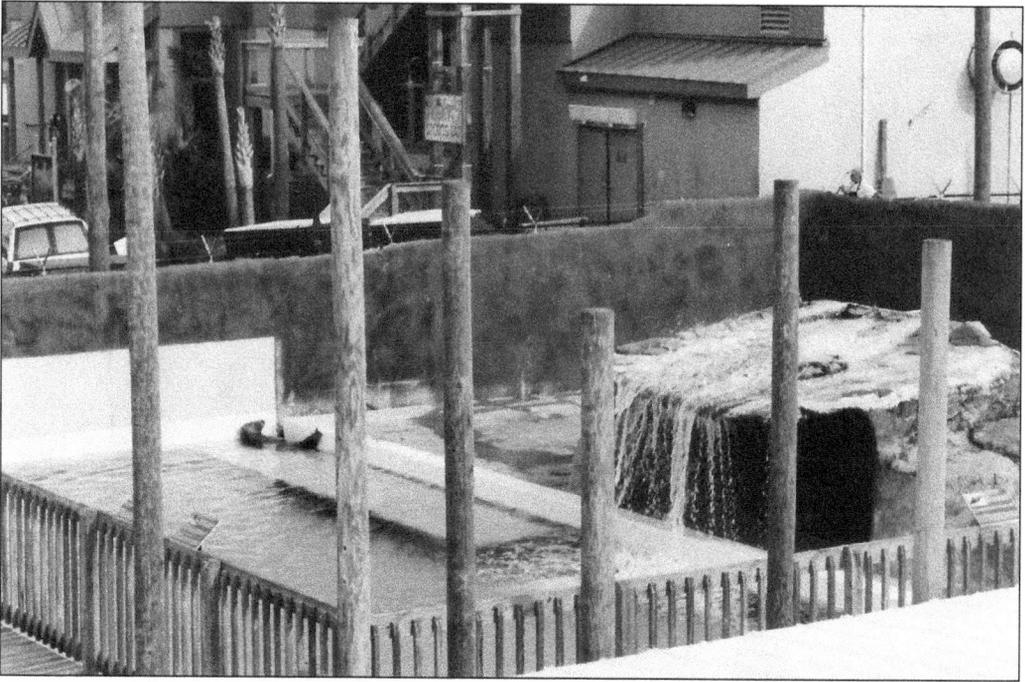

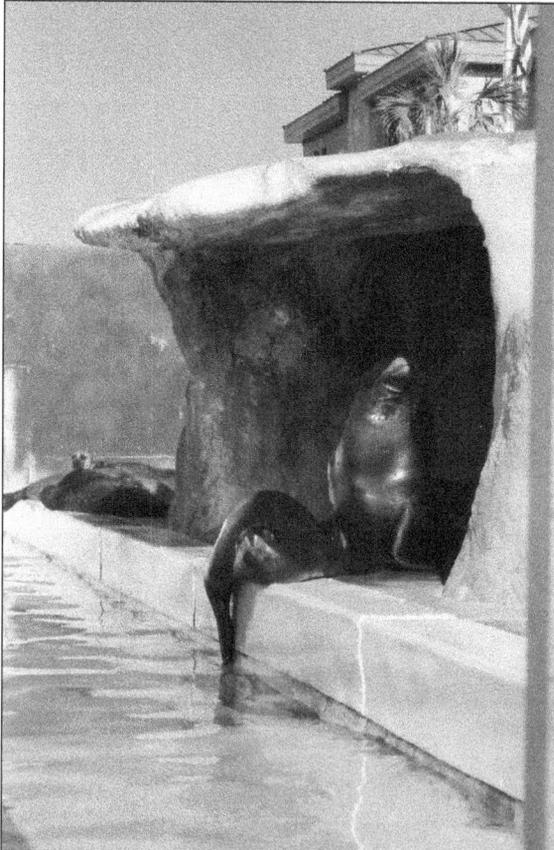

The sea lion rookery, pictured in 2001, shows the running waterfall and the large pool available to the Gulfarium's colony of California sea lions at the eastern edge of the park. Angler's Restaurant is seen in the background of each photograph. Diners and beachgoers using the neighboring parking lot heard an unexpected sound when the Pacific Coast native sea lions barked within view of the Gulf of Mexico. The sea lions were later moved to the west side of the park, into the Shoreline Theater and its network of habitats. The rookery's shallow pool became the home of Gulfarium's new stingray interaction programs. (Both, courtesy of Teri Horton.)

Four

SAVING THE SEA

With the facilities and expertise to transport, house, and care for the large marine animals at the Gulfarium, the park staff assumed the role of wildlife rescue and rehabilitation. From sea turtles to dolphins and even large baleen whales, authorities and concerned citizens called on the Gulfarium to assist whenever large marine animals were in peril.

Many times, law enforcement or the US Coast Guard would respond to a report of a stranded animal, only to arrive and discover that they had no way to so much as move the animal safely. The Gulfarium crew would then arrive with their specialized trucks or boats, an experienced team of staff members, and the equipment to assess and handle the animal.

In the early years, manta rays, dolphins, and sea turtles were transported to the Gulfarium for rehabilitation. Brandy Siebenaler and his primary expert on animal medicine, Dr. Winfield Brady, would learn as much as they could about the animal while trying to nurse it back to health. As they collected data over the years, they got better and better at bringing sick and injured animals back to health.

By the late 1970s, Dr. Forrest Townsend had become the Gulfarium's veterinarian, and he shared Brandy Siebenaler's passion for marine life. Dr. Townsend built his career around caring for the Gulfarium animals and advancing the veterinary community's understanding of marine mammals. With Dr. Townsend leading the Gulfarium's animal rescue and rehabilitation efforts, the park boasted successes such as freeing a Bryde's whale from a sandbar in Pensacola Bay and becoming the first facility to effectively raise an orphaned bottlenose dolphin through voluntary bottle feeding.

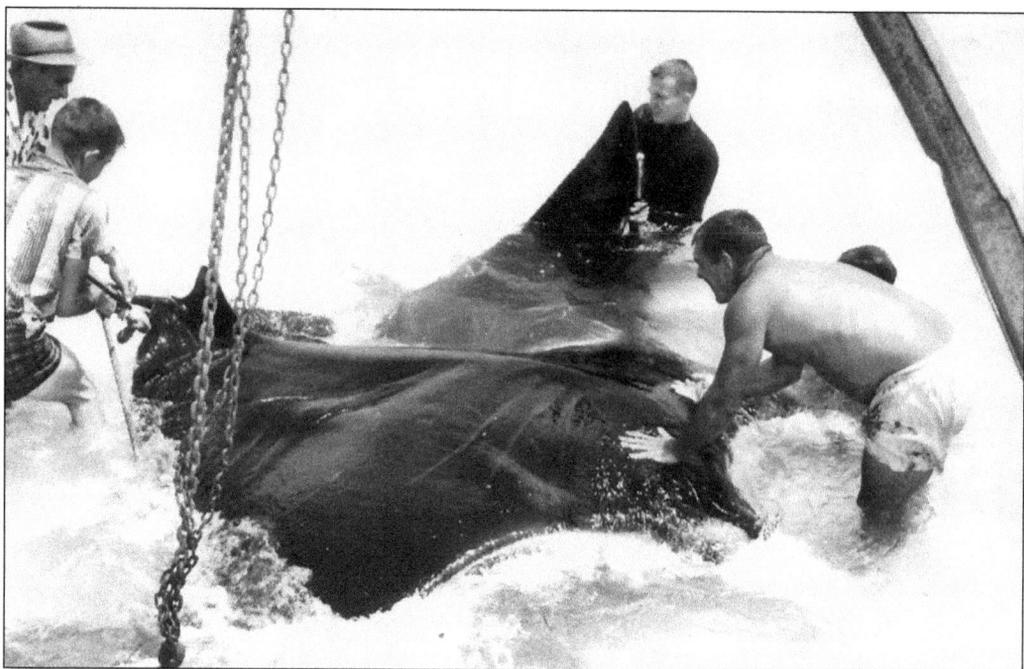

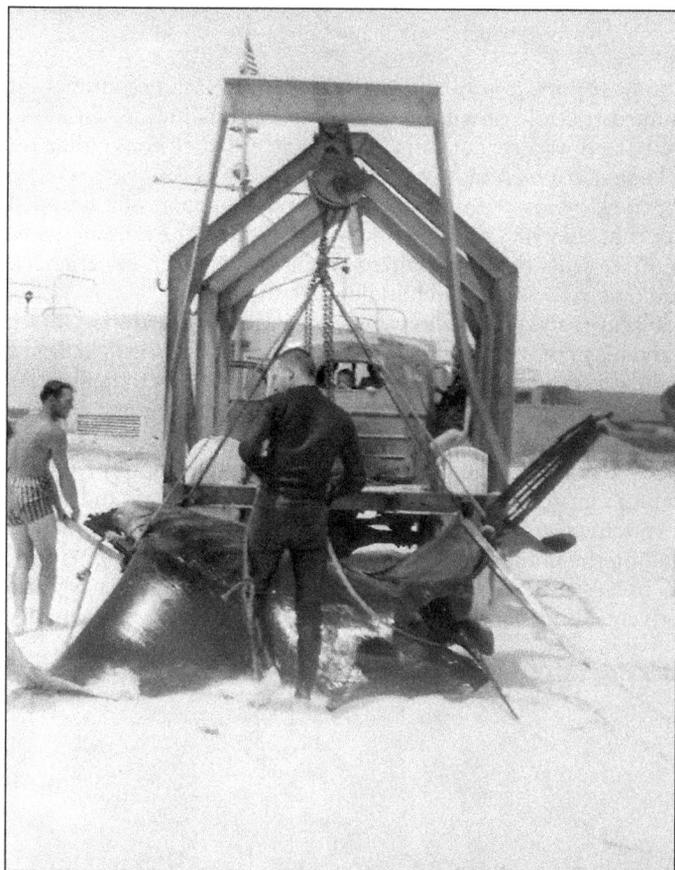

On July 4, 1959, Gulfarium biologist Dr. Winfield Brady received word that Capt. Dewey "Buck" Destin and crew were battling to capture a batlike monster in the East Pass of Destin. Identified as a manta ray, this creature was more popularly known as a devilfish due to the hornlike projections on either side of its mouth. Brady explained to the local newspaper that while manta rays were generally harmless, existing on a diet of microscopic plankton, they had been known to cause the death of deep-sea divers by rubbing against their air hoses in an effort to remove parasites. (Both, courtesy of Gulfarium Marine Adventure Park.)

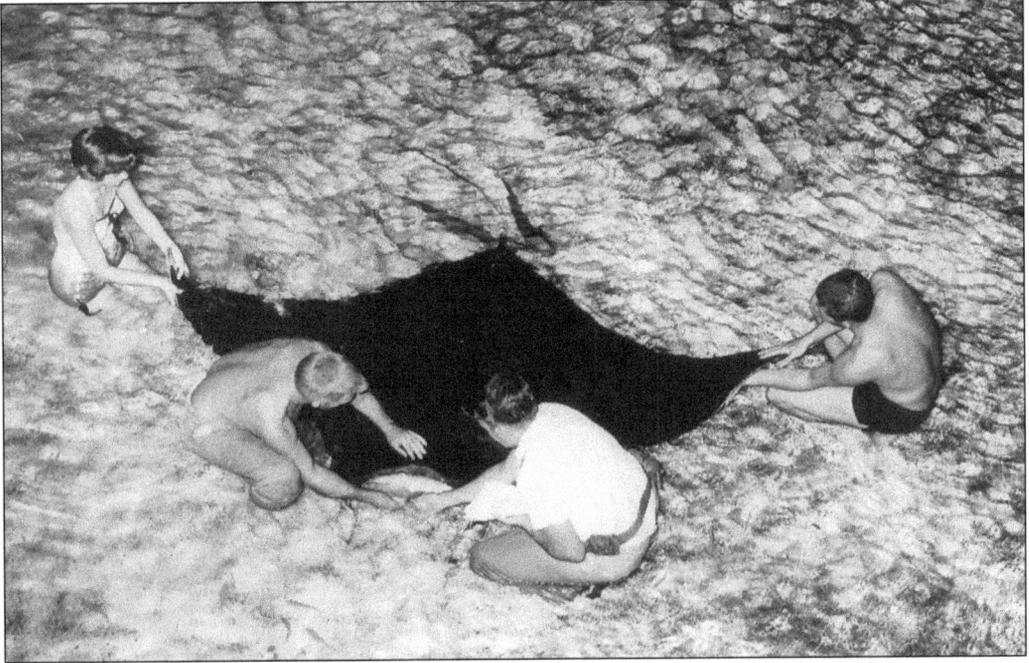

Buck Destin and his crew hurried the manta ray to the Gulfarium, where it was placed in the main tank using the mast boom and electric wench. The 1,000-pound animal immediately sank to the bottom and gave every indication that it was about to expire. But after a brief rest, the massive ray began circling the pool. Above, Gulfarium employees, including Marjorie Siebenaler (far left) and Brandy Siebenaler (second from right) attempt to feed and support the manta ray in the main tank. Below, the dedicated team is shown from eye level. (Both, courtesy of Arturo.)

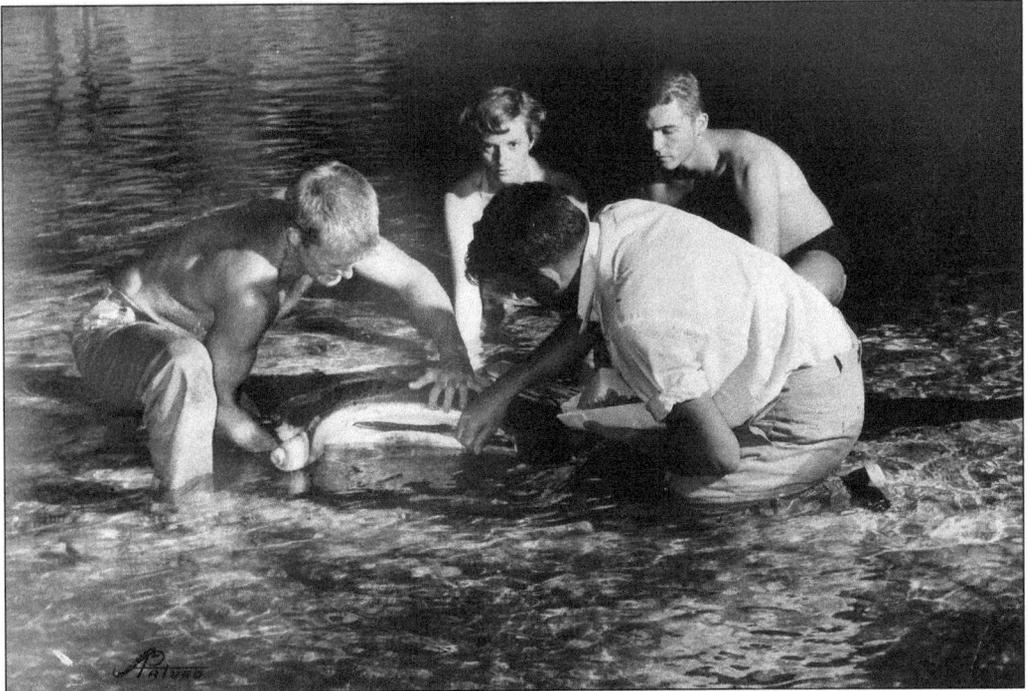

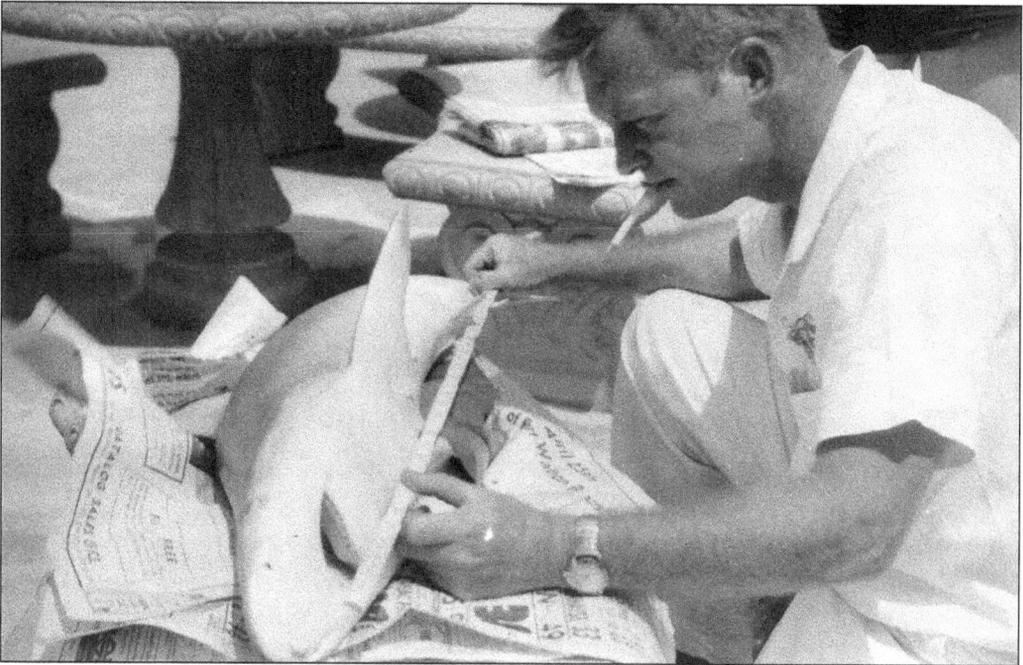

Above, on May 2, 1957, the Gulfarium collection crew netted 12 seemingly young sharks, each only about four feet long and 40 pounds. Placed in saltwater tubs for the short transport from Destin to the Gulfarium, the sharks were found deceased upon arrival. It was only when Brandy Siebenaler began performing an immediate post mortem on one of the sharks that he realized it was a mature specimen carrying several young. As shown below, Siebenaler delivered each shark pup via cesarean section, totaling 30 juveniles from the collection. He later determined they were blacknose sharks, a small species quite rare in the local waters. Although the shark pups lived for a total of only 36 hours, Siebenaler's operation proved significant to the knowledge of the species, as it was not previously known whether they carried their young in a yolk sac, which Siebenaler discovered to be the case. (Both, courtesy of Gulfarium Marine Adventure Park.)

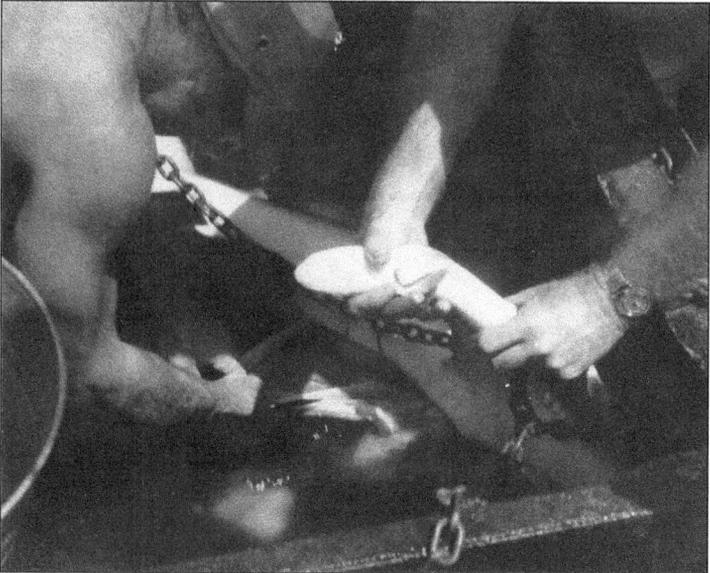

The Gulfarium can be seen in the distance of this 1960s Okaloosa Island photograph. With a lack of beach patrol at neighboring public recreational area Wayside Park, animals were not the only ones that needed rescuing. Water-savvy Gulfarium divers were often relied upon as lifeguards, racing over 100 yards into the Gulf of Mexico to save beachgoers from its strong undertow. In a June 1957 edition of the *Playground Daily News*, the Gulfarium's public relations manager Leonard Hutchinson reports, "Twice in the last ten days, Gulfarium crowds have heard the loudspeakers blare 'Divers report to the beach—rescue operation.' " He continues, "Gulfarium divers have saved about 20 lives and they . . . are risking a lot to render a service that, aside from the humanitarian angle, is no concern of theirs." Credit was given to Gulfarium divers Charles Emmett, Terrell Noyes, Howard Greenman, and Stearns Cofler for braving the rough current sans dive equipment. (Courtesy of the State Archives of Florida.)

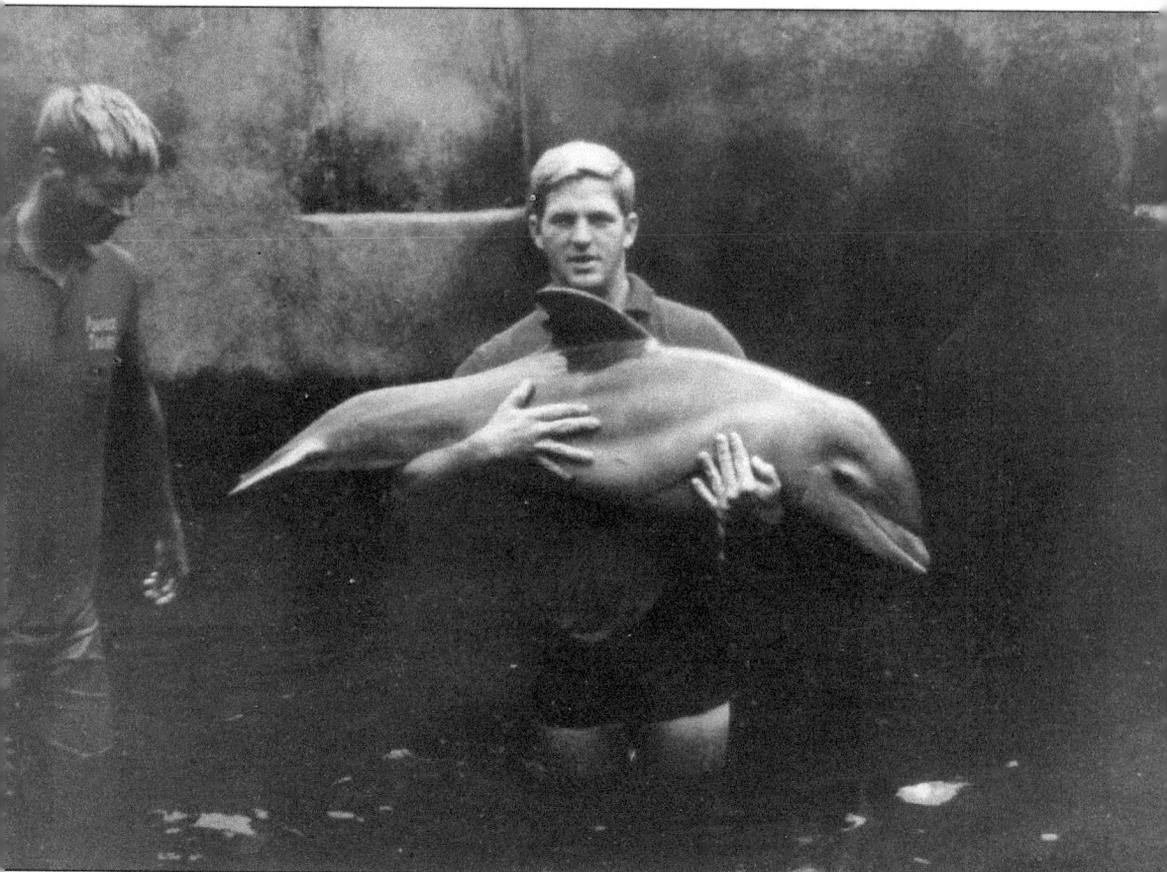

Trainer Terry Watkins holds dolphin calf Rocky during a feeding procedure in 1969. Rocky was a young calf brought to the Gulfarium by fisherman Buck Destin. Faint vertical stripes can be seen before and below Rocky's dorsal fin. These visible remnants of his fetal folds, formed by the way a dolphin fetus is tucked inside the mother's uterus, indicate his age at less than two months old. The Gulfarium staff created a formula containing nutrients a calf like Rocky would need, though he quickly began voluntarily eating fish. Rocky pulled through this fragile stage of life and went on to become the star performer at Marine Life Aquarium in Rapid City. (Courtesy of Terry Watkins.)

Above, from left to right, veterinarian Dr. Forrest Townsend, Lee Kellar, Brandy Siebenaler, and Dan Davies tend to a pygmy sperm whale in Siebenaler's backyard pool in 1978. Siebenaler often said the reason he bought a house in this particular bayou of Choctawhatchee Bay was that this was the area with the cleanest water. He pumped water directly from the bay into an aboveground pool and provided care for collected and stranded animals here for decades. Below, the same team attempts to support the whale with an inflatable raft. This pygmy sperm whale was the first of many marine mammal stranding cases to which Dr. Townsend would attend. (Both, courtesy of Lee Kellar.)

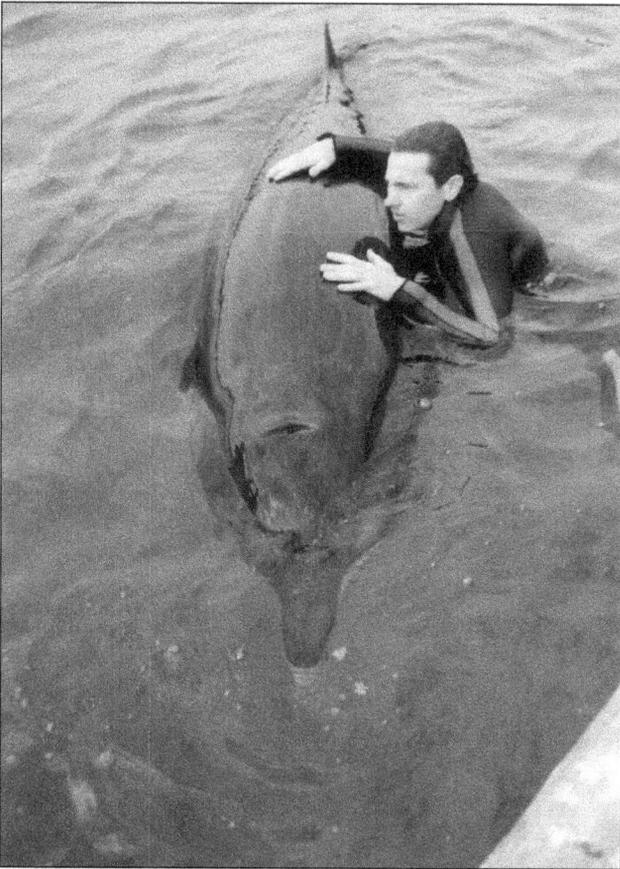

In 1982, this stranded Cuvier's beaked whale, Koko, was initially placed in the Shark Moat but was later moved to the recently constructed "new pool" due to its size, which can be assessed here using the trainer for scale. Below, trainers prepare the beaked whale for tube feeding using a garden hose. The solitary beaked whales, a family of toothed cetaceans separate from dolphins and porpoises, are among the rarest and most unknown animals in the sea. Some of these illusive species are only known from beached specimens. (Both, courtesy of Gulfarium Marine Adventure Park.)

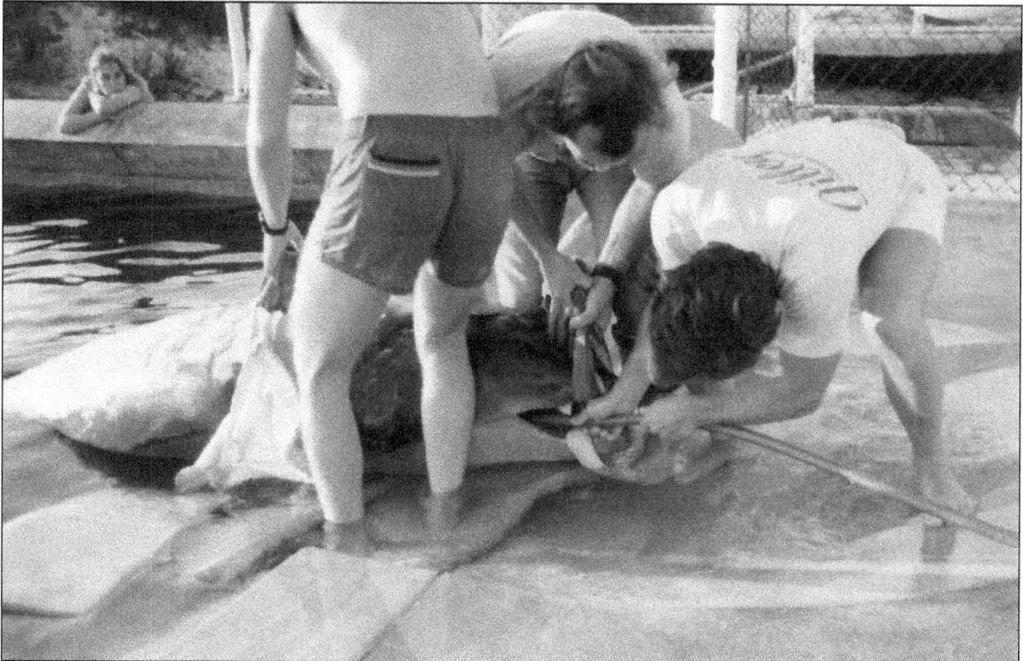

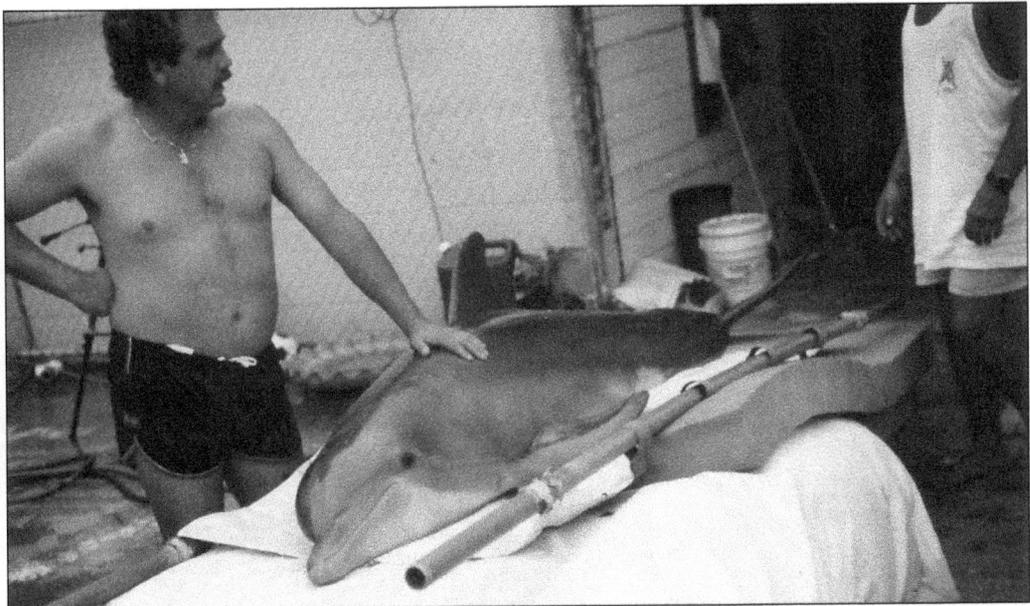

Above, George Gray stands with a stretchered dolphin that swallowed a deflated football. As a testament to the dedication that Gulfarium trainers exhibited toward the care of the park's animals, Ron Bradford (pictured below) retrieves the swallowed item from the dolphin's first stomach. Dolphins lack a gag reflex, so passing a tube or even an arm down a dolphin's throat is entirely possible and can be done with little to no stress to the animal. Bradford had learned the technique while working at the Gulfarium but received the call to assist in this procedure in 1982, three years after his career had led him away from the Gulfarium, because he had the skill as well as the long arms required to successfully remove a swallowed object. Bradford managed to remove the deflated football, and the dolphin quickly recovered. (Both, courtesy of Ron Bradford.)

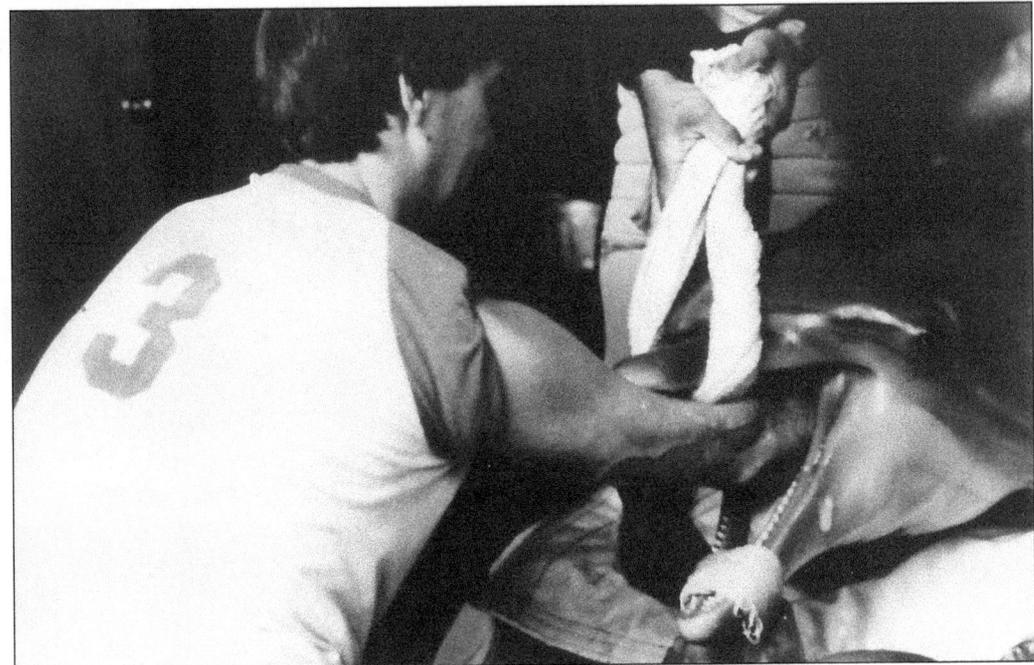

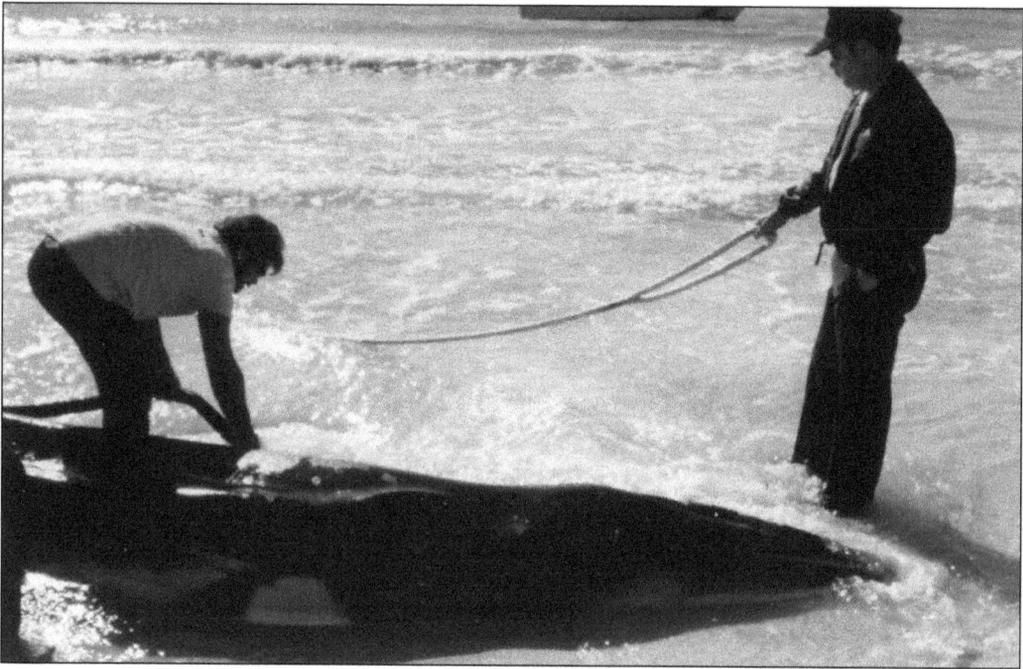

Gulfarium staff and US Coast Guard personnel assess a stranded minke whale on Navarre Beach in November 1983. Above, a sliver of a Coast Guard vessel can be seen at the top of the photograph. The Gulfarium often coordinates with local authorities when working to save stranded marine mammals, which are federally protected under the Marine Mammal Protection Act. In another case involving a baleen whale, Gulfarium trainers and veterinarians worked with the Florida Marine Patrol and the US Coast Guard to free a large Bryde's whale stranded on a sandbar in Pensacola Bay. The Coast Guard fabricated a towing harness for the animal from sturdy straps used to hoist heavy vessels. Once pulled from the sandbar, the whale immediately swam to the safety of the open Gulf of Mexico. (Courtesy of Dr. Forrest Townsend.)

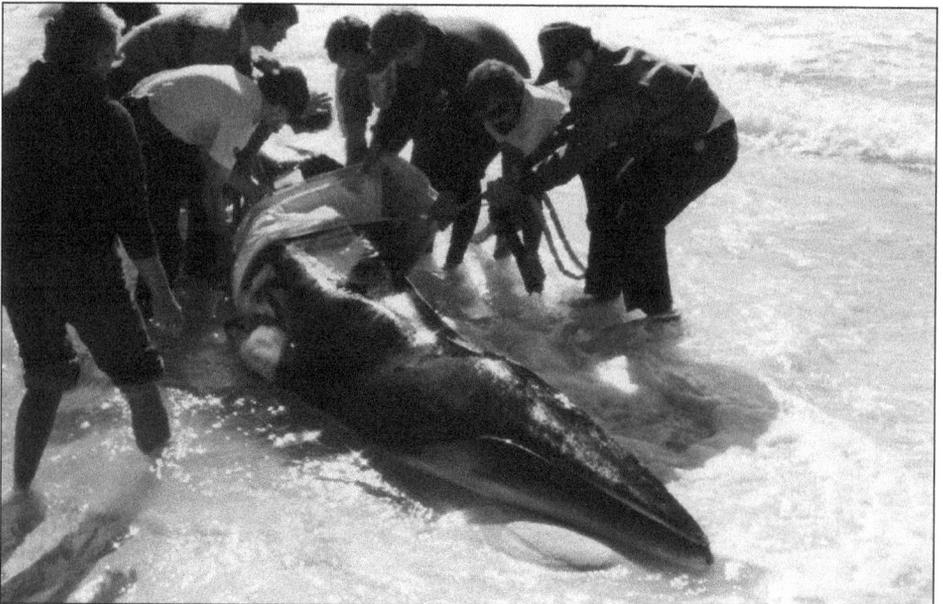

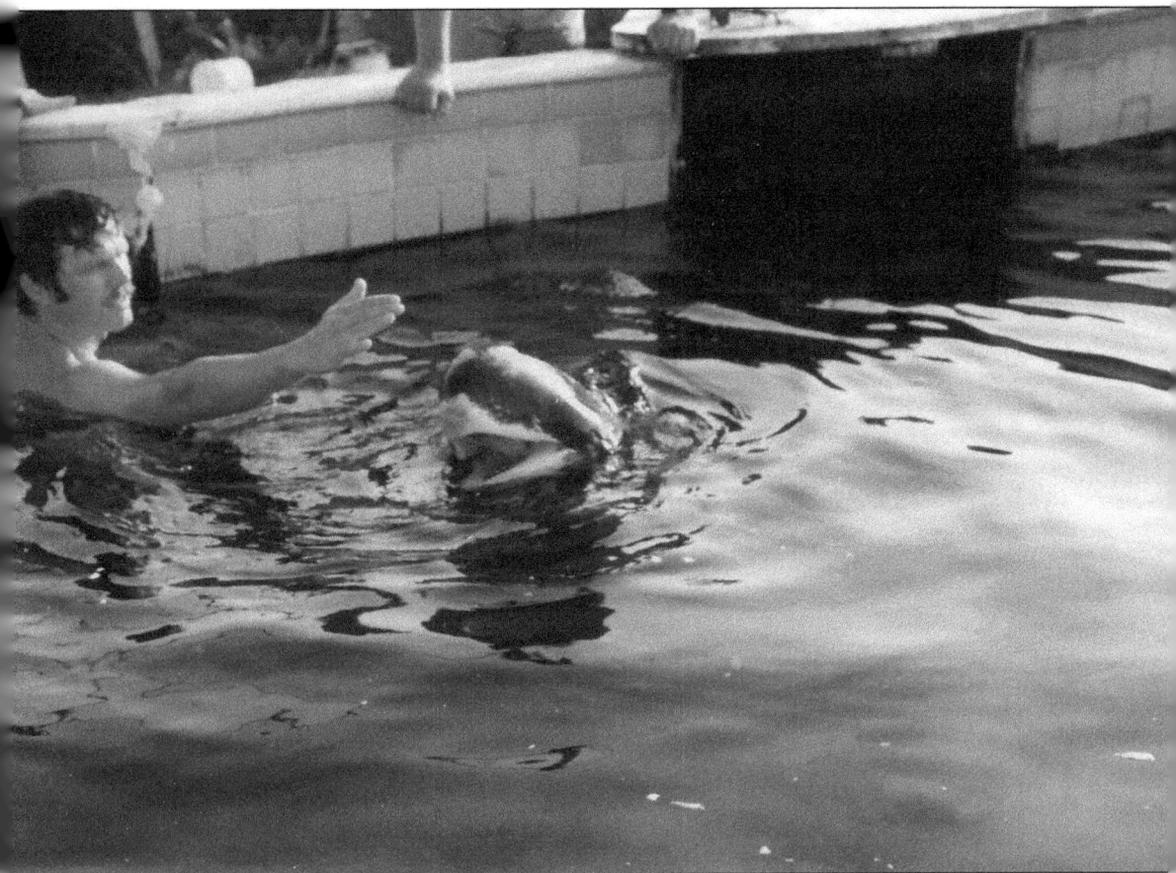

Dr. Forrest Townsend feeds an eight-foot, 350-pound pygmy killer whale in a pool at the Gulfarium in September 1983. This rarely sighted cetacean species had been stranded on Santa Rosa Island near Fort Pickens at the entrance to Pensacola Bay, and the Gulfarium sprang into action to rescue it. Unfortunately, this animal did not survive beyond a few days, but valuable data was collected. Marine mammals commonly beach themselves when they are near death due to injury or illness, and the best that veterinarians can do is learn as much as possible from them. Later, knowledge gleaned from the data may help save the life of another stranded cetacean at the Gulfarium or other marine facility. (Courtesy of Dr. Forrest Townsend.)

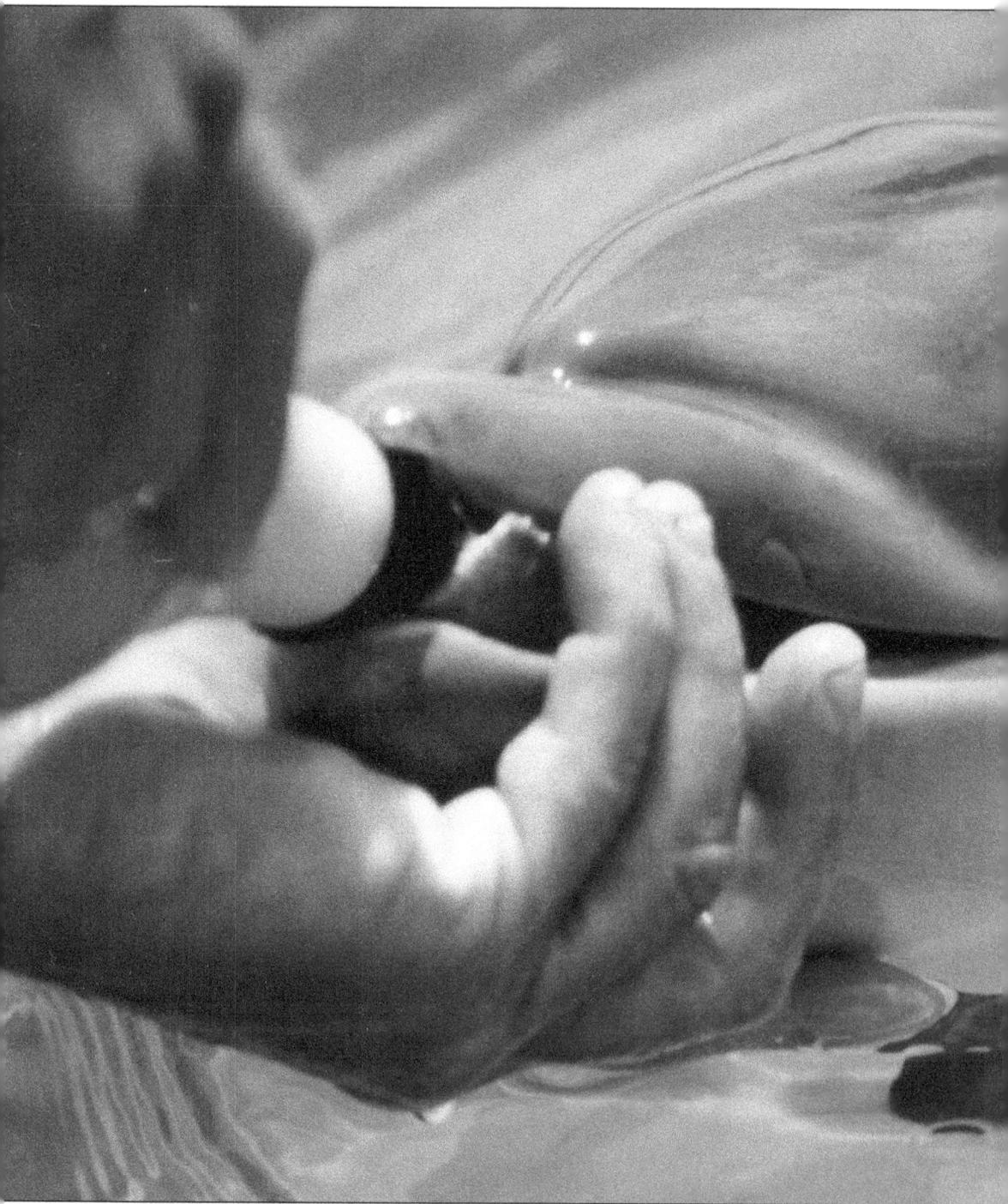

April, an orphaned Atlantic bottlenose dolphin, takes her meal from a bottle in 1992. April was a major success story in the Gulfarium's history because she was the first dolphin ever successfully raised by bottle feeding. Through trial and error, trainers and veterinarian Dr. Townsend discovered that this bottle made for lambs was the perfect size for April. Another challenge was creating a suitable formula. Dr. Townsend worked with the staff at Point Defiance

Zoo in Tacoma, Washington, to fine-tune the formula they had used to raise an orphaned harbor porpoise. However, the harbor porpoise was tube fed, and the goal of the Gulfarium was to allow April to suckle voluntarily from a bottle. Trainers thickened the original formula until April would drink it readily, yielding a fishy milk formula so rich that it looked more like a milk shake. (Courtesy of Dr. Forrest Townsend.)

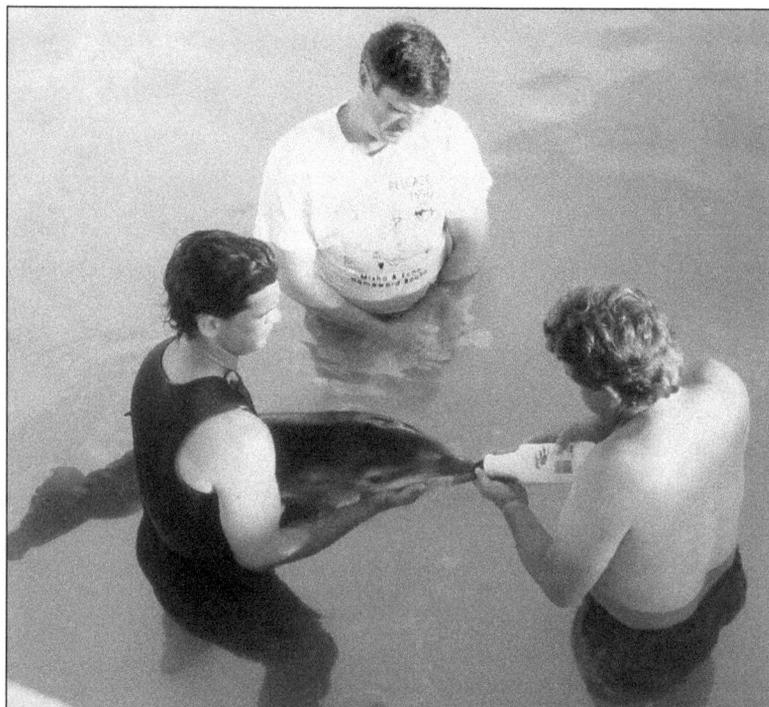

From left to right, Brian Blake, Dr. Forrest Townsend, and George Gray feed April in waist-deep water. For convenience, April's schedule was first set to include feedings only during daylight hours. Following significant weight loss, the team began round-the-clock feedings every one to two hours, along with daily weigh-ins. April soon began to gain weight, her success heavily attributed to this modification. (Courtesy of Dr. Forrest Townsend.)

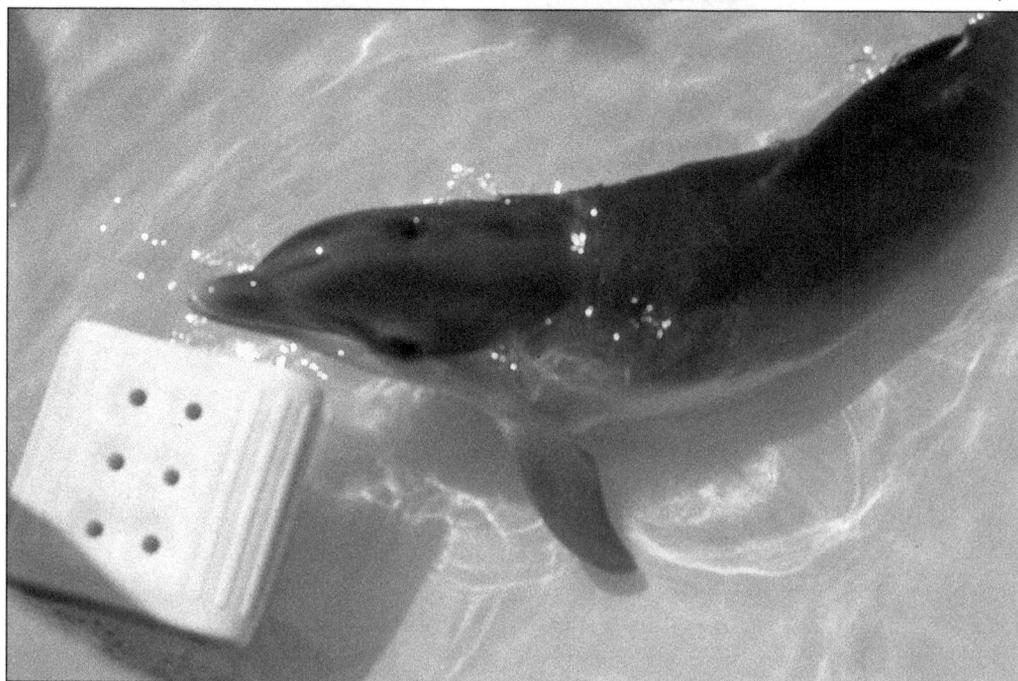

As April grew, so did her curiosity and desire for play and attention. Besides tactile rubs from trainers, her favorite object was a white boat buoy, with which she often preferred to play even during scheduled feeding times. April's trainers swayed from the traditional theory that food is the primary reinforcement for dolphins and instead treated eating as a behavior that April needed to perform in order to receive her reinforcement, the buoy. (Courtesy of Dr. Forrest Townsend.)

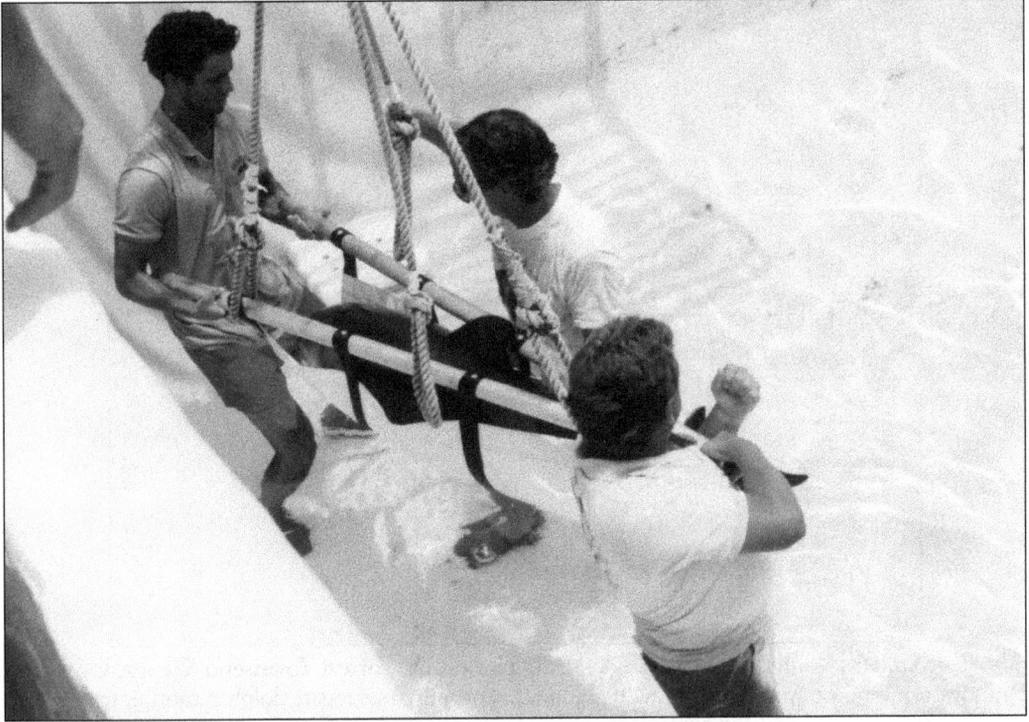

From left to right, trainers Billy Hurley, Greg Siebenaler, and George Gray stretcher April to record her weight. The Gulfarium's mission to successfully raise the orphaned dolphin from nursing age was unprecedented in the field of marine mammal husbandry, so veterinarian Dr. Townsend ordered blood samples, weight readings, and other observations to be logged at regular intervals to learn valuable lessons that would make it possible to save other orphaned dolphins. (Courtesy of Dr. Forrest Townsend.)

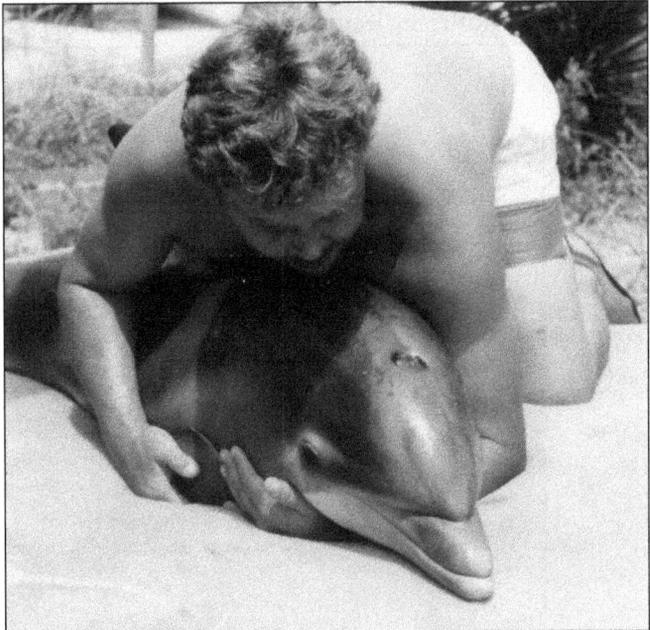

George Gray holds April on a soft closed-cell foam mat. Gray's passion for rehabilitating sick, injured, and orphaned marine mammals like April inspired him to found the Emerald Coast Wildlife Refuge. "I wanted to make sure that we always had a place for these animals to go when they needed us," said Gray. The nonprofit group continues to save marine mammals, sea turtles, and native and migratory birds. (Courtesy of Dr. Forrest Townsend.)

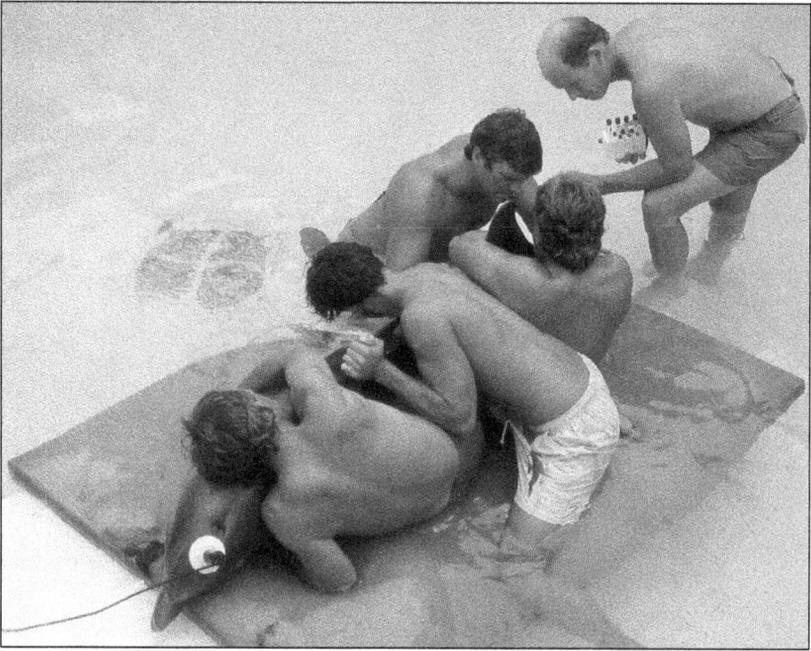

Above, from left to right, Greg Siebenaler, Billy Hurley, Dr. Forrest Townsend, George Gray, and Paul Bratton support April while drawing blood. Eventually, a surrogate dolphin mother was moved into the pool with April for companionship, despite concerns that a surrogate would distract April from her feeds, but Cindy, an older female, gave April the space she needed to continue eating from trainers. Brandy Siebenaler seized this unusual opportunity to contribute to current research on signature whistles, evidenced by the hydrophone sensors attached to April (above) and Cindy (below). While it was already known that wild female dolphin calves typically develop a signature whistle that differs greatly from their mother's, the questions as to whether it was learned or innate remained. Because April developed a signature whistle like Cindy's, researchers inferred the whistles are learned. (Both, courtesy of Dr. Forrest Townsend.)

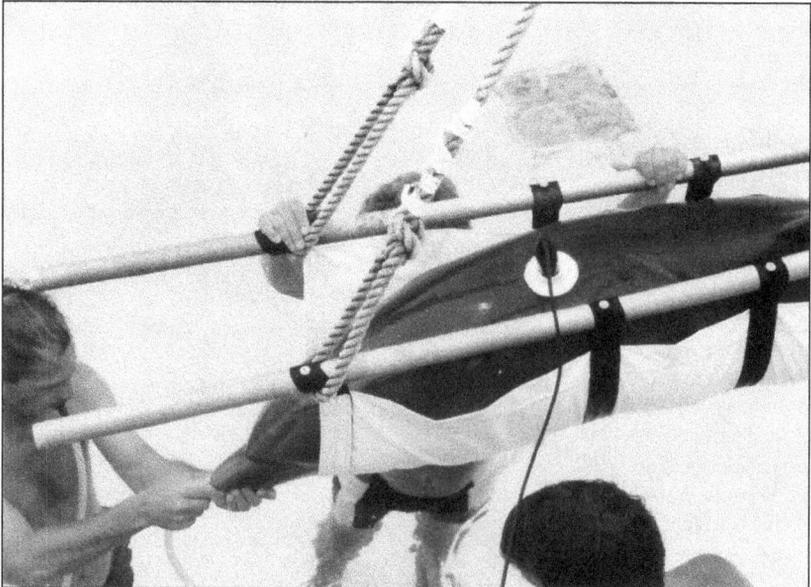

On September 5, 1993, five pantropical spotted dolphins, a species rarely seen near shore, repeatedly stranded themselves on a Pensacola beach despite the efforts of beachgoers to push them back to deeper water. Three of the dolphins died en route as Gulfarium employees transported the group to a quarantine area in the Santa Rosa Sound, leaving Kiwi, a now orphaned two-month-old calf, and Mango, an adult female. Staffers, along with dozens of volunteers, began round-the-clock care for the two sick dolphins, administering antibiotics and fluids. Five days after stranding, Mango sadly succumbed to her illness, and all focus turned to Kiwi. Pictured here during the first week of care, 28-pound Kiwi receives 12 ounces of specially made formula via a stomach tube administered by Gulfarium trainer Billy Hurley (front left), with the assistance of several volunteers, including Stephanie King Davidson (second from left). Hurley recalls wading out into the lagoon every hour and a half to collect Kiwi—a difficult task, particularly in the dark nighttime hours. (Above, courtesy of Billy Hurley; below, courtesy of Dr. Forrest Townsend.)

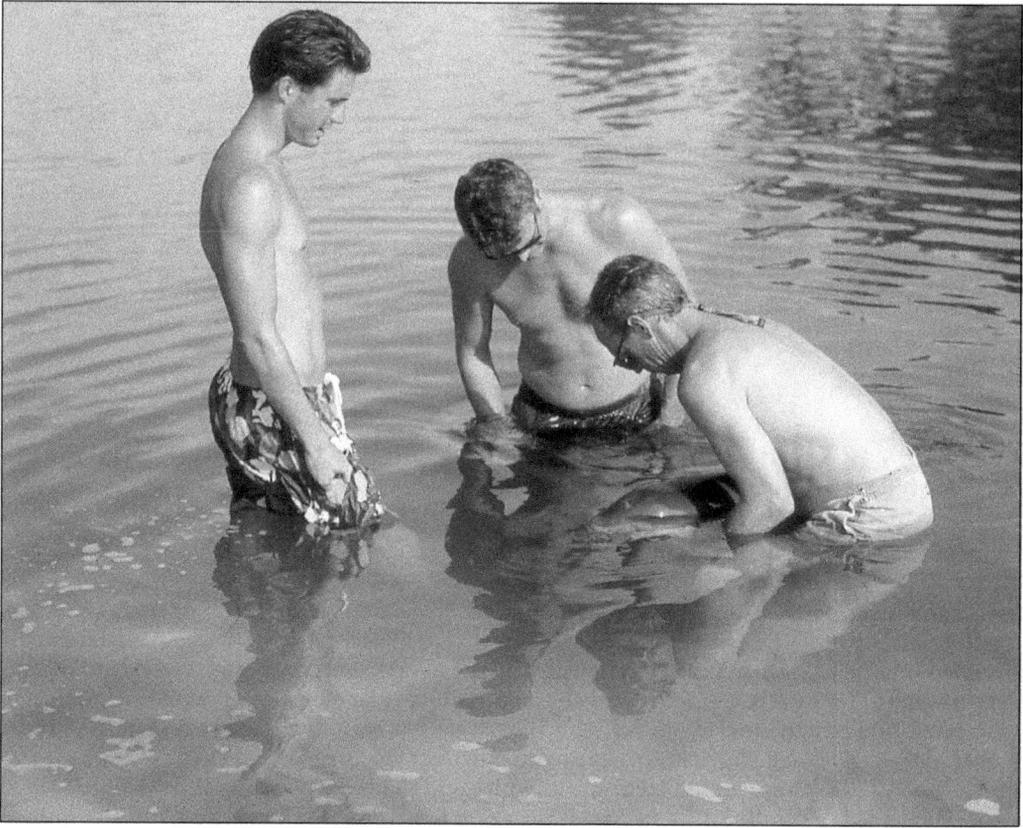

Following her stranding, Kiwi lived in an enclosed pen behind a laboratory of the Environmental Protection Agency, where she remained under constant observation of staff and volunteers from the Gulfarium and the Marine Mammal Stranding Network. Above, Greg Siebenaler lifts the neonate dolphin as Dr. Forrest Townsend performs a visual examination, assisted by trainer Billy Hurley. At left, Hurley stands on a scale, cradling Kiwi to obtain her weight. Other regularly performed procedures included blood draws, sampling from the stomach and blowhole, and measurements of Kiwi's length and girth. Additionally, in preparation for a possible move to the Gulfarium, Kiwi was conditioned to spend time in a water-filled transport box for short durations. (Both, courtesy of Dr. Forrest Townsend.)

Water temperatures plunged from 70 to 55 degrees Fahrenheit during an October cold spell. The decision was made to move Kiwi as soon as possible from her bayside lagoon to a heated pool at the Gulfarium. On October 31, 1994, nearly two months after her initial stranding, George Gray lifts Kiwi and walks the short distance to the transport vehicle, placing her securely in a transfer box. (Courtesy of Dr. Forrest Townsend.)

At the Gulfarium, Kiwi was placed in the College pool, with the water level lowered for easy accessibility. While in quarantine, Kiwi remained on her own until blood tests concluded it was safe for her to interact with others. Gulfarium staff began the process of teaching Kiwi, shown at five months, to eat solid food and wean off her formula. (Courtesy of Teri Horton.)

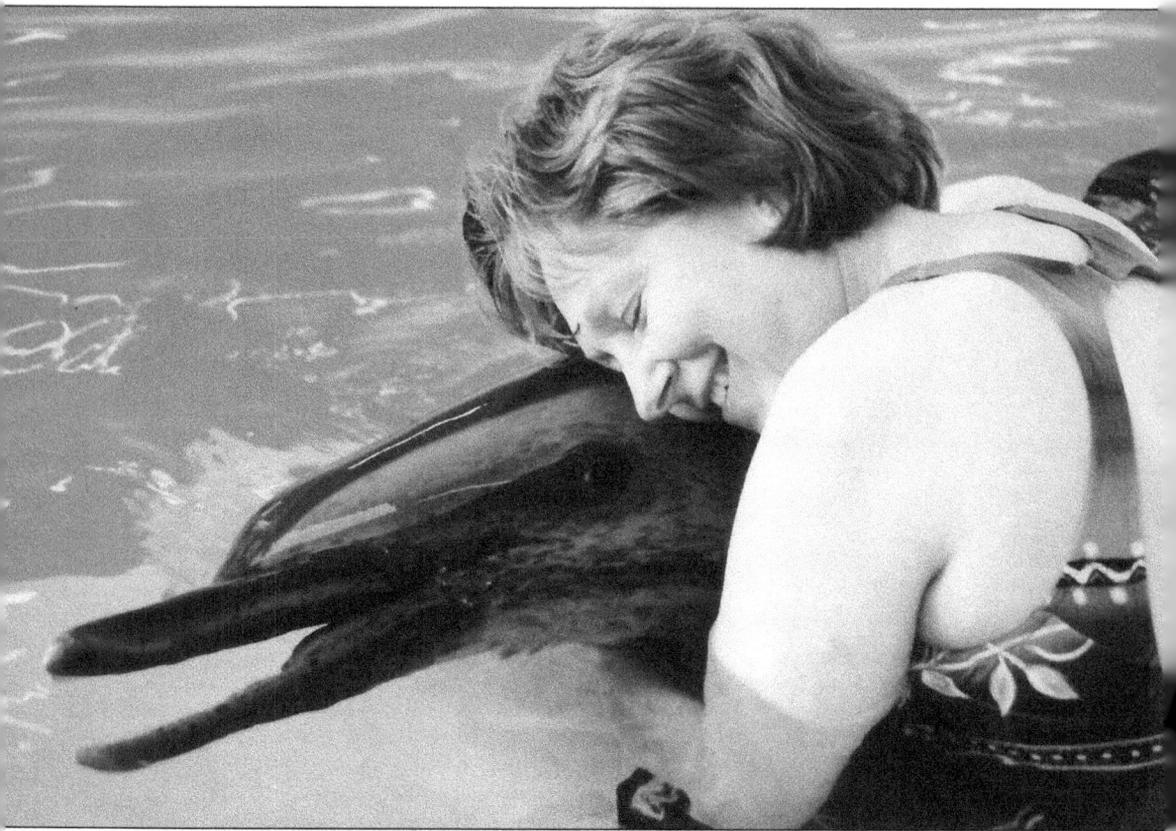

Not only was rescued pantropical spotted dolphin Kiwi loved by the people who cared for her, but she also exhibited a touching fondness for the humans in her life. Here, Teri Horton embraces a rehabilitated and healthy Kiwi; the two of them shared countless moments like this. According to Teri, "She would swim right into my lap and just lay there for a long time." Kiwi was no stranger to human contact by this time, having been held at the surface to breathe and moved several times since she was discovered emaciated and near death. What touched trainers and volunteers was the way she continued to initiate this close contact long after her health status no longer necessitated it. (Courtesy of Teri Horton.)

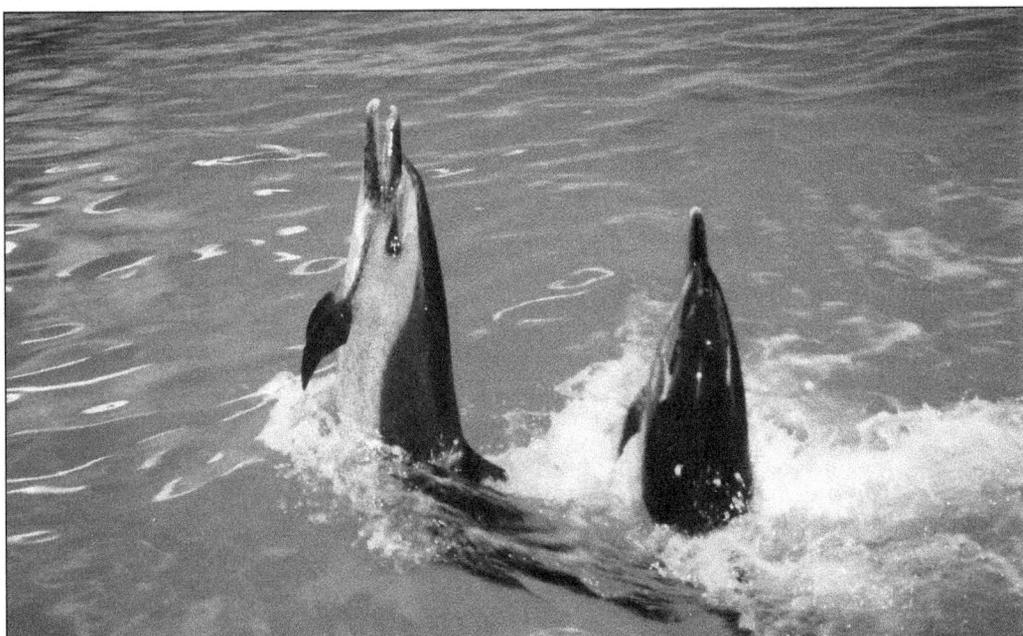

In the summer of 1998, another stranded pantropical spotted dolphin, Daphne, was found in Panama City Beach, and, following treatment for a lung infection, quickly became a companion for Kiwi. Pictured here performing tandem forward tail walks, Kiwi (left) and Daphne became the stars of Gulfarium's dolphin-assisted therapy programs. The two rehabilitated dolphins were naturals for this type of program, as they thrived on interacting with humans. (Courtesy of Teri Horton.)

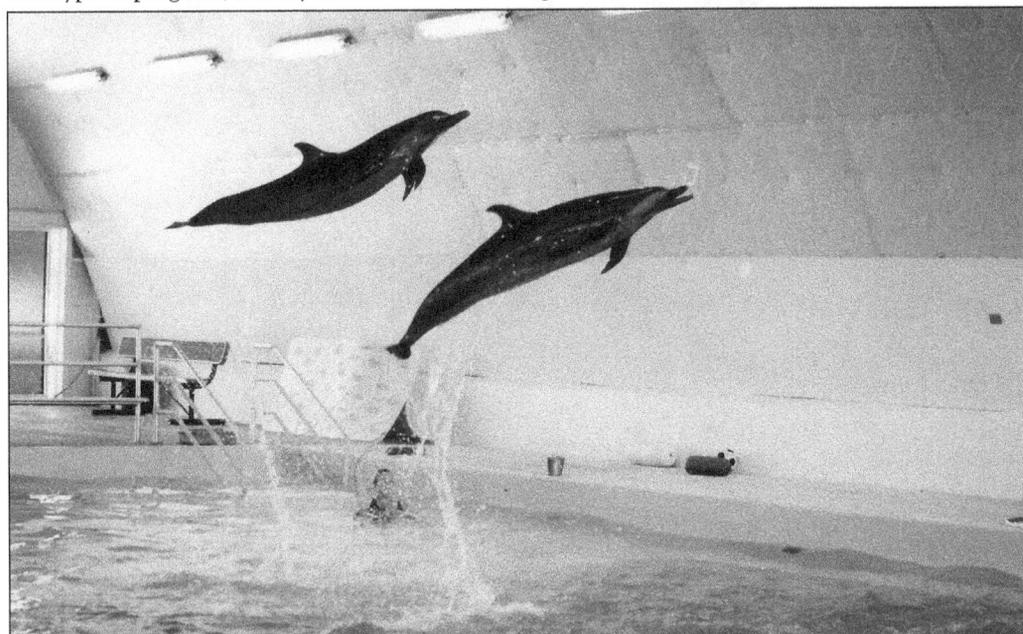

Dolphins Kiwi (left) and Daphne leap into the air on cue as trainer Stacy DiDonato looks on from below. This covered habitat was where guests entered the water to interact with Kiwi and Daphne. The two pantropical spotted dolphins were loved by many for their playful behavior, stunning agility, and touching fondness of human interactions. (Courtesy of Teri Horton.)

FLORIDA'S GULFARIUM

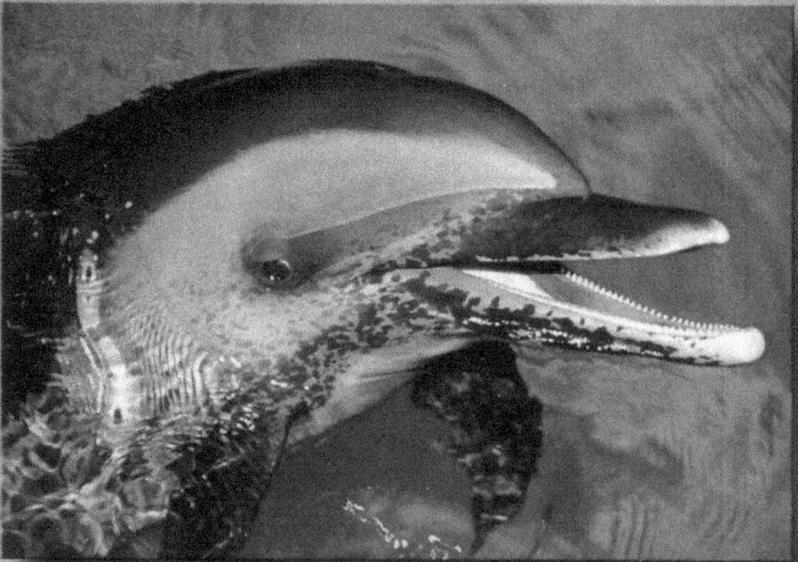

I got wet with Kiwi & Daphne

This postcard shows Kiwi (above), with her signature black tongue spot, and Daphne (below). While many facilities around the world were already offering dolphin swims by the mid-1990s, the Gulfarium's unique twist was the chance to interact with pantropical spotted dolphins, a deepwater species encountered less frequently than their bottlenose cousins. With slender rostrums, expressive eyes, and striking spots, Kiwi and Daphne were regarded by many guests as the most beautiful dolphins they had ever seen. (Courtesy of Teri Horton.)

Five

STORMY DAYS

The Gulfarium remained relatively fortunate in terms of hurricane landfalls through its first 40 years. Despite its vulnerable location on the southern edge of Okaloosa Island and close brushes with destructive storms Eloise in 1975 and Frederic in 1979, the park experienced only minor damage and was never forced to close long term due to storm damage.

In 1995, however, the Gulfarium's luck would change. Just after celebrating 40 years of entertaining crowds on the edge of the Gulf of Mexico, Hurricane Opal swept in as a Category 4 storm with sustained winds of 115 miles per hour and a storm surge of 15 feet above sea level. The main dolphin tank survived, but little else aboveground remained. Damage was so extensive that the park closed for nearly six months while repairs and renovations were made. Thankfully, the majority of the animals made it through the storm as a result of preparations by the Gulfarium staff.

Just a decade after Opal's devastating landfall, the warm waters of the Gulf produced another beast of a storm, Ivan in 2004, which ravaged the Gulfarium yet again. Ivan was one of the most intense and long-lived hurricanes ever recorded. It initially made landfall in the United States as a Category 5 storm near Pensacola, causing immense damage throughout the Florida, Alabama, and Mississippi panhandles. Ivan quite literally leveled much of the Gulfarium, ripping down most standing structures and pushing sand into pools and belowground pump houses. Again, the main dolphin tank survived relatively unscathed. Repairs were extensive, but the Gulfarium opened its doors again soon after Ivan had left the coast.

When Hurricane Katrina destroyed the Marine Life Oceanarium in Gulfport, Mississippi, in 2005, many of their dolphins were swept out to sea. With their former home gone for good, the Gulfarium offered its own pools to house some of the dolphins until a permanent home could be determined.

Hurricanes shape coastal life, and the Gulfarium's history has been profoundly influenced by its share of the fierce storms.

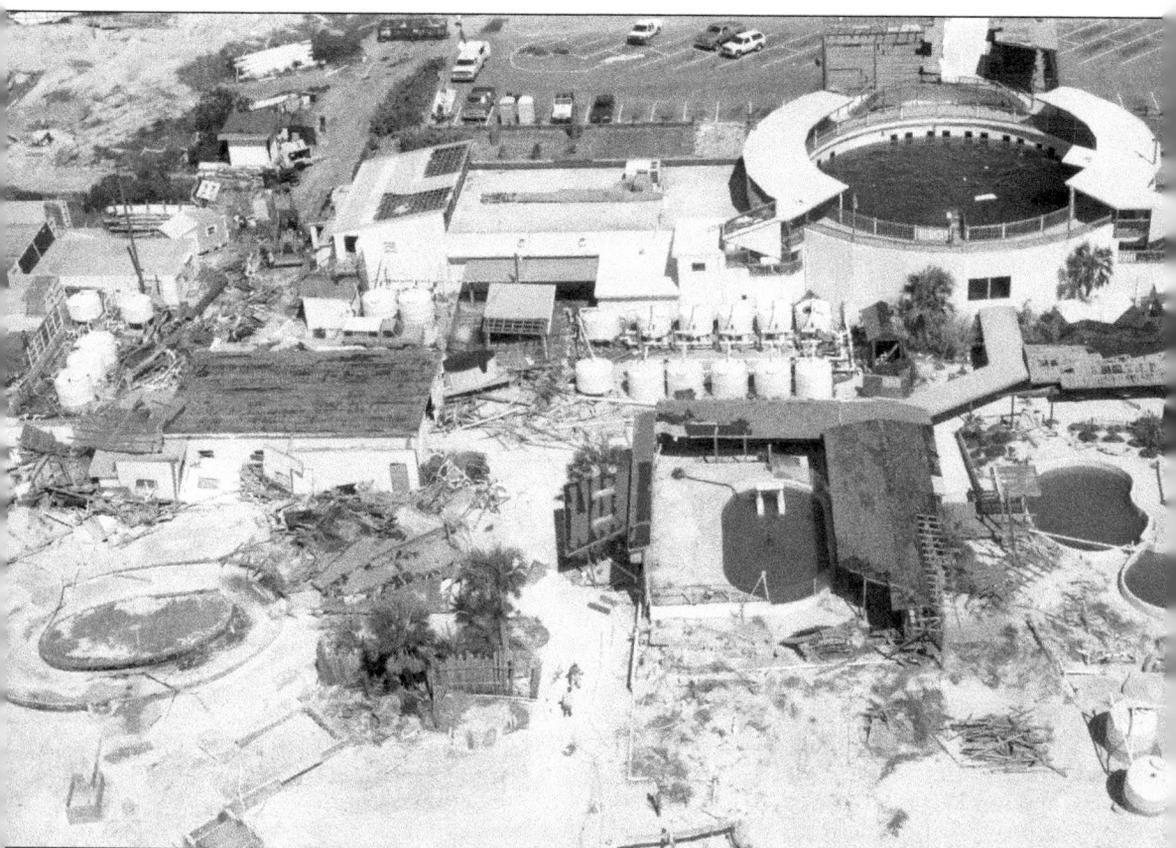

Hurricane Opal slammed into Okaloosa Island in October 1995, and the Gulfarium faced the teeth of the storm. Opal caused massive damage to the park, forcing it to close until March 1996, when nonstop reconstruction efforts had been completed. The main dolphin pool survived, but little else aboveground fared as well, including nearly all the roofing and walkway coverings. Due to power outages and lack of filtration, pool water was contaminated, resulting in the loss of nearly all the fish. Several pools were damaged, and the Shark Moat was filled with sand from the storm surge sweeping across the beach and into the park. After the sand had been excavated, reconstruction on the exhibit from the ground up began. All the park's featured attractions had to be operational by the time the Gulfarium reopened its gates. (Photograph by Tracey Steele; courtesy of the Northwest Florida Daily News.)

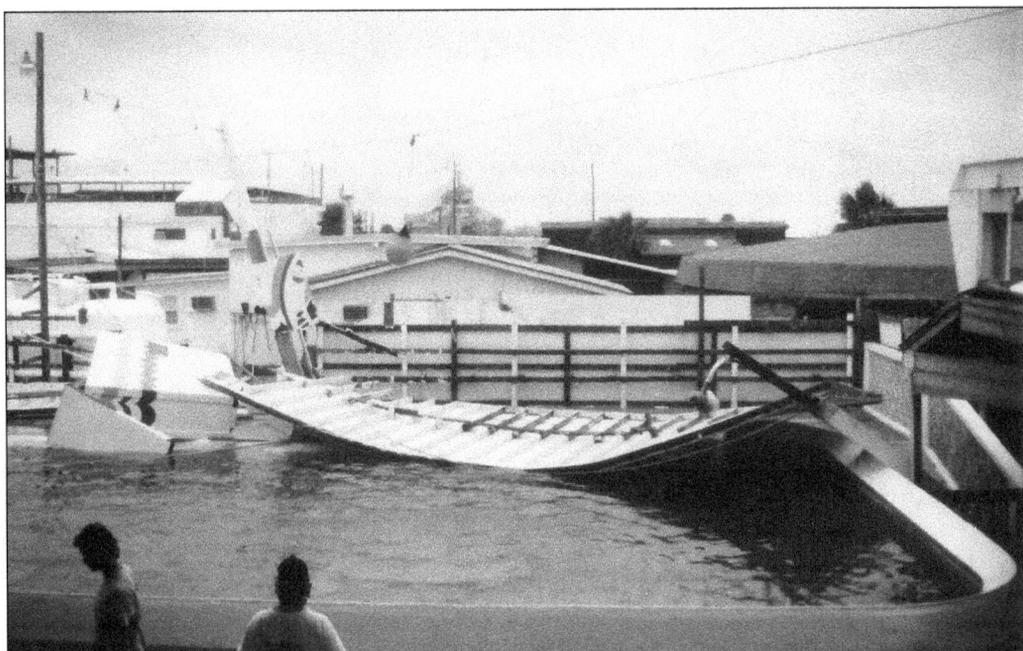

The morning of the storm, the Gulfarium staff moved all the marine mammals ordinarily housed in shallower pools to two 20-foot round interior pools and took the penguins to an indoor holding area. Dedicated staff continued their preparations until forced to evacuate. While most of the animals fared well through the storm (one harbor seal, two turtles, and several sharks were lost), many of the exterior structures, bleachers, and display pools were destroyed. These two photographs show the front (above) and back view of the remnants of the Multi-Species Show pool. While the backdrop and surrounding structures have collapsed due to the storm, high-jump target buoys still hang strong. (Both, courtesy of Justin Viezbicke.)

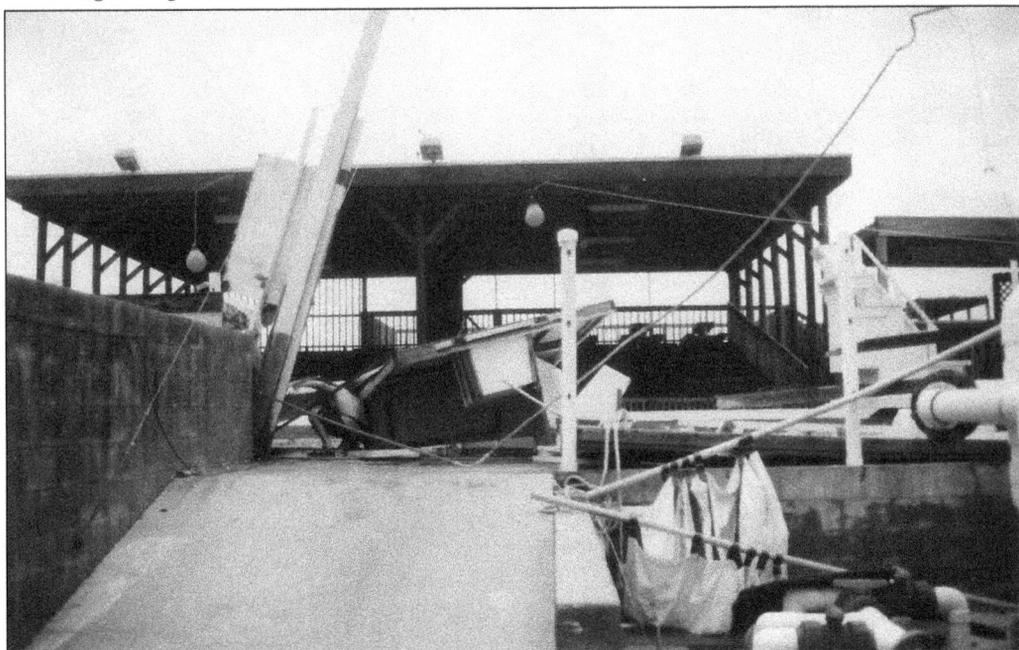

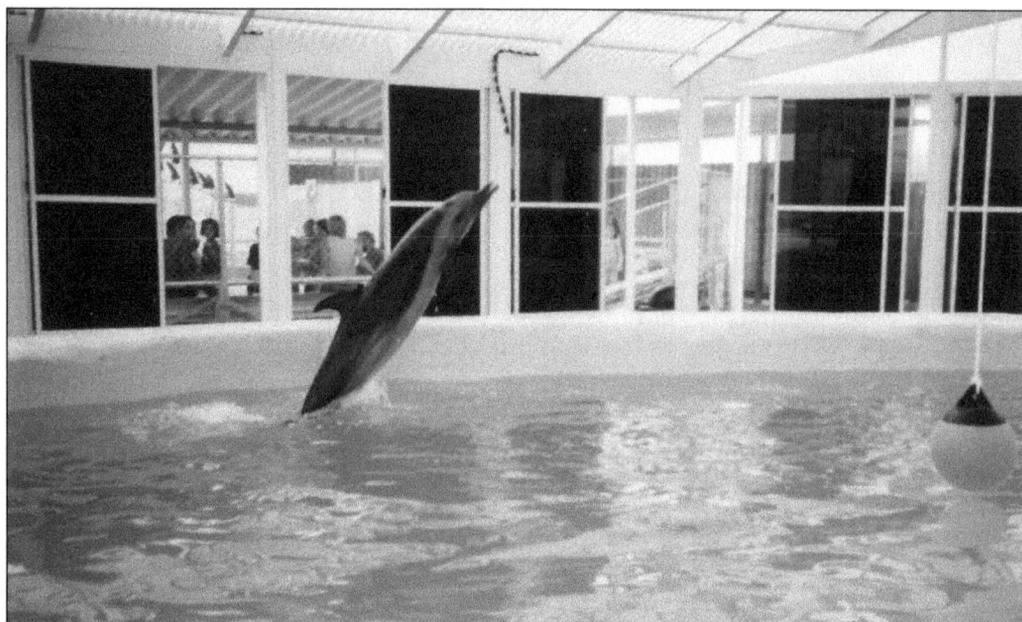

While practical and beautiful most times of the year, the Gulfarium's seaside setting proved detrimental during Hurricane Opal. Above, Kiwi is seen jumping in a covered portion of the College pool. Below, the structure has buckled and given way during the storm. After Opal had passed, firefighters immediately arrived on-site with hoses and a generator to restore the aquarium's saltwater environments, yet the Gulfarium incurred over $100,000 in damages due to high winds and a 15-foot storm surge. The park was closed for several months to rebuild and to reacclimate the healthy but traumatized animals to their surroundings. (Above, courtesy of Teri Horton; below, courtesy of Justin Viezbicke.)

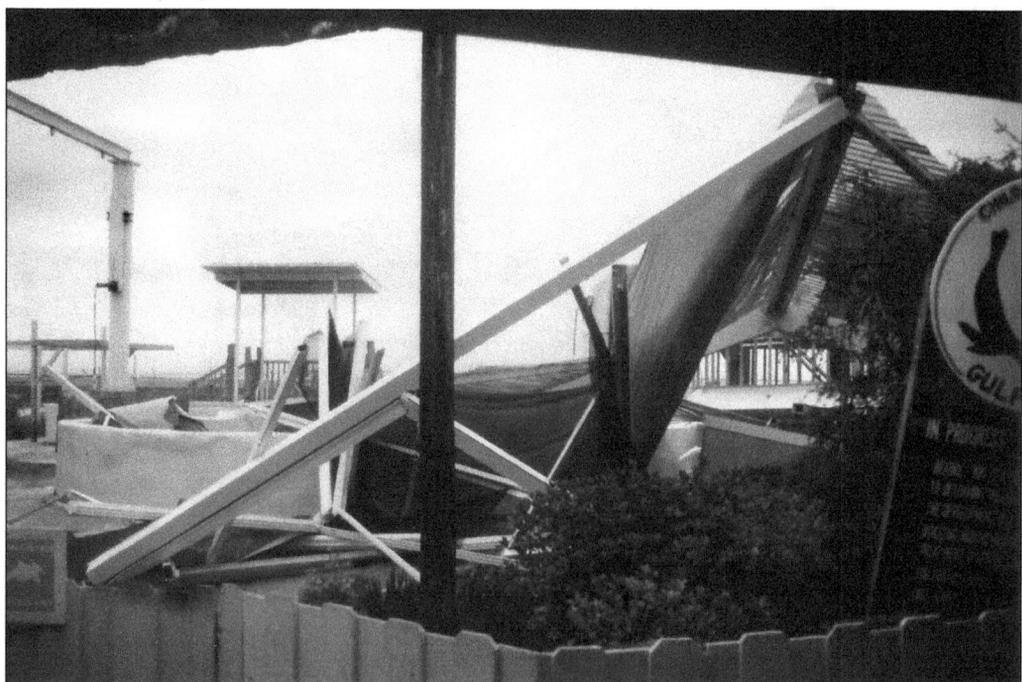

Beginning with Opal in 1994, the Gulfarium experienced more than a decade of constant cosmetic changes forced by a string of severe hurricanes. This mural painted by Dann "Spider" Warren in 1999 shows a transition period between Hurricanes Opal and Ivan, the Gulfarium's bright new face during a difficult time. This photograph shows the mural in progress, the leaping dolphin facade, a new awning, and a theater-style sign highlighting the park's main attractions. (Courtesy of Teri Horton.)

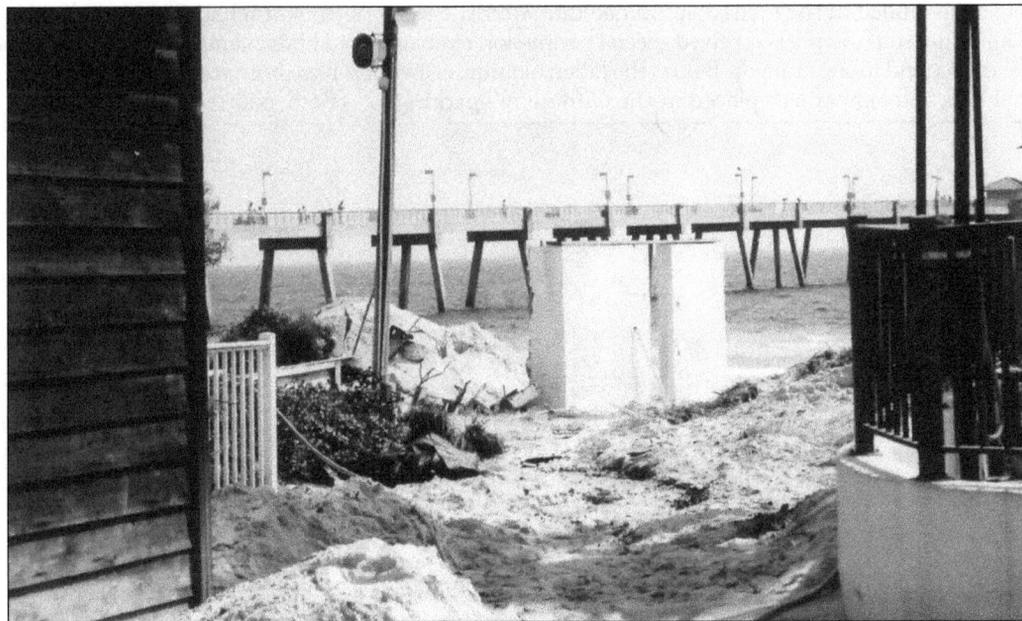

With a span the size of Texas and winds of 120 miles per hour, Hurricane Ivan slammed into Florida's panhandle the morning of September 16, 2004. With mandatory evacuations declared in Okaloosa County, the Gulfarium staff prepared by crating small animals and moving sea lions to back holding areas. The Gulfarium took the brunt of the storm, losing many of its structures due to high winds and storm surge. Pictured here, the beachside pump house is obliterated after the storm. (Courtesy of Teri Horton.)

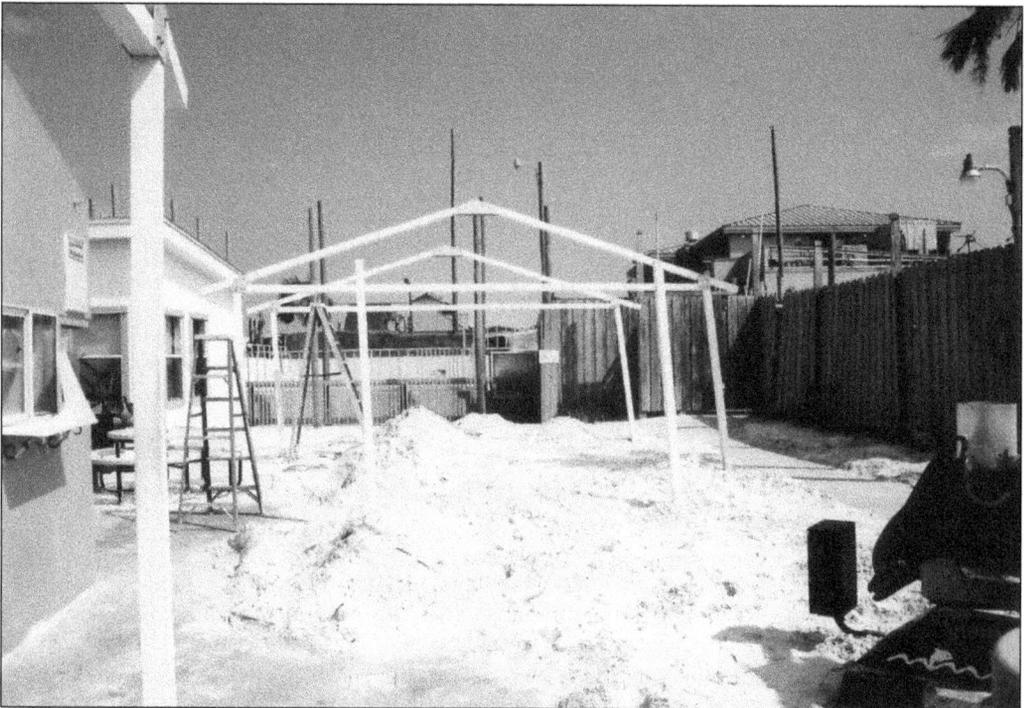

Pictured above are the skeletal remnants of the park's shade covering post Hurricane Ivan, much of which landed in the main dolphin habitat. After the worst of the storm had passed, dedicated Gulfarium staff members received special permission to cross closed bridges and come to Okaloosa Island to tend to the animals. Below, the fallen aluminum awnings have been removed from animal habitats and temporarily placed in the Gulfarium's parking lot. (Both, courtesy of Teri Horton.)

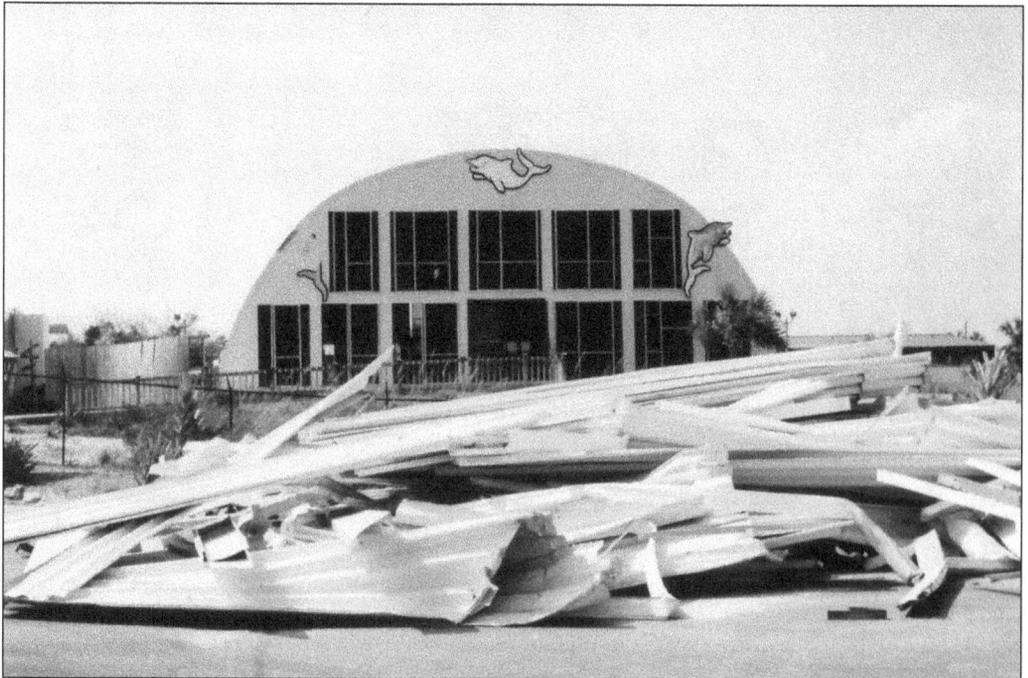

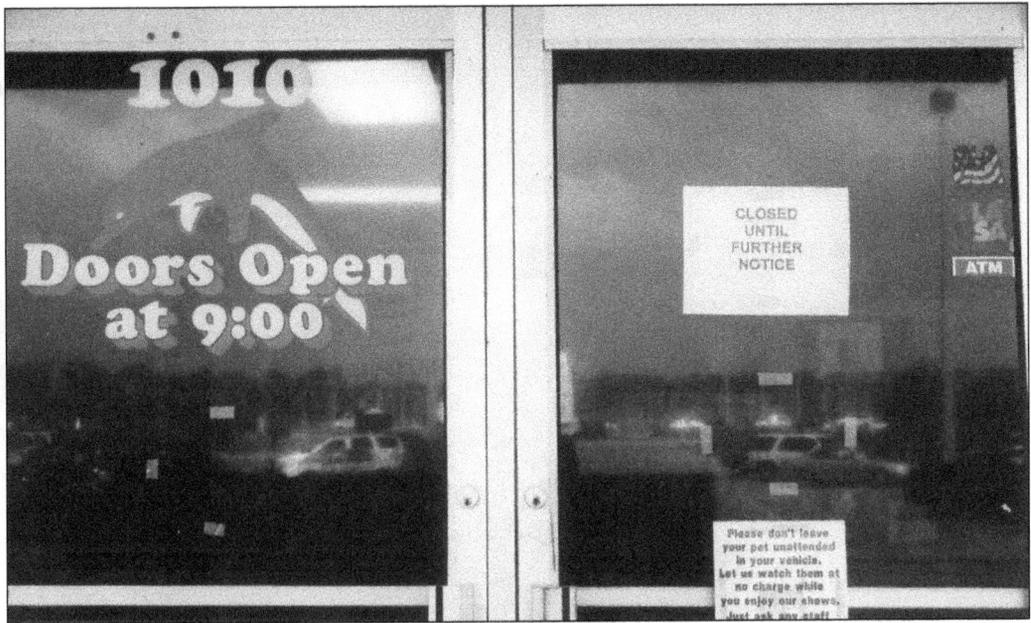

Above, signs on the door show the park was closed for several months due to Hurricane Ivan while work began to get the park open for business again. Luckily, all the animals fared well, with the exception of the fish in the Living Sea exhibit. Only the tarpon, a fish that is capable of gulping air from the surface, could survive the lack of dissolved oxygen in the water due to the power loss. Below, staff members and local volunteers begin the intense cleanup process, mainly shoveling sand into wheelbarrows to return to the beach. The sea lion show pool sustained heavy damage, as seen by the pane of glass leaning against the railing, temporarily replaced with plywood. (Courtesy of Teri Horton.)

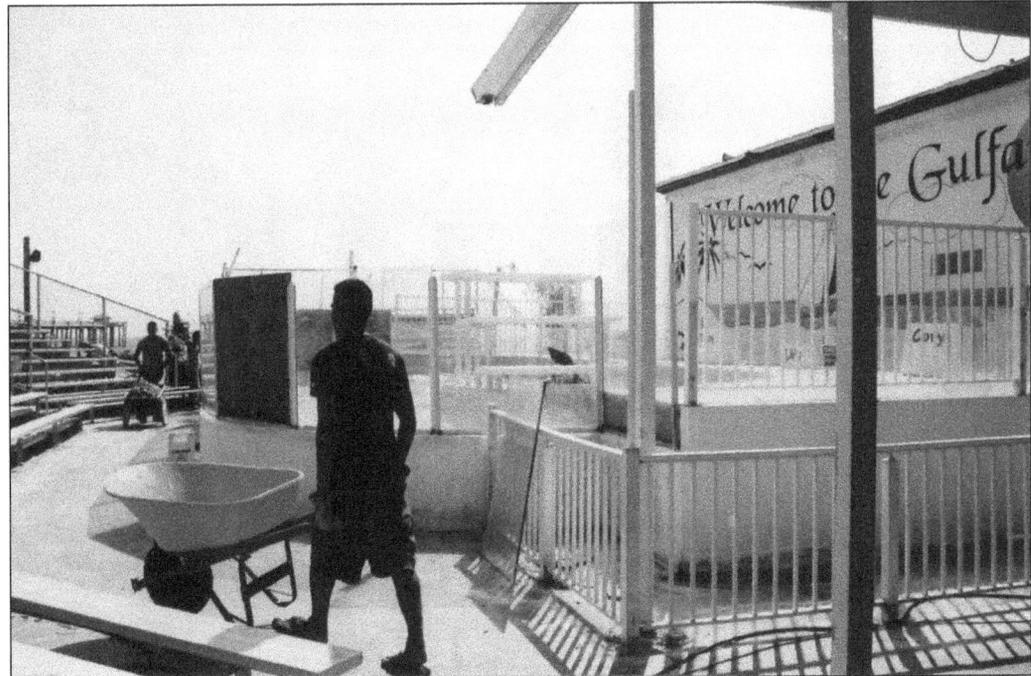

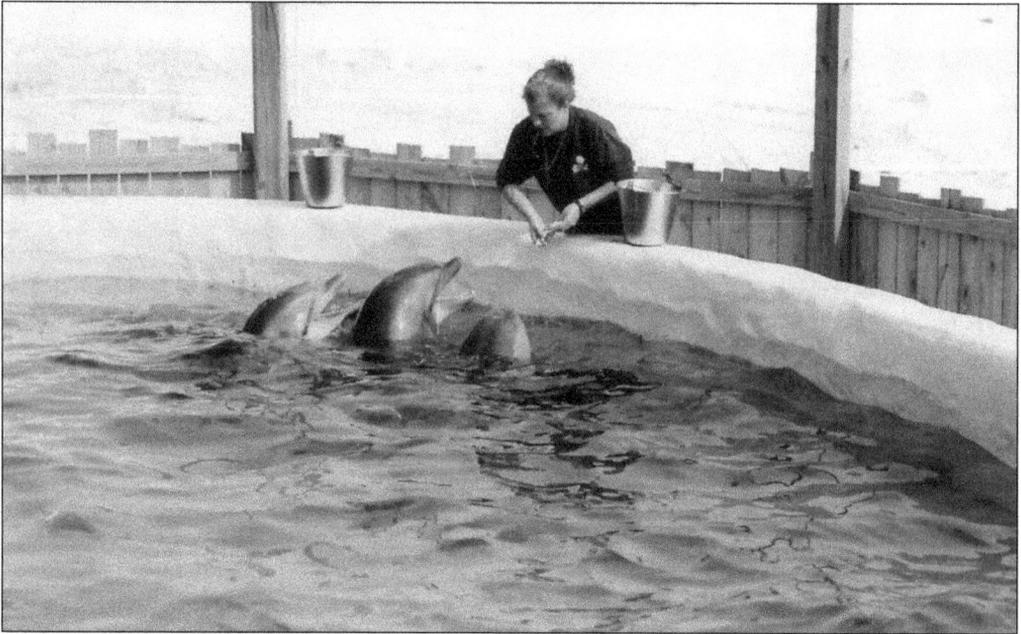

Hurricane Katrina made landfall on the Gulf Coast on August 29, 2005, leaving a path of destruction in its wake, the majority of which was due to storm surge. While the Gulfarium was spared, the Marine Life Aquarium in nearby Gulfport, Mississippi, was completely annihilated, losing several dolphins that would later be recovered in the Mississippi Sound and even in local golf course lakes. After a brief period of time in local hotel pools, six of these dolphins were transported to the Gulfarium College pool, where they received cooperative care from Gulfarium and Marine Life Aquarium staff for several months. Above, Marine Life Aquarium trainer Elizabeth Sack feeds displaced dolphins (from left to right) Brewer, Cherie, and Tessie. Below is a close-up view of Jonah (top) and Brewer as they swim in the College pool. (Courtesy of Teri Horton.)

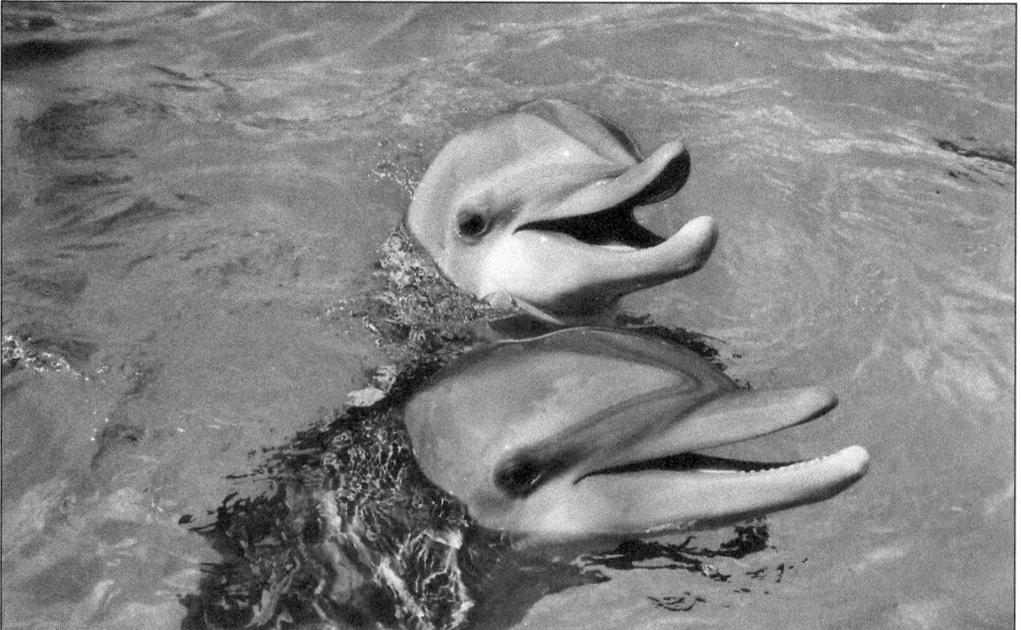

Six

BECOMING A
MODERN CLASSIC

Beginning in the 1990s, the Gulfarium began to evolve with the rest of the marine park industry into a place where guests could interact with the animals. Dolphin swim programs were developing across the world, and the Gulfarium kept pace with both dolphin swims and therapy sessions for people with chronic neurological diseases. Pantropical spotted dolphins Kiwi and Daphne became star attractions at the Gulfarium during this period. Because humans had handled Kiwi from the time she was an orphaned calf being nursed back to health, she thrived on the closeness with humans in the interaction programs.

Even as interacting with the dolphins became the main attraction, the dolphin show continued in the main tank designed by Brandy Siebenaler and constructed in 1954. After the relentless hurricanes of 2004 destroyed the original dolphin habitats at Marineland near St. Augustine (Florida's first oceanarium), the Gulfarium's main tank became the oldest dolphin habitat still in use. The battleship steel and concrete structure that withstood several fierce hurricanes continues to be the scene of the Gulfarium's dolphin show to this day, although the show now focuses on conservation and education rather than the high feeds and flaming hoops of bygone days.

The Living Sea also thrills guests to this day as they peer through the original floor-to-ceiling Herculite windows installed nearly a decade before Flipper first splashed onto the silver screen. Today, the exhibit features many tropical reef fish, and the Living Sea provides a stunning backdrop for wedding receptions and other banquet events.

With guests still flocking to the park annually, cheering for the dolphins, sharing photographs on their social networks, and coming face-to-face with fascinating creatures of the sea, the Gulfarium has more than achieved Brandy Siebenaler's original vision to provide the public with an accessible window into the sea. The park has become a portal through which guests can gain a personal connection with the sea, fostering conservation of the resource so dear to Siebenaler's heart.

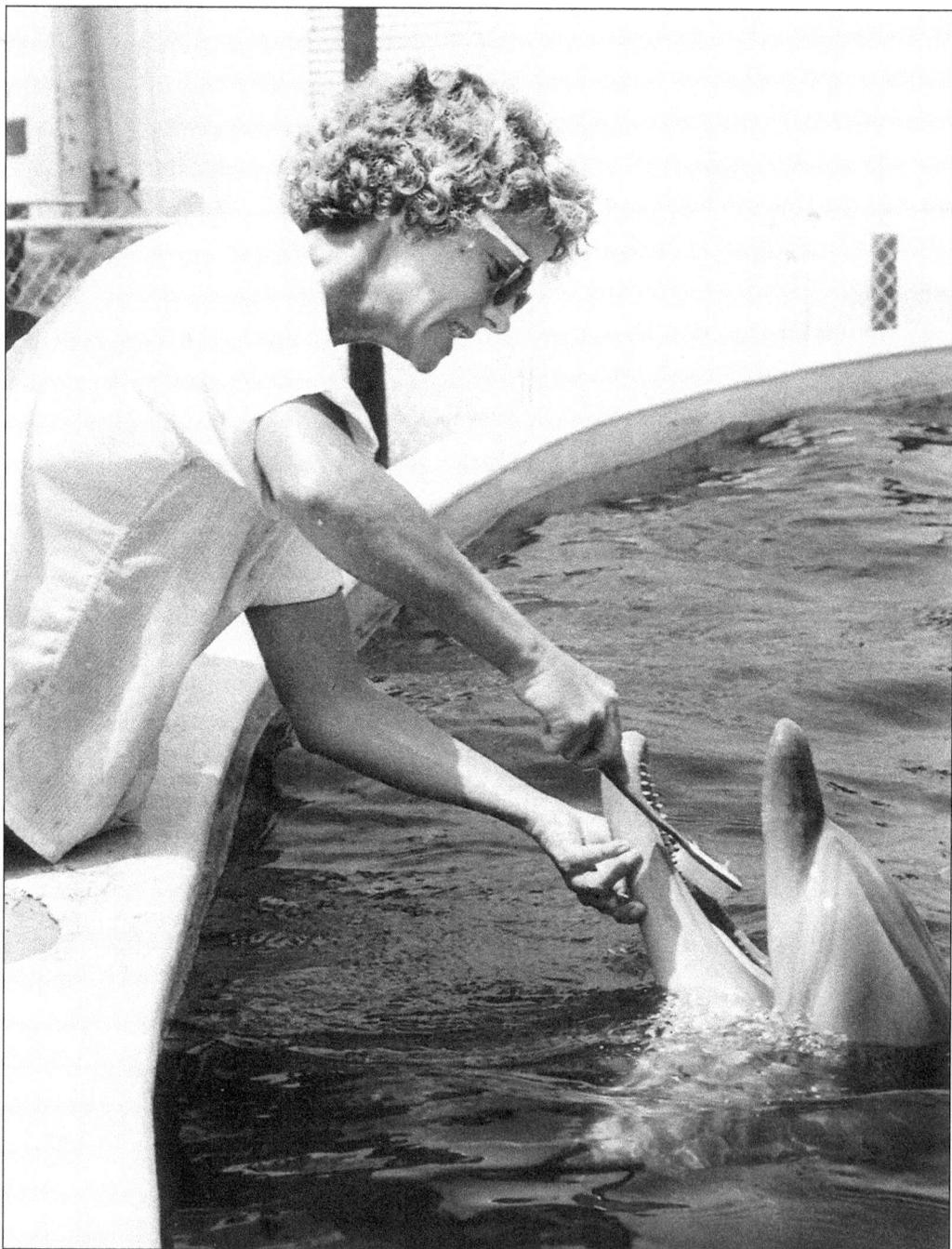

Marjorie Siebenaler demonstrates proper dolphin dental hygiene maintenance. Although brushing a dolphin's teeth is not considered necessary in most cases, this photograph depicts not only Marjorie's innate ability to train almost any behavior but also the commitment to animal care the Gulfarium's founders had fostered. The Gulfarium would continue to be a leader in the field of marine mammal husbandry throughout its history, including the first successful raising of a bottle-fed calf and the development of a noninvasive dorsal pack used by the US Navy for attaching research data recorders. (Courtesy of Arturo.)

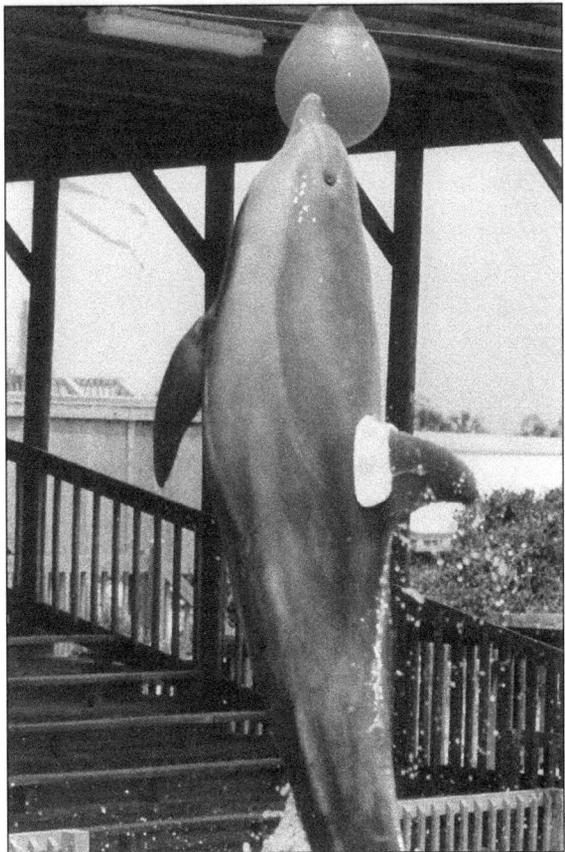

Above, in 1993, Gulfarium curator Greg Siebenaler steadies dolphin Delphi's dorsal fin while Eglin Air Force Base senior engineer Ed Keller attaches a saddle pack. Gulfarium dolphins were enlisted to assist in development and testing of the noninvasive device, which could hold a transmitter and sensors and be used on wild dolphins to study swim patterns, dive depths, and water-quality components. At right, small and formfitting, the dorsal pack stays in place as Delphi performs a high-jump behavior. Veterinarian Dr. Forrest Townsend and prosthetics expert Frank Deckert eventually developed smaller satellite tags based on this early prototype. (Both, courtesy of Gulfarium Marine Adventure Park.)

The presence of hurricanes led to studies on disease contraction in dolphins due to the spread of a toxic airborne fungus in high winds. After dolphins at several facilities were lost due to this fatal fungus, Dr. Forrest Townsend and his colleagues developed a test using blood samples provided by the Gulfarium to diagnose the toxin. Above, in 2014, trainers Meleah McLendon (left) and Cat Rust prepare to take a blood sample from the tail fin of a dolphin. Based on this research, a course of fungal treatment was determined, and Lily, a current Gulfarium resident pictured below in 2014, became one of the first successfully cured dolphins. (Both, courtesy of Krista Stouffer.)

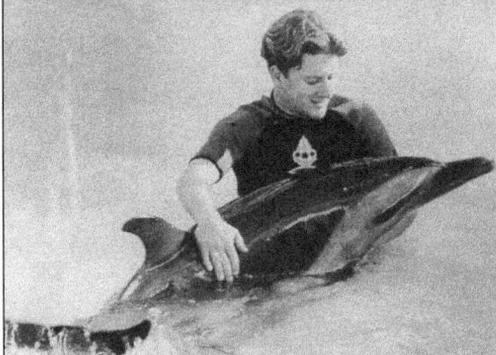

These brochures from the mid-1990s, featuring a young Elizabeth Petermann (left), who would later become a Gulfarium veterinarian, and trainer Kevin Krueger (right), reflect the Gulfarium's shift from primarily a show facility to one providing opportunities for guests to interact with the animals. Dolphin swim programs, dolphin-assisted therapy, and even parrot interactions became part of daily operations as guests desired to experience interactions with the animals. This trend can be seen across the zoo industry beginning as early as the 1980s. (Both, courtesy of Gulfarium Marine Adventure Park.)

By exhibiting some of the ocean's most feared creatures, the Gulfarium took an active role in conveying the real story of these animals to the general public. Above, diver Kevin Krueger holds a large nurse shark near a window to the delight of visiting schoolchildren. Below, Doyle Horton wraps a full-grown green moray eel around his body. A key moment in the Living Sea show in the late 1990s was when the diver would wrap the eel around his arm like saltwater taffy. This demonstrated to guests that these fearsome animals were not simply mindless eating machines but, rather, animals with unique positions within the oceanic ecosystem, which helped to foster a respect for and desire to conserve the Earth's resources. (Both, courtesy of Teri Horton.)

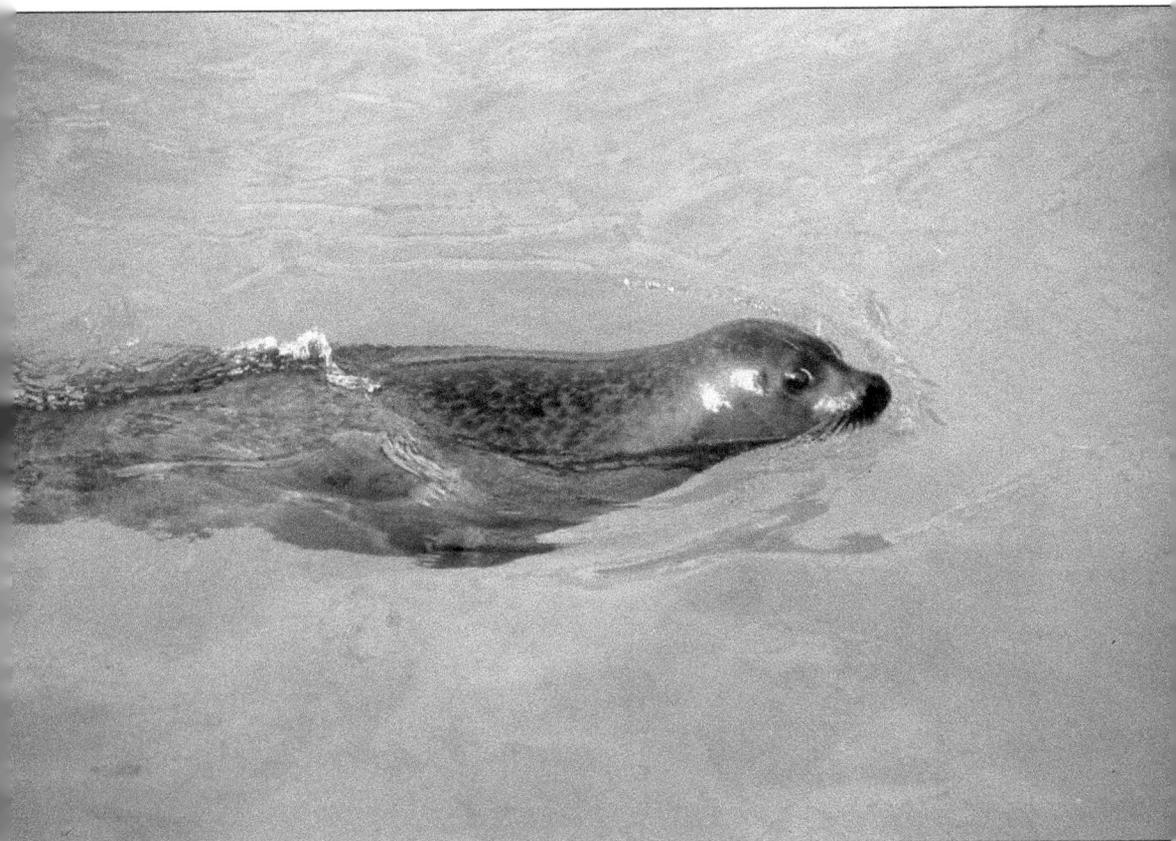

Harbor seals Kona (pictured here around 1989) and Domino (not pictured) came to the Gulfarium in the early 1980s from the New England Aquarium in Boston, Massachusetts, after stranding along the northern Atlantic coast. A former pinniped trainer at the Gulfarium, Lee Kellar calls to mind a friendly rivalry between the dolphin trainers (always dressed in clean white boots and crisp white pants) and the pinniped trainers (more casual in black boots and jeans). To tease the dolphin trainers, Kellar and his pals once trained Kona and Domino to execute the same routines performed in the dolphin show, including a high jump, mouth feed, and even a tail walk—an impressive feat for a seal. (Courtesy of Gulfarium Marine Adventure Park.)

One of the Gulfarium's most memorable residents was LB, a 1,000-pound sea lion easily recognized by his immense stature. Acquired from a tourist attraction in Homosassa Springs, Florida, LB was thought to be a large California sea lion. However, looking back, the Gulfarium's premiere pinniped trainer Lee Kellar speculates that LB was actually a hybrid of this and a Stellar sea lion, the largest of the eared seals. Short for "Left-eye Blind," LB suffered from an optical occlusion in his left eye, and as an unidentified trainer demonstrates below in April 1986, trainers always stood toward his right side for better visual acuity. (Both, courtesy of Gulfarium Marine Adventure Park.)

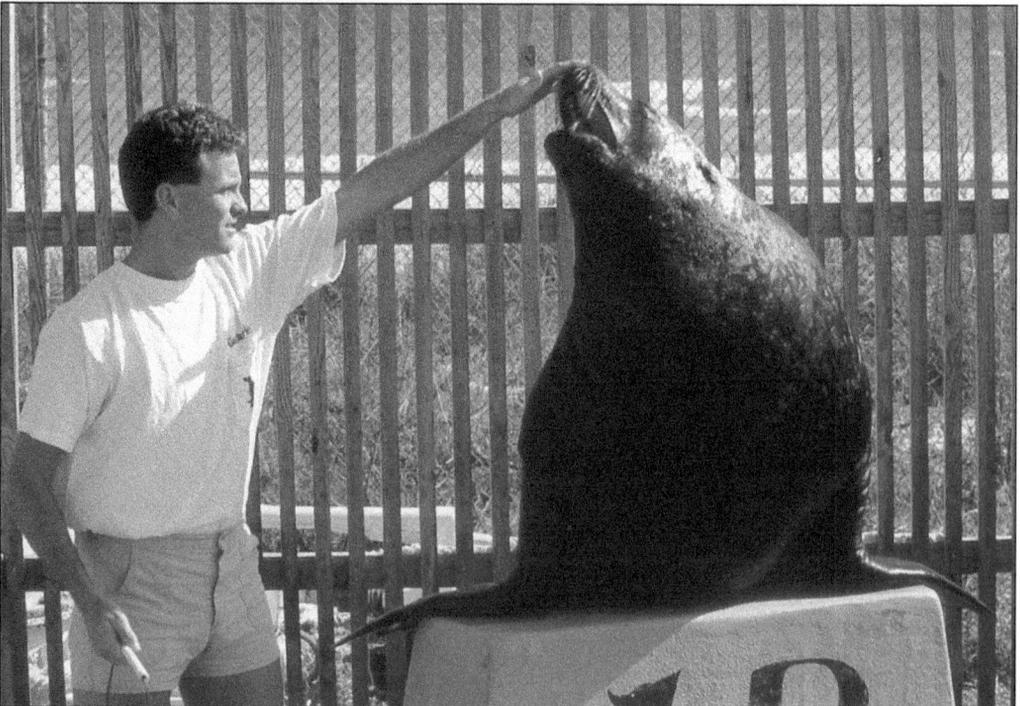

Above, a pair of grey seals lounge side by side in the rookery exhibit around 1990. The Gulfarium acquired Grendel (female, left) and Woody (male) when the Mystic Aquarium in Mystic, Connecticut, sought an alternate location for the pair. Due to an outdoor exhibit and extremely cold northeast winter, Woody had endured frostbite on his flippers and needed a warmer environment. Below, a profile view of Woody from January 1989 shows his elongated nose, highlighting the physical dimorphism between male and female grey seals. The scientific name of the grey seal, *Halichoerus grypus*, is Latin for "hook-nosed." (Above, courtesy of Billy Hurley; below, courtesy of Gulfarium Marine Adventure Park.)

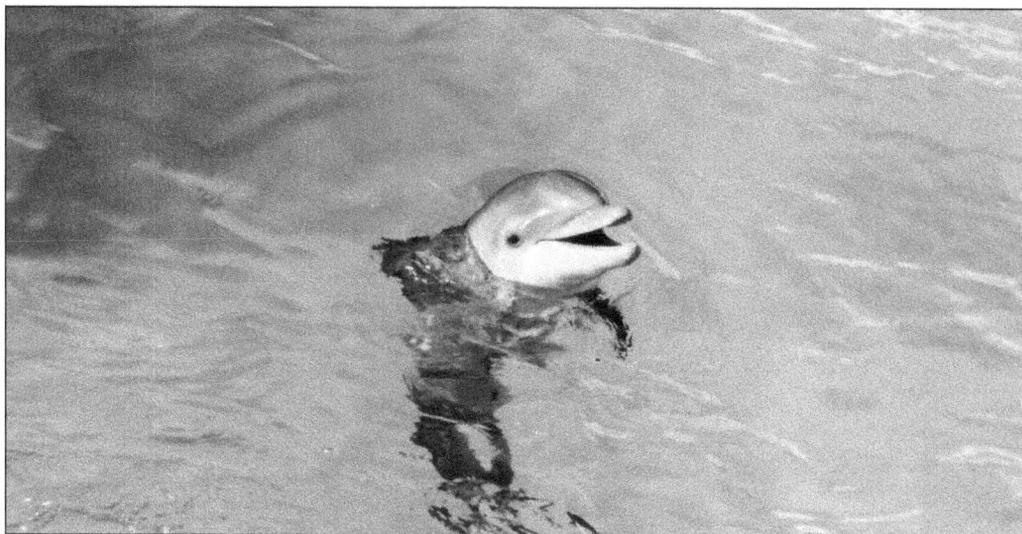

Shown above, Brandy was born just days after Gulfarium founder Brandy Siebenaler's passing in 2000 and was named in his honor. On his first birthday, the Gulfarium hosted a birthday bash to celebrate Brandy's first year and the man whose vision had become the Florida Gulf Coast's first marine attraction of its kind. Today, Brandy the dolphin thrives at Six Flags Discovery Kingdom in Vallejo, California. (Courtesy of Teri Horton.)

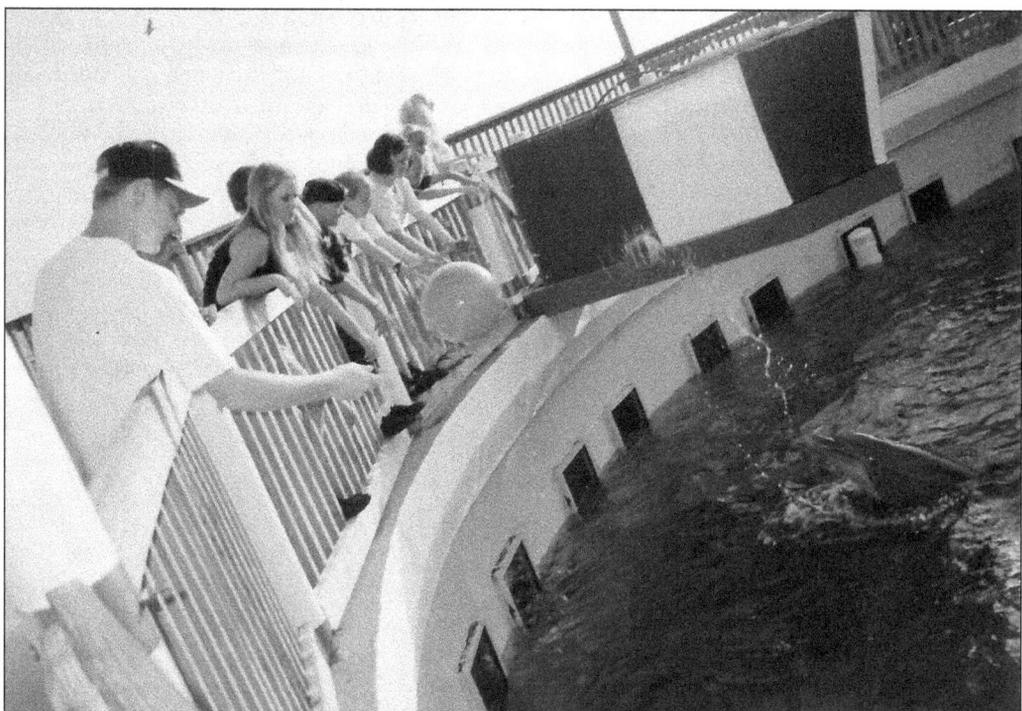

Guests play catch with a playful dolphin after a show in 1994. Providing a window into the sea was the Gulfarium's goal from the start, but allowing guests to gain an even more intimate connection with beloved sea creatures became one of the park's missions. Trainers who have conducted and witnessed interactions like this simple playtime speak of the smiles and the lifelong passion for conservation they foster in Gulfarium visitors. (Courtesy of Teri Horton.)

The Tide Pool exhibit allows guests of all ages to interact directly with sea creatures, no matter their comfort level in the water. These photographs from the early 1990s show several species exhibited at arm's length for curious guests. Above, horseshoe crabs, pencil urchins, and a hermit crab rest in shallow water. Below, a scrawled filefish swims past two pencil urchins. A member of the education staff stationed at the exhibit ensures the safety of animals and guests while answering questions about the shallow-water creatures. This evolution of the Gulfarium, from its original Living Sea show to an opportunity for guests to actually handle Gulf of Mexico sea life, fits squarely with Brandy Siebenaler's mission to connect the park's guests with the marine ecosystem he loved. (Both, courtesy of Teri Horton.)

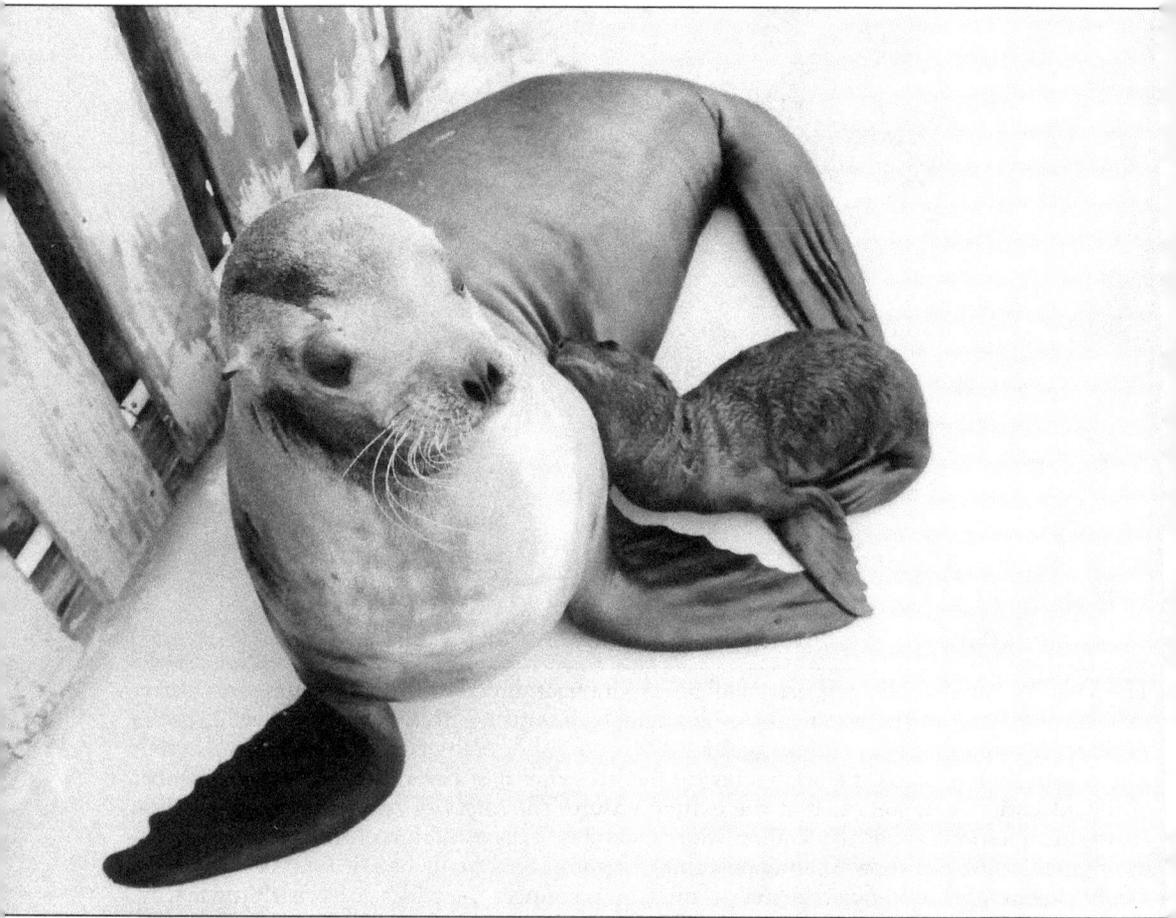

Sea lion Cory nurses her new pup, Libby, in 2004. The Gulfarium announced its first sea lion pup birth in 1977 when Dolly successfully birthed her first pup, fathered by Smasher. Although some stranded and orphaned sea lions were still brought into the Gulfarium as rescues, the breeding program remained strong throughout the decades following that first pup. At just 10 days old, Libby is completely dependent upon her mother's milk. Trainers allow the mother to raise her young through this early stage of life, waiting until the pup is weaned to begin training. (Courtesy of Teri Horton.)

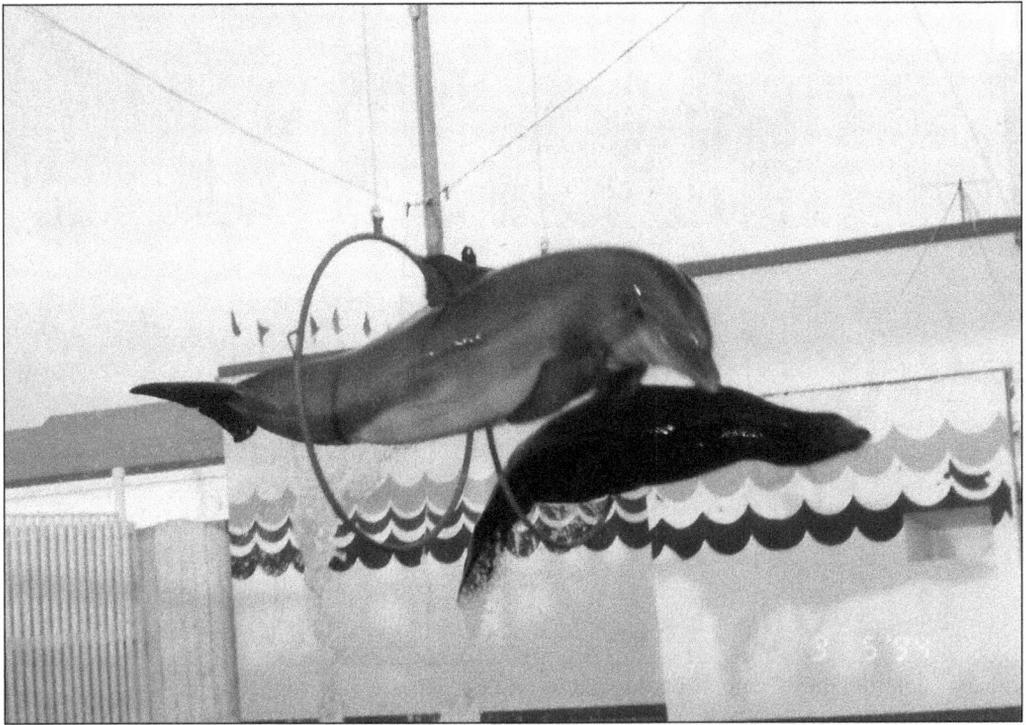

Dolphins and sea lions performed together daily in the Multi-Species Show. Here, bottlenose dolphin Prince and sea lion Kyle leap through hoops suspended above the water during a show in 1994. These very different marine mammals show that they share incredible agility and strength. Few facilities in the United States offer the opportunity to watch dolphins and pinnipeds perform side by side. (Courtesy of Gulfarium Marine Adventure Park.)

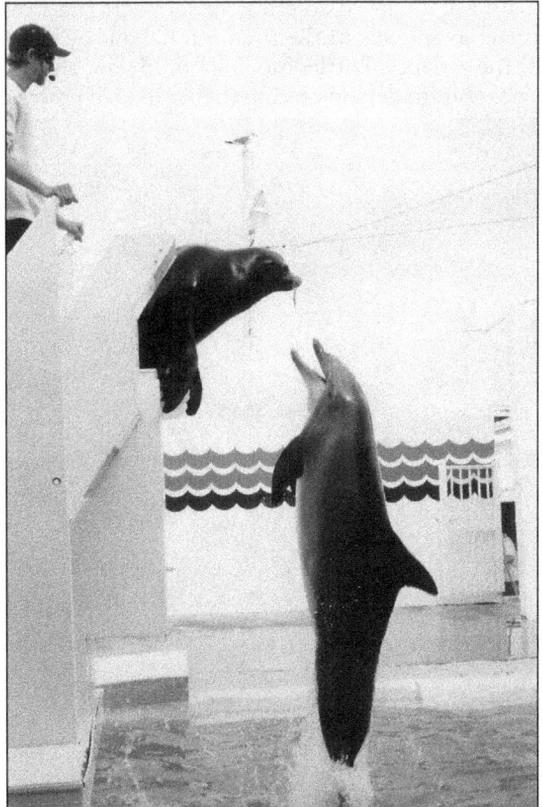

The pinnacle behavior of the Multi-Species Show featured a sea lion patiently holding a fish in its mouth for a dolphin to retrieve. Pictured here in the 1990s, Princess the dolphin grabs a fish from sea lion Kyle as trainer Jeff Woods looks on. The impressively collaborative behavior, first trained at the Gulfarium by Lee Kellar, required immense control from the sea lion and pinpoint accuracy on behalf of the dolphin. (Courtesy of Teri Horton.)

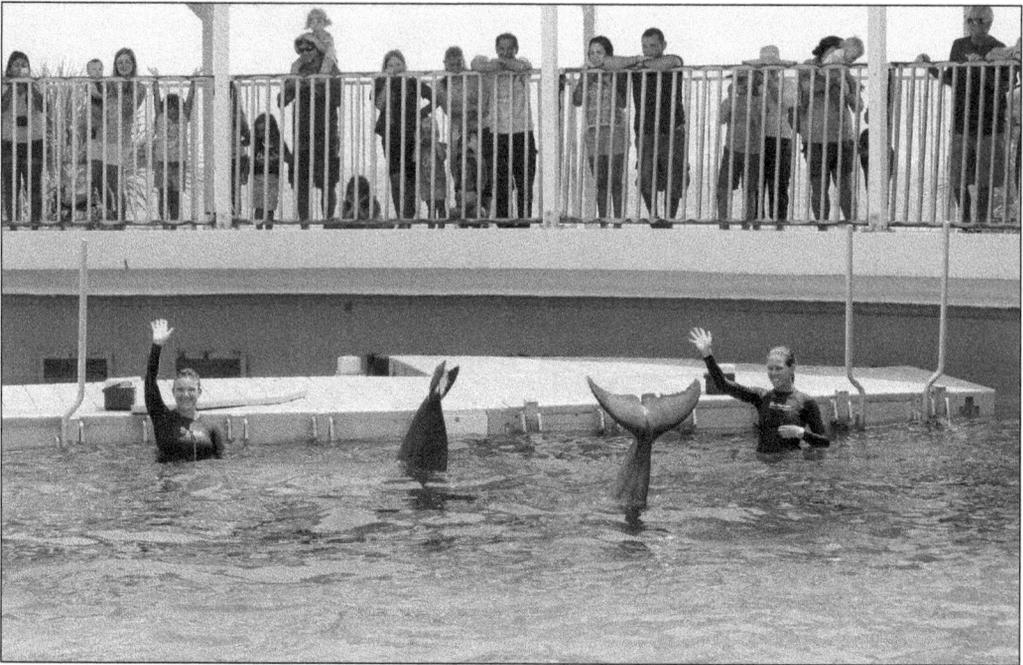

Current dolphin shows emphasize education and conservation, while still entertaining crowds with a spectacle of agility and acrobatics. Above, trainers Shannon Yoskoski (left) and Rachel Cain ask a pair of dolphins to show off their tail flukes, empowering visitors to respect and preserve animals in their natural habitat by demonstrating physical attributes and adaptations of the Atlantic bottlenose dolphin. Below, the audience cheers as trainer Stephanie Link leads Sebastian in demonstrating the incredible power of his tail. (Courtesy of Krista Stouffer.)

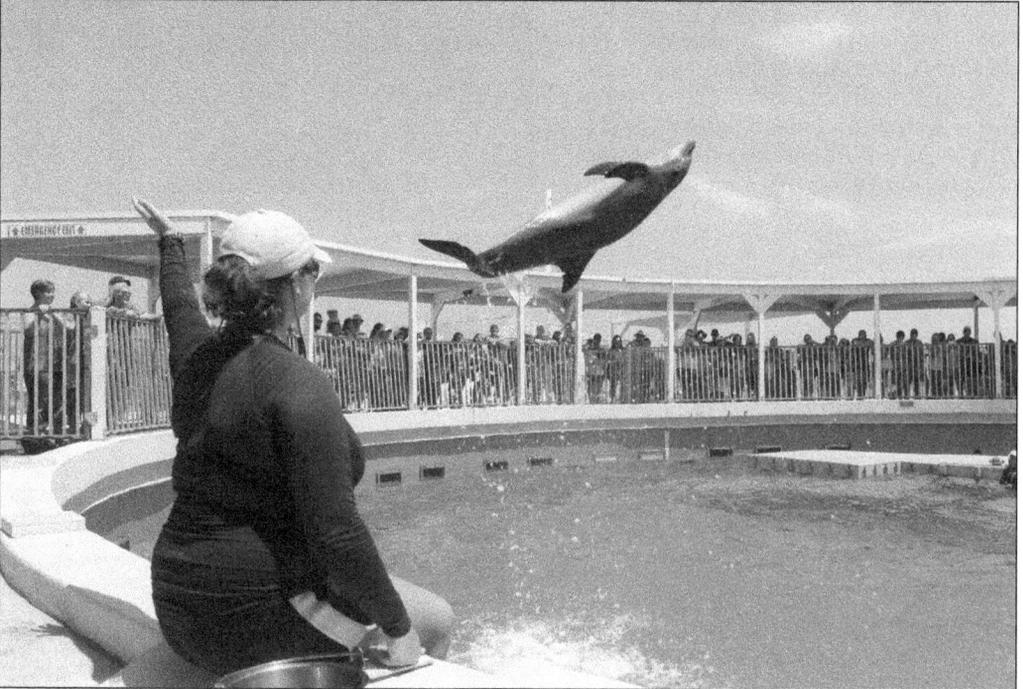

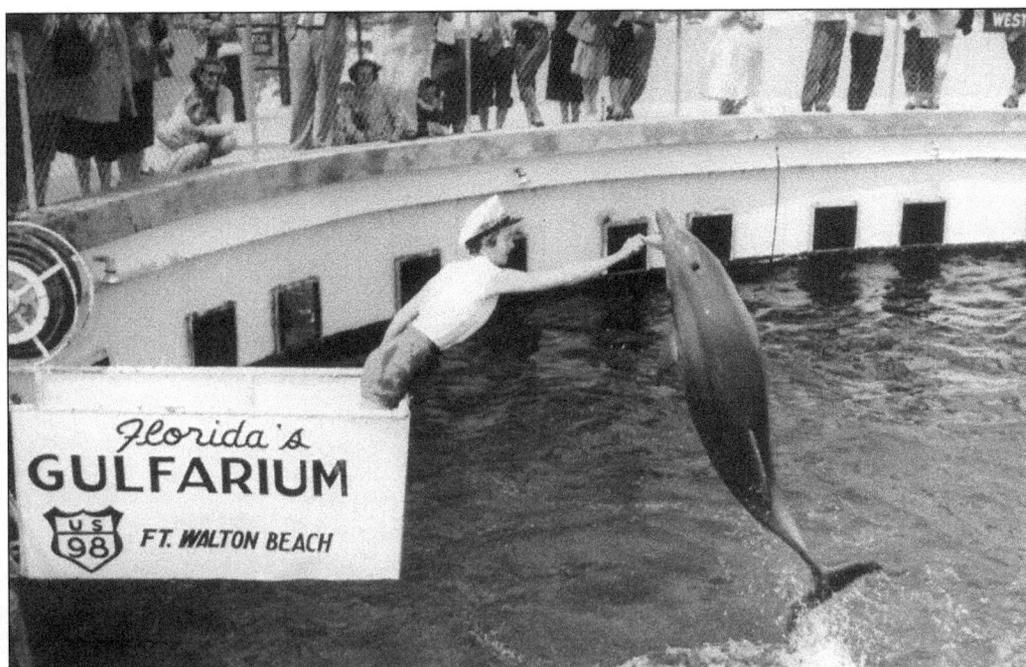

The Gulfarium's Living Sea, the cherished aspiration of marine scientist Brandy Siebenaler, has flourished over the last 60 years to become a modern interactive oceanarium known as Gulfarium Marine Adventure Park. Embracing the history of theatrics with a nod to early high jumps, trainer Stacy DiDonato (right, in the early 2000s) mirrors the enthusiasm once portrayed by Marjorie Siebenaler (above, in the 1950s). Dedicated to educating and entertaining visitors by offering unique and memorable opportunities to connect with marine animals, Gulfarium Marine Adventure Park continues to uphold the vision of its founders and provide first-rate animal care. (Above, courtesy of Arturo; right, courtesy of Teri Horton.)

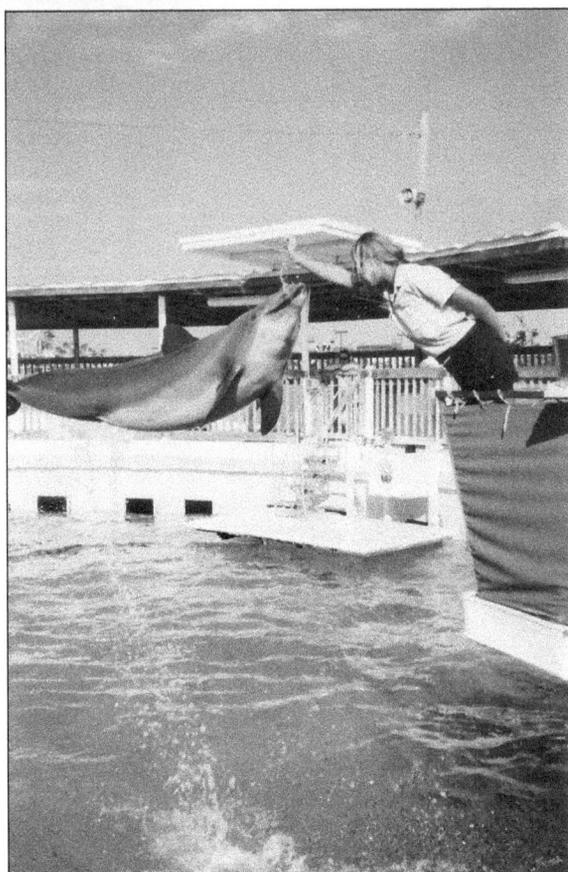

Visit us at
arcadiapublishing.com

www.ingramcontent.com/pod-product-compliance
Lightning Source LLC
Chambersburg PA
CBHW050629110426
42813CB00007B/1758